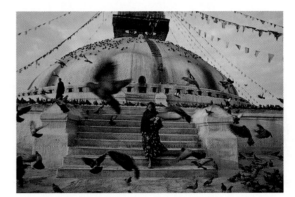

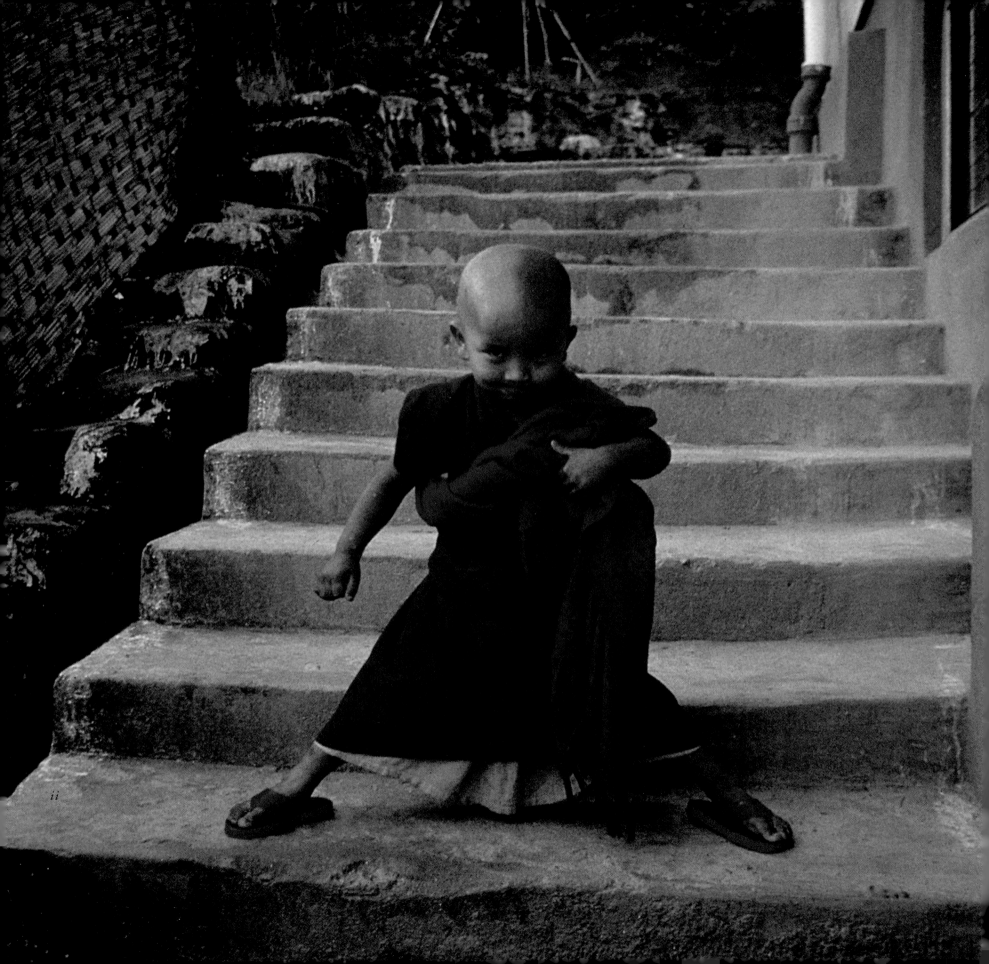

VISIONS OF BUDDHIST LIFE

DON FARBER

FOREWORD BY HUSTON SMITH

UNIVERSITY OF CALIFORNIA PRESS

Berkeley Los Angeles London

University of California Press
Berkeley and Los Angeles, California

University of California Press, Ltd.
London, England

Library of Congress Cataloging-in-Publication Data

Farber, Don.
 Visions of Buddhist life / Don Farber ; foreword by Huston Smith.
 p. cm.
 ISBN 0-520-23361-1 (Cloth : alk. paper)
 1. Buddhism—Pictorial works. I. Title.
 BQ4030 .F37 2002
 294.3'022'2—dc21

 2002003434

Manufactured in Singapore
11 10 09 08 07 06 05 04 03 02
10 9 8 7 6 5 4 3 2 1

THIS BOOK IS THE STORY OF TWO LOVES THAT merged to become one. Don Farber's first love was photography, his chosen profession—or more accurately his vocation, for it came to him as a calling. Then, at a relatively early age, a second love, Buddhism, entered his life and caught up with the first. The tangible issue from these complementing loves is the book the reader holds in his or her hands.

Early in its conception, Don approached me and asked if I would write a foreword to his book if it found a publisher. Listening to his plans and casting a reflective eye over the sample photographs he had brought with him, I found myself readily agreeing.

My first hours with his completed book, while exceeding the already high expectations his initial photographs had awakened in me, left me with an anomaly. Here were stunning, arresting photographs, but only a brief text to indicate what there was about Buddhism that had drawn Farber to it. It took several days of circling that anomaly for me to see that it arose from my approaching the book in the wrong way. As my medium for communication is words, I had been expecting Farber to tell us *in words* what it was about Buddhism that had attracted him. How could I have been so wide of the mark! As a historian of religion, I should have realized that Buddhism entered the world through civilizations in which most of the people were unlettered. This meant that they found most of its texts in stories, chants, drama, dance, and stone. In my response to Farber's work, I was playing out the philosopher's prejudice of assuming that truth comes to us primarily through ideas, forgetting that "when logics die, truth leaps through the eye" (Dylan Thomas). Farber doesn't tell us what drew him to

Buddhism. He shows us. (His introduction and captions traffic in words, as they necessarily must, but that does not alter my basic point.)

This observation leads directly to what Farber explained to me was one of his hopes for this book, which is that it will move photography into the company of the other art forms that have been so vital in the transmission of Buddhism as a religion. Child of technology as it is, photography is a latecomer to this company and is still having difficulty crashing the party, if I may use that crass manner of making my point. We are still laboring under the cliché that portrait photography (to cite an instance) has its uses but cannot hold a candle to portrait painting, which can capture the spirit of subjects, not just physiognomies. That put-down may have carried some weight in the early days of photography, but now that subtleties of light, shade, composition, and color have entered the technology to make it unquestionably an art form, the put-down approaches (as this book clearly indicates) outright slander.

Having moved this general point into place, I add several specifics about the photographs that are assembled here. As I leafed lovingly through them, the points listed here came to mind.

First, these photographs, as Farber states explicitly in the book's title, are of Buddhist *life*. People are everywhere.

Second, they are *his* people. The photographs themselves all but proclaim this, yet it also has a factual basis. A Buddhist practitioner for many years, he is married to a Tibetan.

Third, if there is a single Buddhist attribute that shines through these photographs it is (for me) devotion. Look at the

human body—a woman's—that is virtually plastered to a *mani* stone on page 171 or the prostrate monk on page 179.

Fourth, Farber is not only a master photographer, he is an accomplished portrait photographer. The faces in these photographs will remain with me for a long, long time.

Fifth, artistry enters these photographs not only when they are viewed individually but from the way Farber has arranged them in his book. The two generations of women juxtaposed on pages 238–39 proclaim without using a word the bridging of generations that is the key to any tradition's survival. Or look at the remarkable sequences of His Holiness the Dalai Lama on pages 69–75 and again on pages 199–203, which catch him in a variety of moods that range from solemnity to playfulness and show him in the round, so to speak, as a complete human being. Whereon hangs a tale, a personal memory of His Holiness that I will indulge myself in.

A decade or so ago the University of California at Los Angeles had His Holiness for a day and invited me to kick the event off with a half-hour dialogue with him. As I was working my way through the crowd that was entering the theater, someone in the throng recognized me and said, "You're going to be dialoguing with him, aren't you? He's goofy." Recognizing a good line when I hear one, I used his remark as my gambit for entering the dialogue. His interpreter's English approaches that of a native speaker, but he had never encountered the colloquialism "goofy," and it took several minutes of negotiating with me for him to arrive at a Tibetan equivalent. We settled on "playful"—childlike without being childish.

Finally (to conclude my short list—you will no doubt formulate your own), look at the way context affects what is

stage center. My favorite examples here are the priest *gasshoing* toward Mount Fuji on page 115 and the touching photograph of two child monks that appears on page 59. In both cases the subjects' backs are toward the camera, but what a telling difference in what the figures look out on. The priest sees forms—Mount Fuji and the cloudscape that crowns it—which symbolize the forms Japanese Buddhism has acquired over six centuries. The child monks face blank space, a Tibetan future that is totally unformed and will acquire the forms they must help in creating.

I must stop lest the verbal encroach inappropriately on the visual. I suggest that you let your eyes wash back and forth, again and again, through the visual feast that is in store. And then *gassho* to the artist who brought it into being.

IN 1968 AT AGE SIXTEEN, I TOOK MY FIRST CLASS IN photography at Barnsdall Park Junior Art Center in Los Angeles. My teacher was the documentary photographer Seymour Rosen, with whom I would later apprentice. He took the class to see an exhibition of Dorothea Lange's photography at the Los Angeles County Museum of Art. Her extraordinary photographs expressed her deep concern for the people she photographed. I was so inspired by her work that I decided then to become a photographer. I began collecting photography books, and my first were by Lange, Henri Cartier-Bresson, Eugene Smith, Edward Weston, and Robert Frank.

In 1969 I went to England to study at Manchester College of Art and Design, where I continued to learn about the fundamentals of photography. I returned to California the next year and photographed mothers and children for a datebook made by the antiwar group Another Mother for Peace. The purpose of the datebook was to voice opposition to America's involvement in the Vietnam War and to convey the preciousness of life.

The following year I became a student at the San Francisco Art Institute, studying with Dorothea Lange's assistant, Richard Conrat, and with John Collier Jr., who had worked with Lange as a Farm Security Administration photographer in the 1930s. From Collier, who wrote the book *Visual Anthropology: Photography as a Research Method,* I learned to integrate principles of anthropology with documentary photography. I was also studying art in a variety of mediums and art history. In 1973, for an independent study project to complete my Bachelor of Fine Arts degree, I photographed organic farming in San Diego County for nine months. I also studied cultural

anthropology and filmmaking at the University of California, Los Angeles, during this time.

In the late sixties and seventies, the Vietnam War was raging and it seemed that the negative emotional patterns we had inherited and the psychological conditions in our society that led us into the war had to be transformed for a culture of peace to develop. At the same time the human potential movement was blossoming, and the public was being introduced to meditation, yoga, tai chi, and many other practices from various wisdom traditions. Humanistic psychology drew from these time-honored teachings and practices so that healing addressed both the emotional and spiritual aspects of the person. Many people, including myself, found tremendous benefit from this approach.

In 1974 I photographed the spiritual musical *The Cosmic Mass,* directed by the Sufi master Pir Vilayat Khan. This was a profound and epic performance celebrating the underlying unity of the various faiths. Also, during this period, I attended teachings by great spiritual masters, including Krishnamurti, Swami Muktananda, Swami Satchidinanda, and Chogyam Trungpa Rinpoche.

From 1975 until 1979 I worked as the staff photographer for public relations at Santa Monica Hospital, photographing everything from the drama of the emergency room to a day in the life of a nurse. The skills I developed there proved useful both in my future work as a freelance photographer and for my photography of Buddhist life.

In 1977, when I found the Vietnamese Buddhist Temple in Los Angeles and began my long-term study of the life there, I also made a commitment that Buddhism would be my spiritual path. I didn't feel it was superior to any other religion. It just felt right for me. Within Buddhism, I found not only spirituality but also psychology, philosophy, and a rich diversity of cultures.

I believe that for there to be peace in the world, it has to start with peace in the individual. The Buddha taught that we could find inner peace and freedom from suffering by study and practice of the Dharma. He taught his disciples to follow the principle of *ahimsa,* or nonviolence, and this became the foundation on which Buddhist societies were built. When I reflect on the unimaginable suffering experienced by my cousin who survived Auschwitz, the many relatives of mine who perished in the Holocaust, and countless others who have suffered from war and genocide, I am reminded of how critically important it is to generate *ahimsa* in the world.

I still hope to photograph the other great Buddhist cultures not represented here, but after twenty-five years of photographing Buddhist life, this seems a good point at which to share this work in progress and to celebrate the contribution these wonderful traditions are making in the world. I hope that these visions of Buddhist life help open doors to ways that can bring peace in the world.

These photographs came into existence as a result of a group effort with those people who graciously allowed me to photograph them and with the many individuals and organizations that gave their support in various ways. I wish I had more space here to list all the people who have contributed.

During the first ten years of my photographing Buddhist life, the California Arts Council, the California Council for the

Humanities, and Shirley Burden generously supported exhibitions and the printing of the book *Taking Refuge in L.A.: Life at the Vietnamese Buddhist Temple.* I'm grateful to my teacher Dr. Thich Thien-An, as well as to Most Venerable Thich Man Giac, Irv and Rose Kramer, Lynn Diederich, Kittie White, Rick Fields, and David Kamansky.

In 1988 I established the Images of Dharma Project to photograph endangered Buddhist cultures. With contributions from Alan and Marion Hunt-Badiner, Lucile Lampkin, Toni Marcus, Elinor Stark, Terry Sullivan, Shanly Weber, and Stanley Weiser, I set out to photograph Kalu Rinpoche's funeral in Darjeeling, India, in 1989. Also that year, thanks to the generosity of Ish Ishihara and Kim Kapin, A&I Color Lab in Los Angeles began providing free color processing for the project, and Eastman Kodak Company generously donated film.

For my work photographing Japanese Buddhist life, I'm grateful to Rev. Daichi Yoshimizu and Rev. Bunkei Yamamoto, and especially my sponsor, Yutaka Takahana, for his amazing generosity. The Los Angeles Buddhist Church Federation, the Japan Buddhist Federation, and Bukkyo Dendo Kyokai USA all made very generous contributions. My thanks to Higashi Honganji Temple, as well as to Hideo Aoki, Rev. Ken Kawawata, Rev. Takashi Kiuchi, Ikuo Sato, Hiroko Yamaguchi, Izumi Umeno, K. Watanabe, Bishop Seigen Yamaoka, and the California Council for the Humanities, which funded an exhibition of this work.

For my work in Thailand, I am very grateful to Mr. Anurut Vongvanji and his family and the Tourist Authority of Thailand for their generous sponsorship.

For my work in Taiwan, I am grateful to the Buddhist Association of Taipei and its director, Venerable Kuang Hsin, as well as to the Tzu Chi Foundation, Ken Yang and Wind Records, the Chinese Young Buddhist Association, Professor Cheng Chen-huang, Guey Shen Teng, Dr. Hsiang-Chou Yo, and Vicky Sun.

For my work photographing Tibetan Buddhist life, I am most grateful to His Holiness the Dalai Lama, his secretary Tenzin Geyshe, Tsering Tashi, Venerable Geshe Gyeltsen, Rinchen Dharlo, Lhundup Tseten, and my wife, Yeshi Chozom Farber. Special thanks goes to the J. William Fulbright Foreign Scholarship Board for supporting my work photographing Tibetan Buddhist life in India and Nepal and to Gary Garrison and Rajni Nair for their assistance.

I am grateful to the Asian Cultural Council for their generous support. My thanks also goes to the scholars who served as advisors and who wrote crucial letters of support for grant proposals, including David Blundell, Francis Cook, His Excellency Ananda W. P. Gurugé, Lewis Lancaster, Jacques Maquet, Hajime Nakamura, and Gary Seaman. I am also very grateful to Mike Arlen, Joanie Chodorow, my parents, Rose and Hy Farber, Rob Jacobs, Tony Leitner, Teri Lim, Dave Lumian, Tano Maida, Moke Mokatoff, Lama Ngawang, Gary Shafner, Gvido and Inguna Trepsa, Rick Wallace, Pete Zackery, Bob Zaugh, and Hanna Zylberberg.

I wish to thank the staff of the University of California Press, including John Cronin for his production expertise, Nicole Hayward for her beautiful design, Sue Heinemann for her outstanding copyediting, and especially Reed Malcolm, my editor, for believing in this book and guiding it to completion. Finally, I wish to thank Huston Smith for his eloquent foreword.

VISIONS OF BUDDHIST LIFE

IT WAS JANUARY 1977, LESS THAN TWO YEARS AFTER the fall of Saigon brought 100,000 refugees to America, when I first visited the Vietnamese Buddhist Temple in Los Angeles. I had previously met the Vietnamese Zen master Venerable Dr. Thich Thien-An at the International Buddhist Meditation Center, which he established in 1970. I knew that refugees were being taken in at the center, and I learned that, in response to the needs of the refugees, Dr. Thien-An had established the first Vietnamese Buddhist temple in America, one block away from the center.

This scene, which I saw on my first day there, with the barber giving haircuts in the courtyard, children running around, monks and nuns performing ceremonies, and elderly Vietnamese women welcoming me like grandmothers, was too good to resist. That night, after developing the film and seeing the proof sheet, I decided to make a book about life in the temple.

I embraced Buddhism, becoming a disciple of this gentle Zen master, Thich Thien-An. For many years, I had felt great sadness for the Vietnamese and Americans whose lives were ruined by the Vietnam War. This oasis in the heart of L.A., where the brilliant spiritual tradition of Vietnam was being kept alive, was the perfect place to heal from those painful years. Nearly every Sunday for the next ten years, I went there to commune with the people, to photograph, practice the religion, enjoy wonderful food, and learn all I could about Vietnamese Buddhism. After a day at the temple I felt cleansed, ready to face the week as a freelance photographer.

Dr. Thien-An became a monk when he was a young child. After many years of monastic training in Vietnam, he studied at Waseda University in Tokyo and achieved the rare distinc-tion in Japan of earning a doctorate of literature, doing his research on early Buddhist texts.

Dr. Thien-An became a spiritual father to me. Along with attending his Sunday teachings and Zen retreats, I took courses from him at the University of Oriental Studies, which he had established. In the small, intimate classes, we looked deeply into the meaning of passages in Buddhist texts and examined the connections between Buddhism and other Asian religions. The classes, held in the *zendo,* included periods of meditation.

Sadly, Dr. Thien-An developed cancer and in November 1980 passed away at age fifty-four. It was a very difficult time for me as well as for his other Western students but, most of all, for the Vietnamese Buddhists in America who embraced him as their spiritual leader. The funeral procession stretched for miles as it passed through the streets of Los Angeles.

In the brief time that Dr. Thien-An was in Los Angeles, between 1966 and 1980, he had a tremendous influence on the establishment of Buddhism in the West. Nearly every Buddhist master visiting the West Coast gave teachings at the International Buddhist Meditation Center. The teachers and students who have been a part of the center continue to influence the course of Buddhism in America.

Dr. Thien-An loved the diversity of Buddhism, taking keen interest in the many ways that the Buddha's teachings have manifested in different countries. I caught his enthusiasm and have been inspired ever since to see, experience, and photograph Buddhist life in its many forms.

Vietnamese Buddhist Temple, Los Angeles, 1977

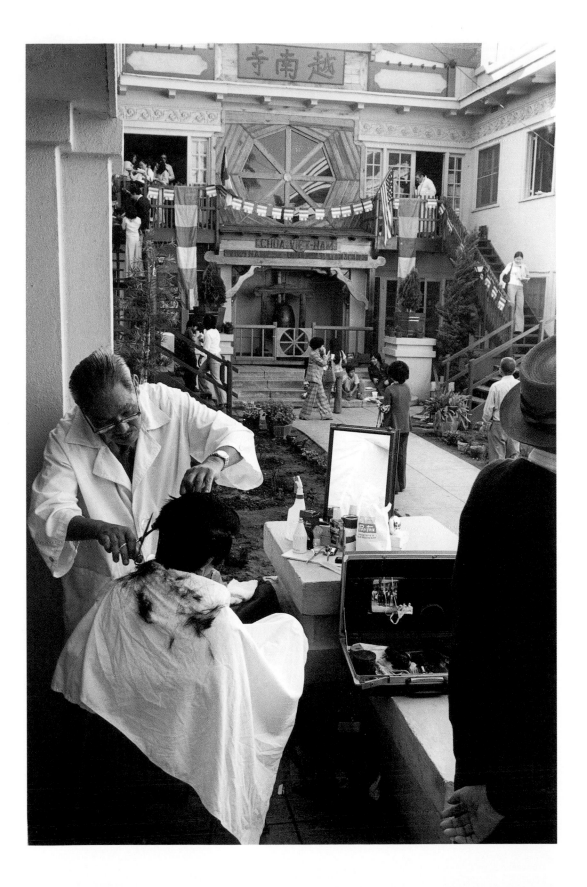

When the Vietnamese refugees were airlifted to the United States, whole families came, including the elderly. In contrast to the negative images of the Vietnamese shown in the media during the war, it was a great awakening for me to discover that they have an extraordinary spiritual culture. I was deeply moved by the compassion of these elderly Vietnamese women. (Vietnamese Buddhist Temple, Los Angeles, 1977)

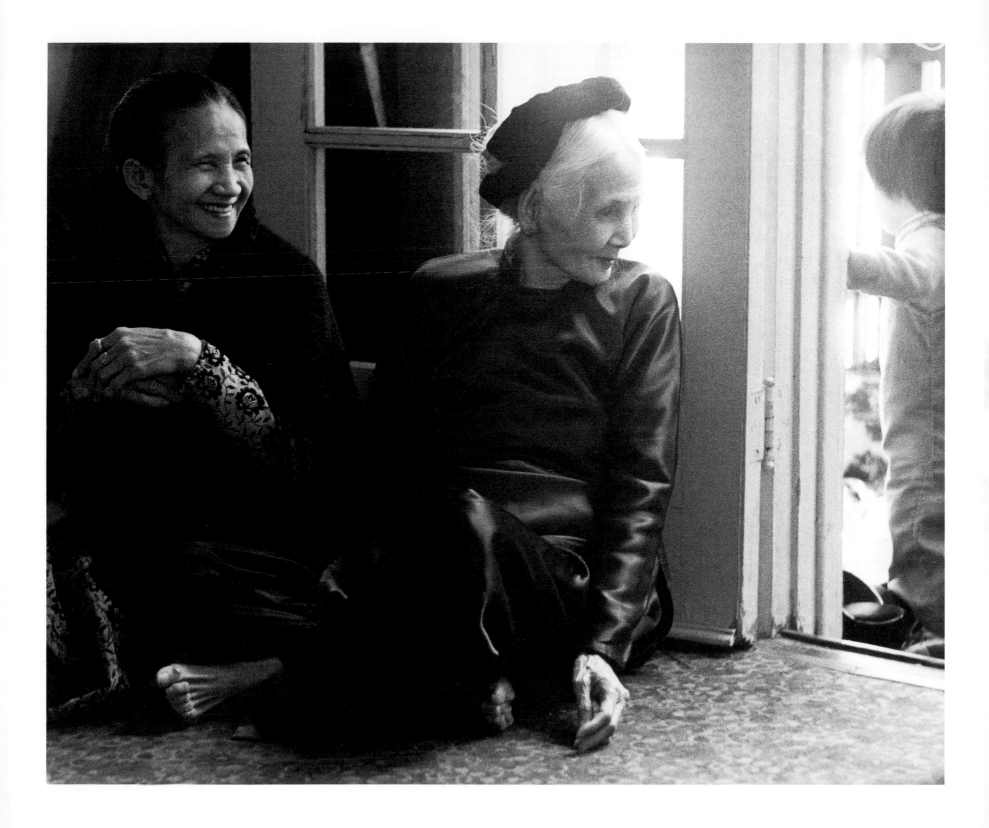

These women moved together like birds in formation through the courtyard, finding comfort in each other and from the community of monks, nuns, and laypeople. (Vietnamese Buddhist Temple, Los Angeles, 1977)

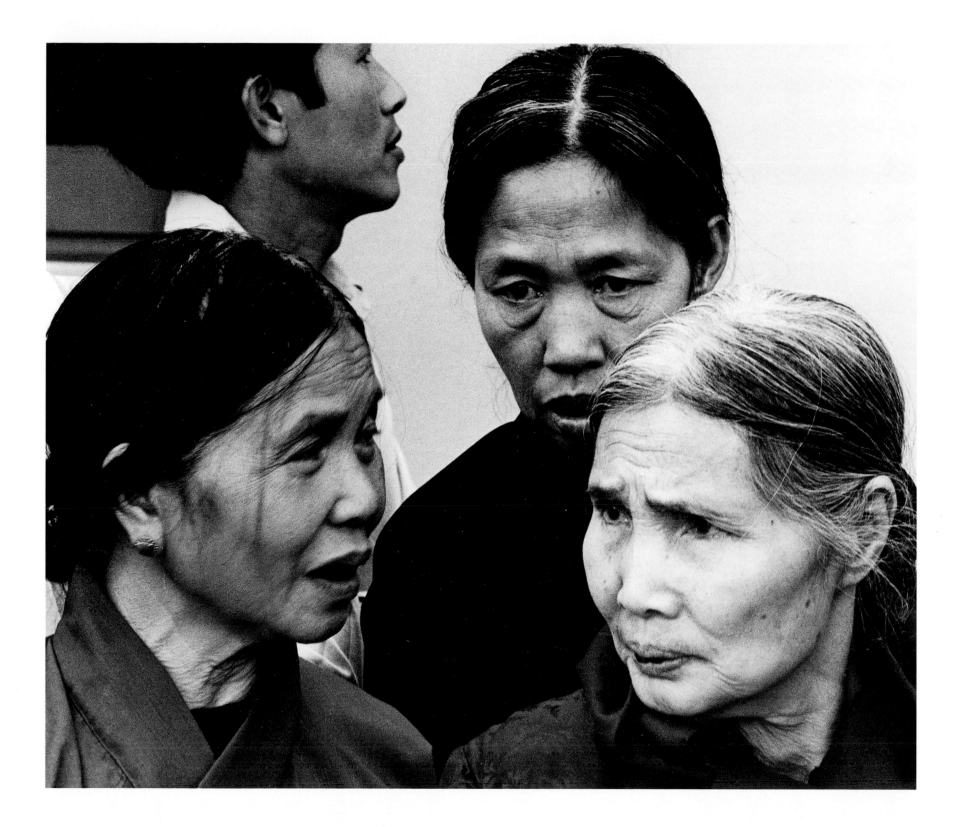

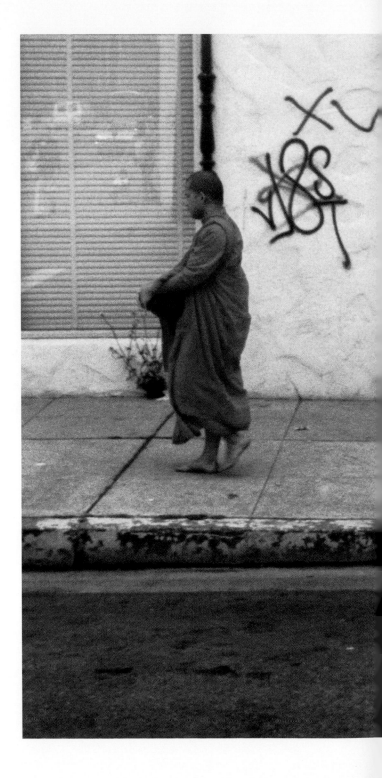

These Vietnamese boys became monks for a week under the guidance of a Malaysian monk living at the Vietnamese Buddhist Temple in Los Angeles in 1977. As they went to receive donations of food from a Thai restaurant near MacArthur Park, they passed graffiti expressing hatred between two rival gangs.

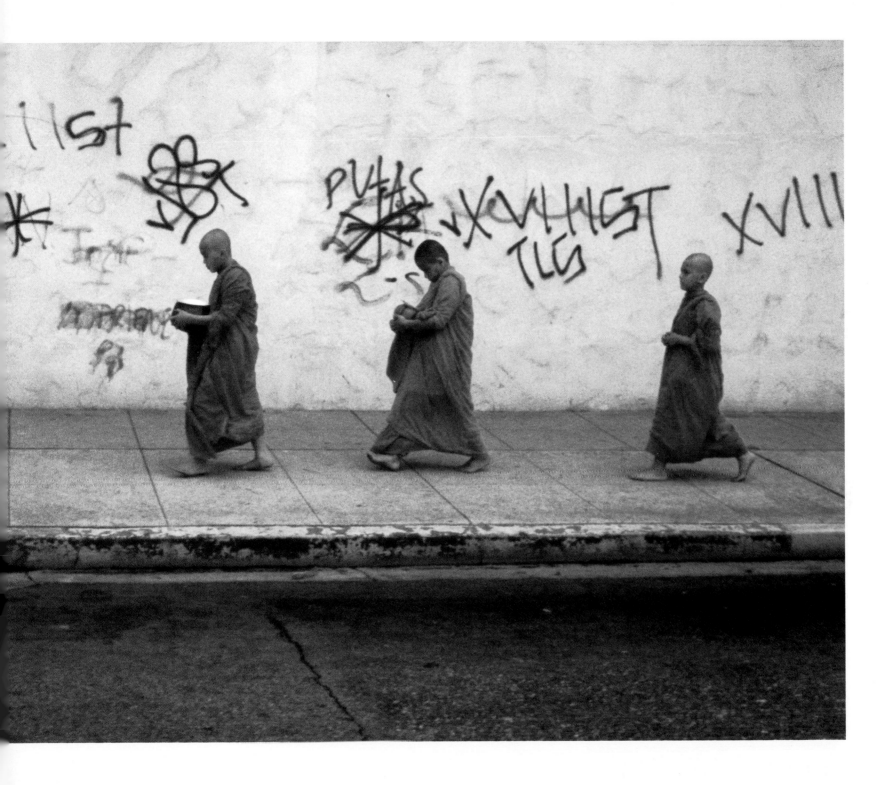

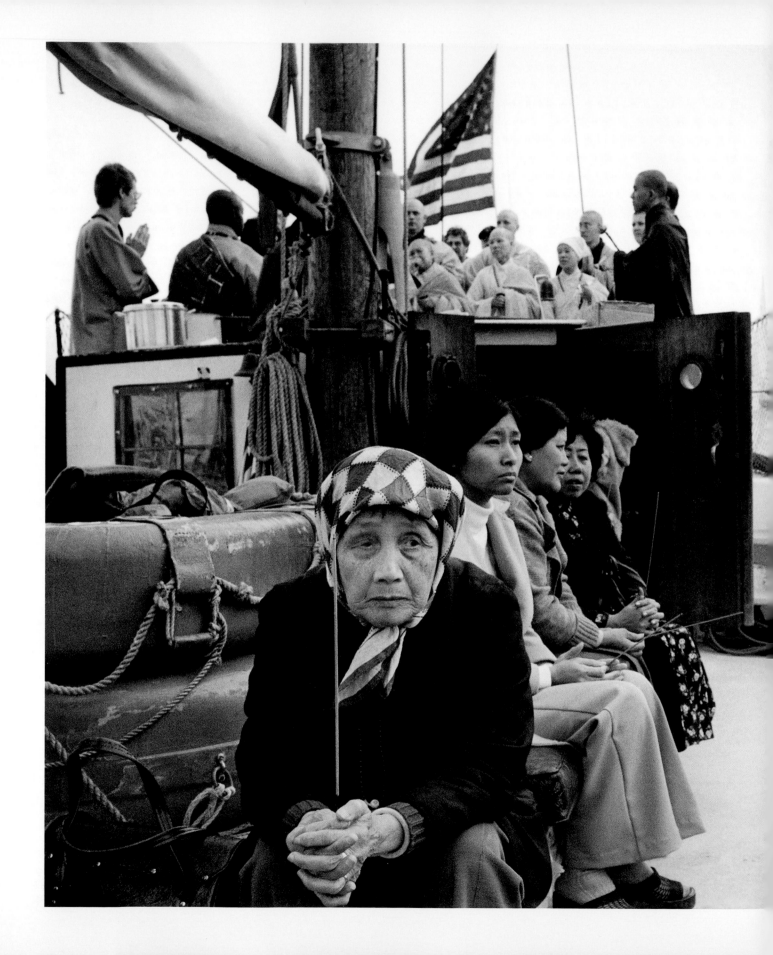

In 1979, when thousands of "boat people" were trying to escape from Vietnam, Venerable Thich Thien-An led a ceremony on a boat in Los Angeles Harbor to ease the suffering of the spirits of those who had died at sea.

My friend the young Vietnamese monk Thich Thanh Thien explained, "You stand in front of Buddha, not to a statue but to Buddha inside yourself. It's important to know that; otherwise you're bowing to a piece of wood or metal. When you look inward to the Buddha nature, you feel peace in your heart. You give thanks to Buddha because without his teachings you would not have found this way of understanding and loving." (Vietnamese Buddhist Temple, Los Angeles, 1977)

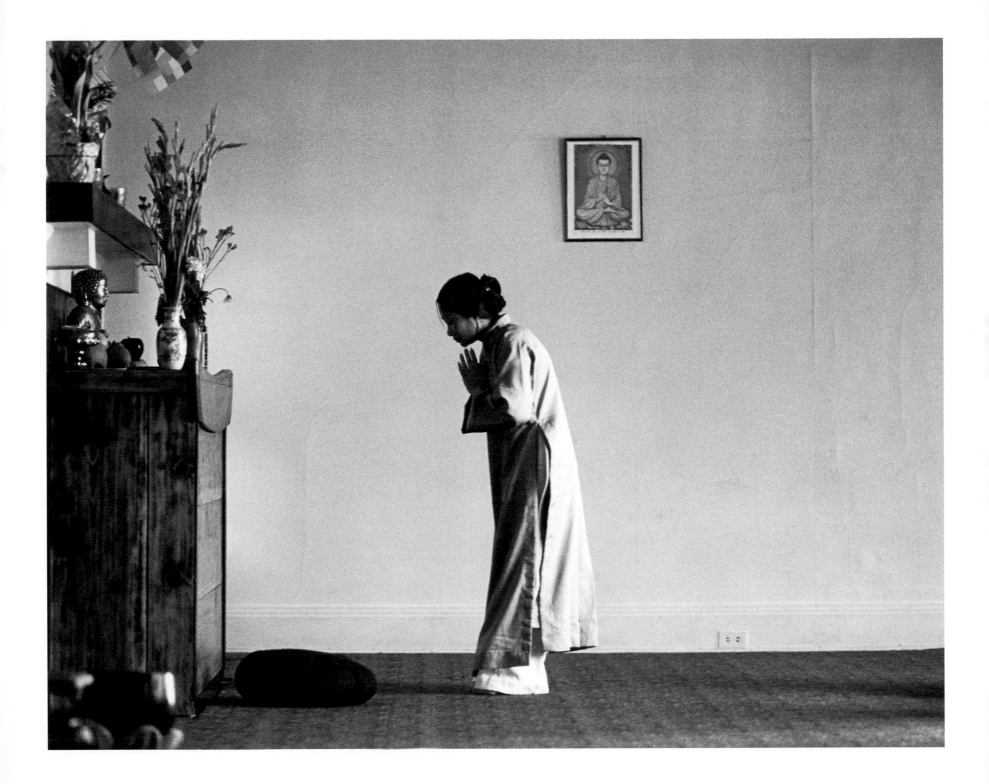

During the summer rainy season in southern Asia, the *sangha* (the community of monks and nuns) traditionally stay in their temples or huts, devoting themselves to practice and study. Remaining inside helps protect the many insects active at this time of year from being trampled on. In 1979 Thich Thien-An's students from the International Buddhist Meditation Center joined Vietnamese *sangha* for ceremonies held each Sunday during the summer retreat (called An-Cu). As the monks and nuns raised their bowls, they offered food to the Buddhas, bodhisattvas, and all sentient beings and then joined in quiet meditation before beginning their meal.

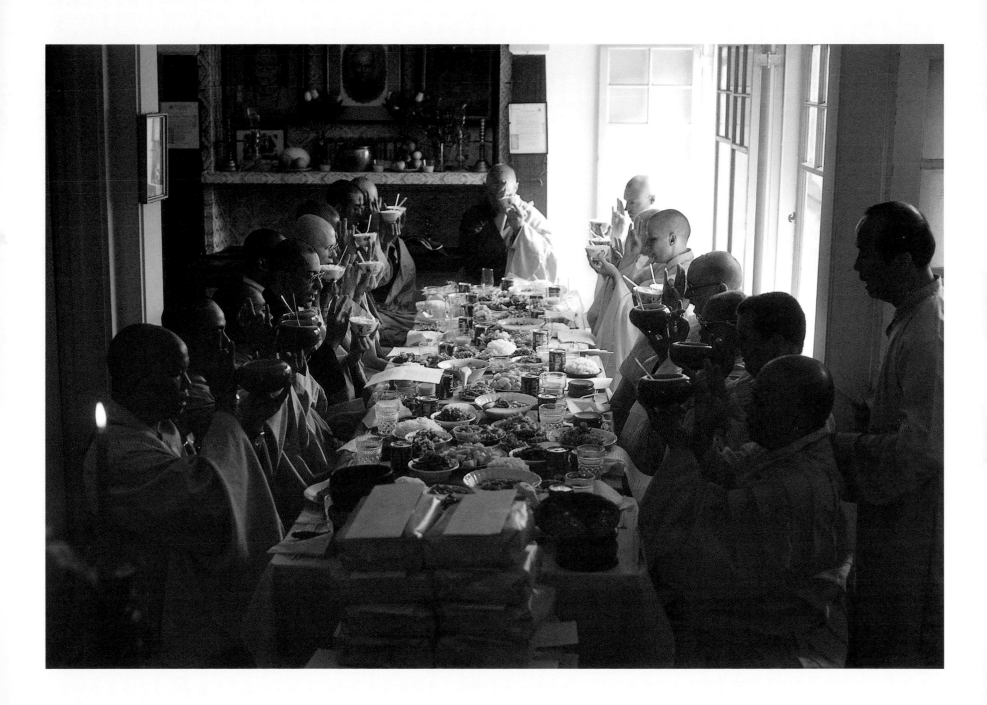

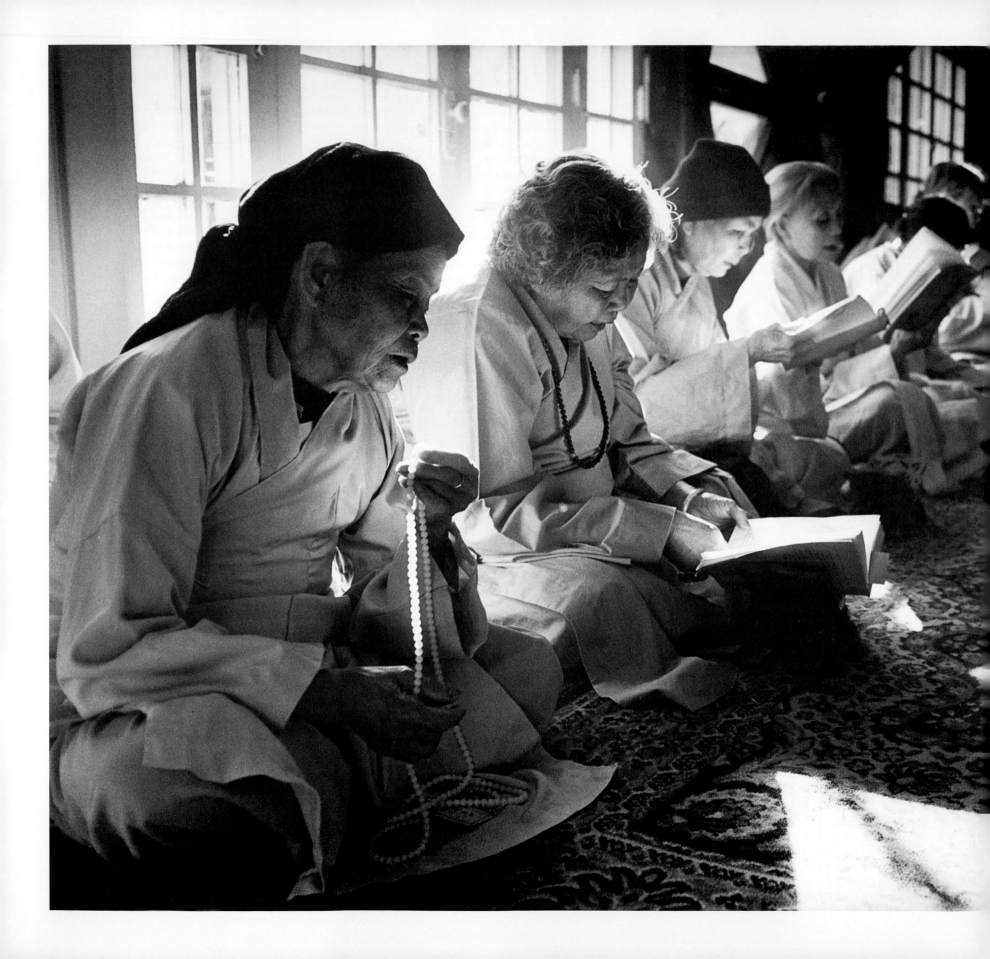

Early morning during a three-day retreat at the Vietnamese Buddhist
Temple, Los Angeles, 1982

Vietnamese Zen master Venerable Dr. Thich Thien-An and the Tibetan master His Holiness the Sixteenth Gyalwa Karmapa at the International Buddhist Meditation Center, Los Angeles, 1977

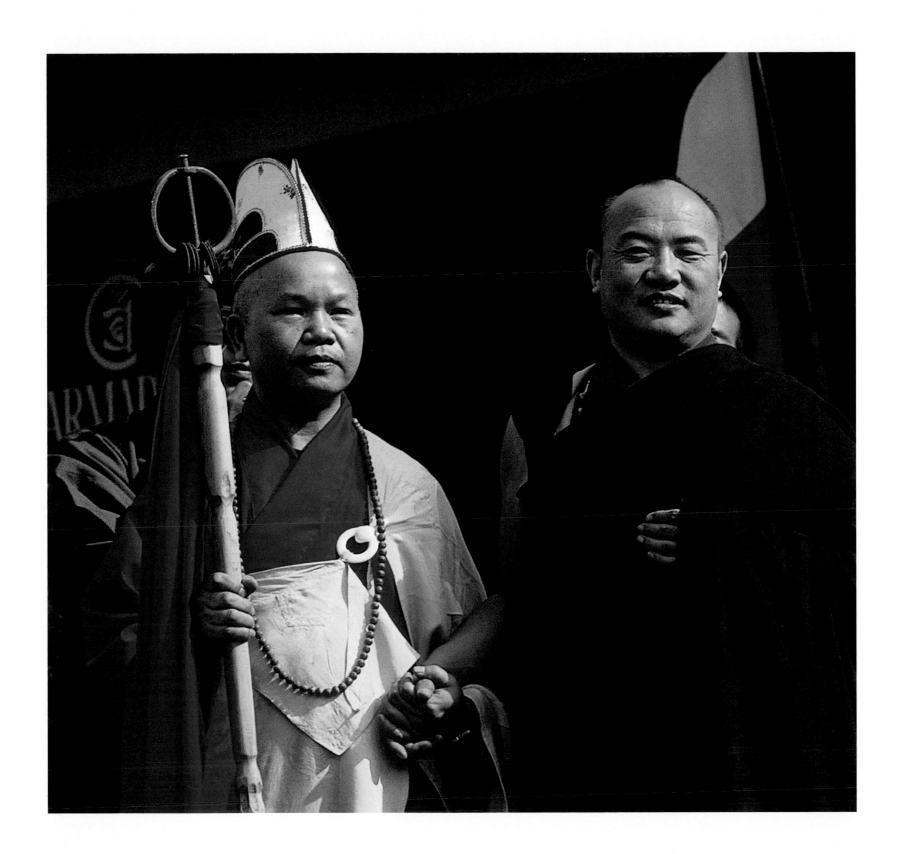

His Holiness the Sixteenth Gyalwa Karmapa, seen here in Los Angeles in 1977, is regarded as one of the great spiritual masters of the twentieth century. He passed away in 1981, and a young boy who was born in 1985 in Tibet, Ugyen Trinley Dorje, was formally recognized in 1992 as the reincarnation of the Karmapa. In 2000 the young seventeenth Karmapa, who assumed the leadership of the Karma Kagyu lineage of Tibetan Buddhism, escaped Tibet to India, where he lives today under the protection of the Indian military.

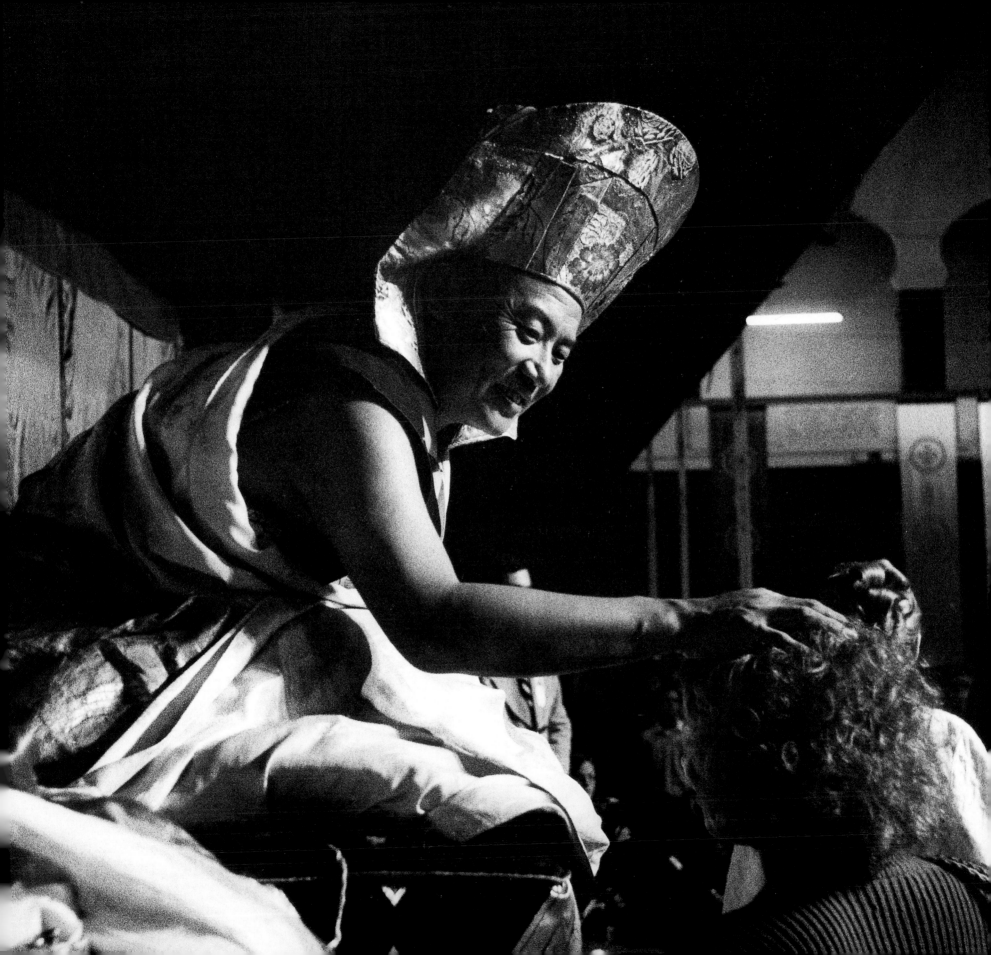

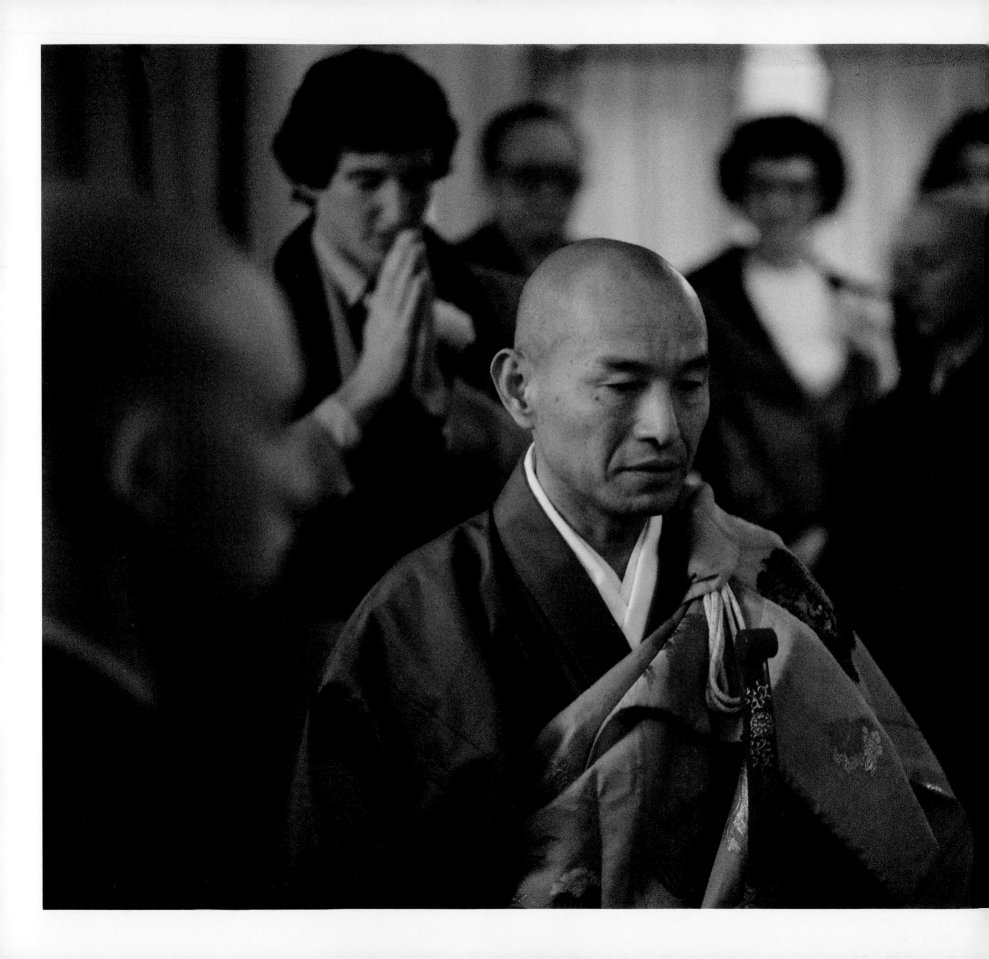

While I continued my project at the Vietnamese Buddhist Temple after Dr. Thien-An's passing, I also began going to the Zen Center of Los Angeles to study with Taizan Maezumi Roshi to practice Zen, and to photograph the life there. This center's members, most of whom were Westerners, diligently practiced under the guidance of this master of both the Rinzai and the Soto traditions of Japan. Maezumi Roshi, seen here performing a wedding ceremony in 1981, was one of the most influential pioneers in the establishment of Buddhism in America.

PAGES 25–27 During a retreat *(sesshin),* sitting meditation practice *(zazen)* alternates with walking meditation *(kinhin)*. Practitioners maintain awareness in stillness and movement. (Zen Center of Los Angeles, 1982)

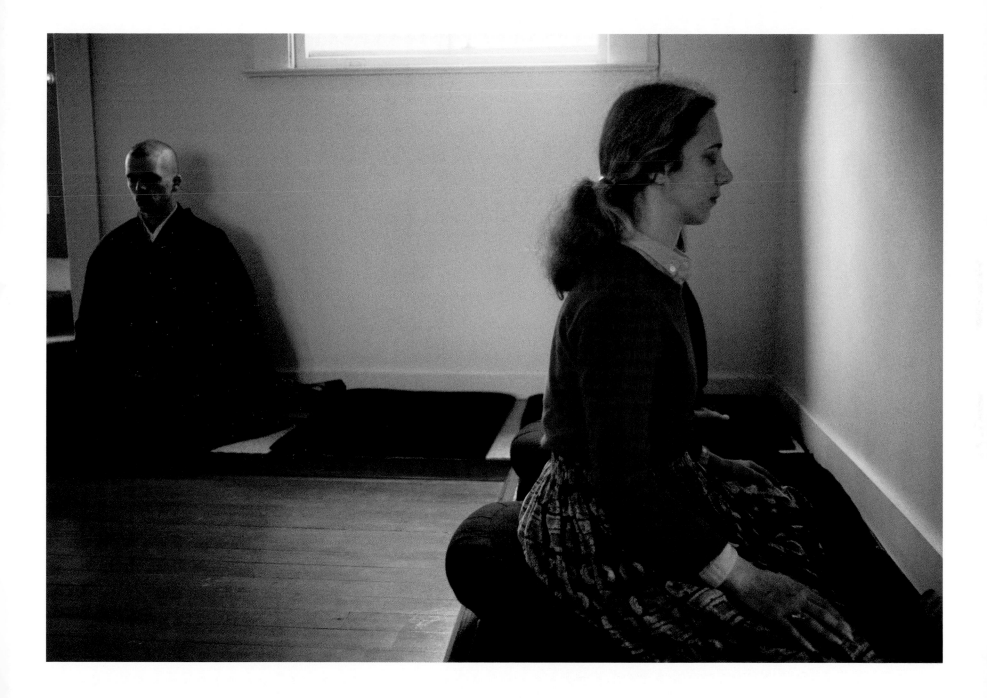

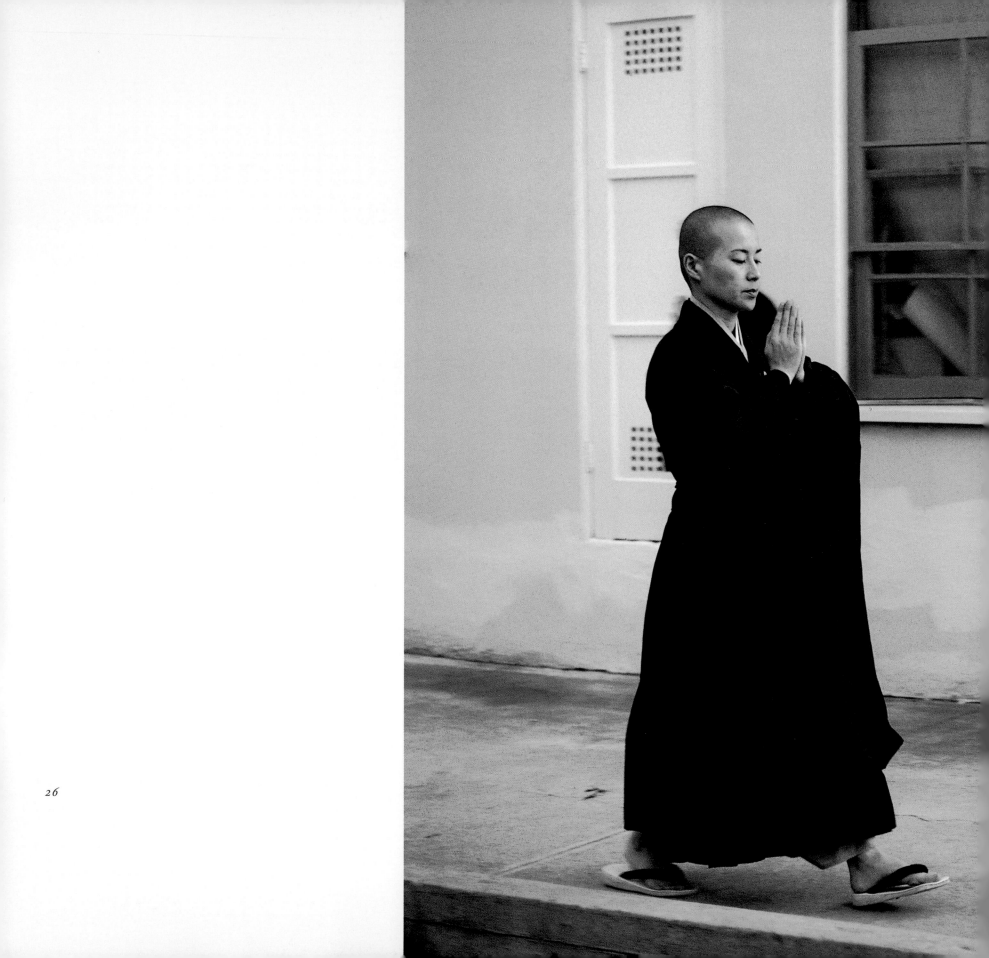

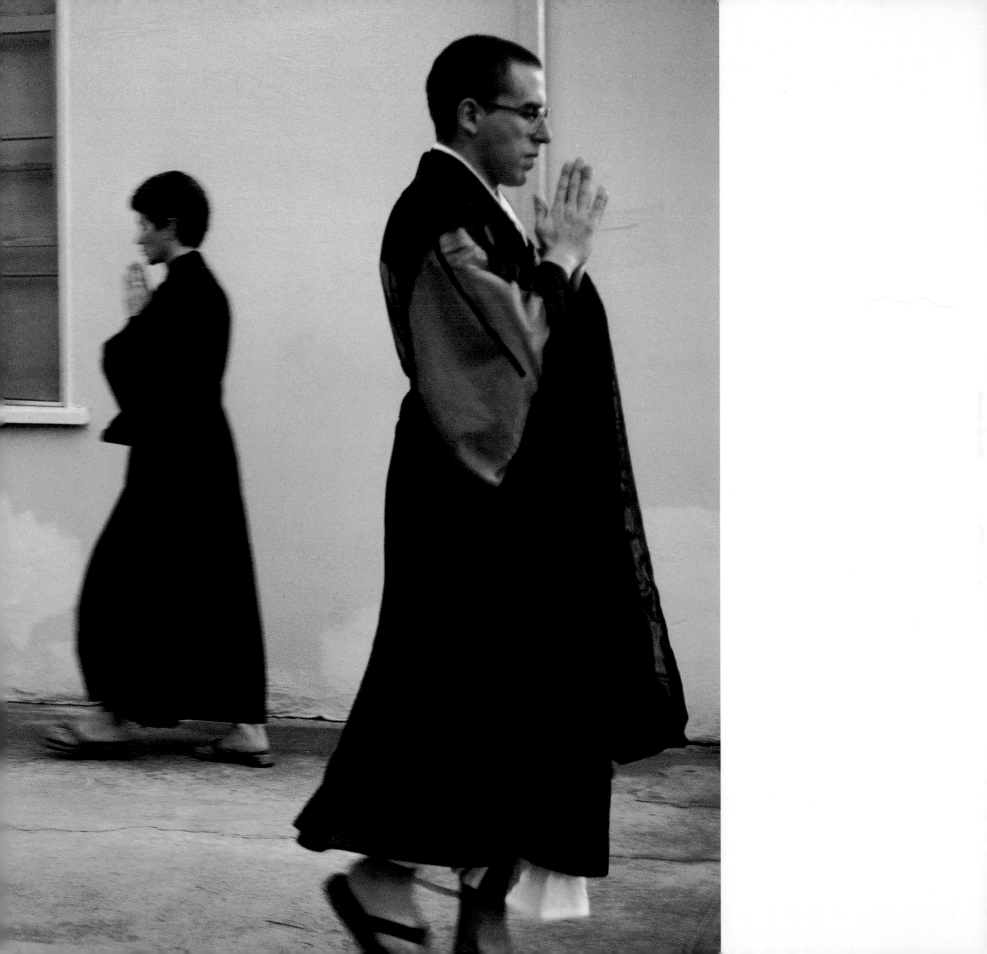

ORIGINALLY I HAD HOPED TO TRAVEL TO BUDDHIST countries with Dr. Thien-An, but I never had the chance. In 1985, however, I made my first trip to Asia—to Japan and Taiwan—with Most Venerable Thich Man Giac, Dr. Thien-An's old friend and his successor as a religious leader for Vietnamese Buddhists in America. They had studied in Tokyo at the same time and, before that, had trained together as monks in Vietnam. In Tokyo we stayed with two old friends of Thien-An and Man Giac—the Jodoshu priest Daichi Yoshimizu and the Rinzai Zen priest Bunkei Yamamoto, who lived in their temples with their families. Then we went to Kyoto, where we stayed at the temple of the Jodoshu nun Tessho Kondo, a teacher for nuns of her sect. In Taiwan we were guests of Dr. Thien-An's old friend Master Hsing Yun. We stayed at several of the temples he had established around the island, including the most important one, Fo Guang Shan near Kaohsiung.

Two years later, in 1987, I again traveled to Japan and Taiwan, as well as to South China. The nuns at Fo Guang Shan recommended that I visit the temples of the great Ch'an (Zen) master Hui Neng near the city of Shaoguan. I had read about this master's extraordinary story in the book *The Sutra of the Sixth Patriarch* when I was studying with Dr. Thien-An. To see the temples where Hui Neng had resided would be a pilgrimage of special significance to me.

After traveling by train from Hong Kong to Guangzhou and then to Shaoguan, my travel companions and I journeyed on to Biechuan Temple high on Mount Danxia. In the darkness of nighttime we climbed hundreds of steps up the mountain, arriving at the monastery at about 4 A.M. It was full of monks, nuns, and laypeople chanting sutras. In this period when the Chinese government was just beginning to allow religious practice, this was the only time of day that ceremonies could be held.

We met one elderly monk, whose robes were old and torn, who said he was one of the few monks allowed to stay in the monastery during the Cultural Revolution. Then we met Venerable Master Ben Huan, the Dharma successor of the lineage of the Sixth Patriarch, Hui Neng, and the abbot for several of the historically important monasteries that Hui Neng had lived in. He told us that he had been imprisoned for twenty-three years only because he was a Ch'an master. He was not allowed to meditate in prison, nor could he read any religious texts. It was a great privilege to meet the master, but it was also a great tragedy that such a being, with only the purest of motivation to benefit all beings, had to endure so much suffering for so long.

PAGE 29 Venerable Tessho Kondo, Jodoshu nun, Kyoto, Japan, 1985

PAGE 30 An old monk in tattered robes, Biechuan Temple, Guangdong, China, 1987

PAGE 31 A nun at Nanhua Temple, near Shaoguan, Guangdong, China, 1987

PAGES 32–33 Venerable Master Ben Huan, the abbot for the temples of the Sixth Patriarch, Hui Neng, writing (left) and sitting in front of a banner commemorating his eightieth birthday (right), Biechuan Temple, Guangdong, China, 1987

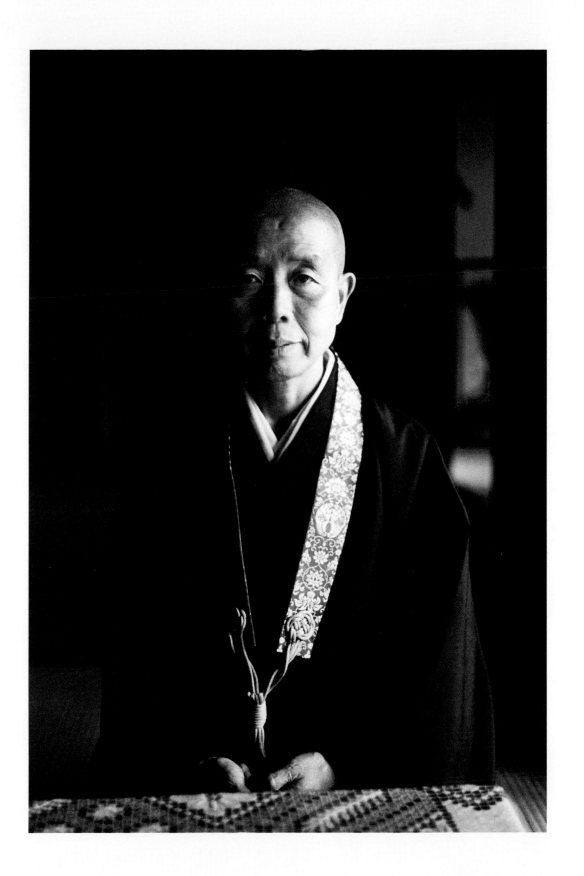

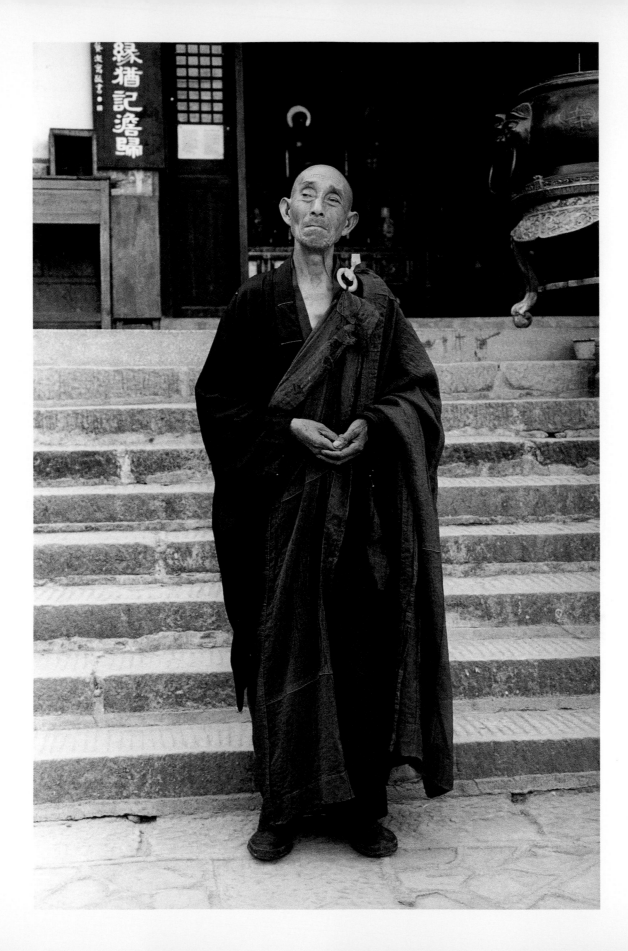

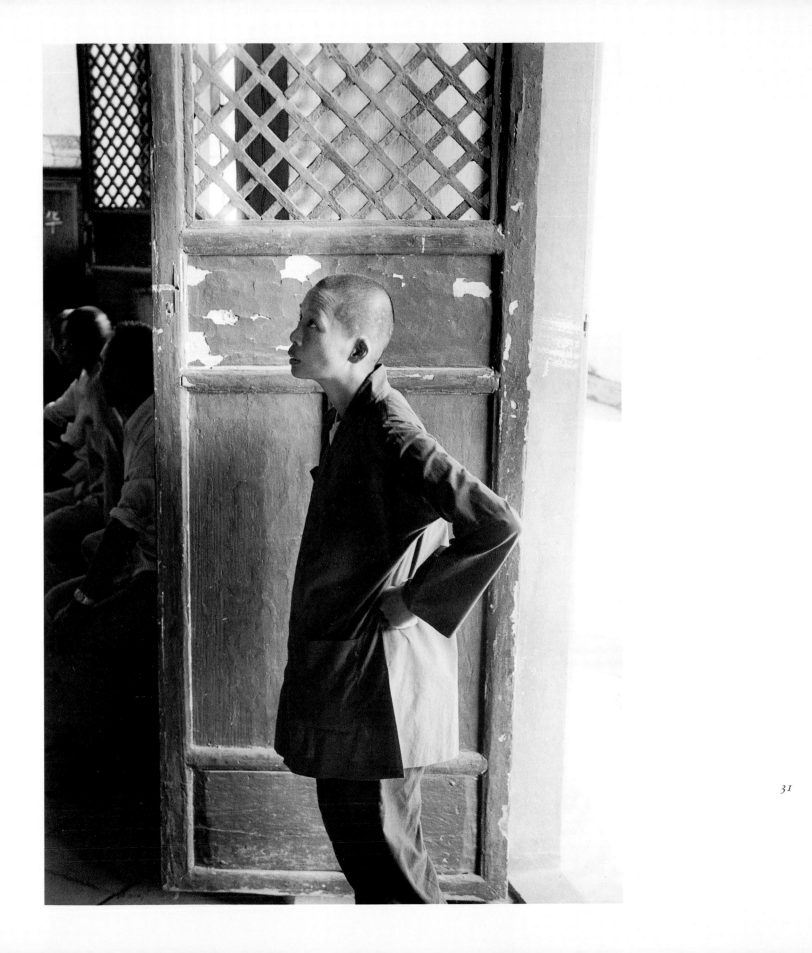

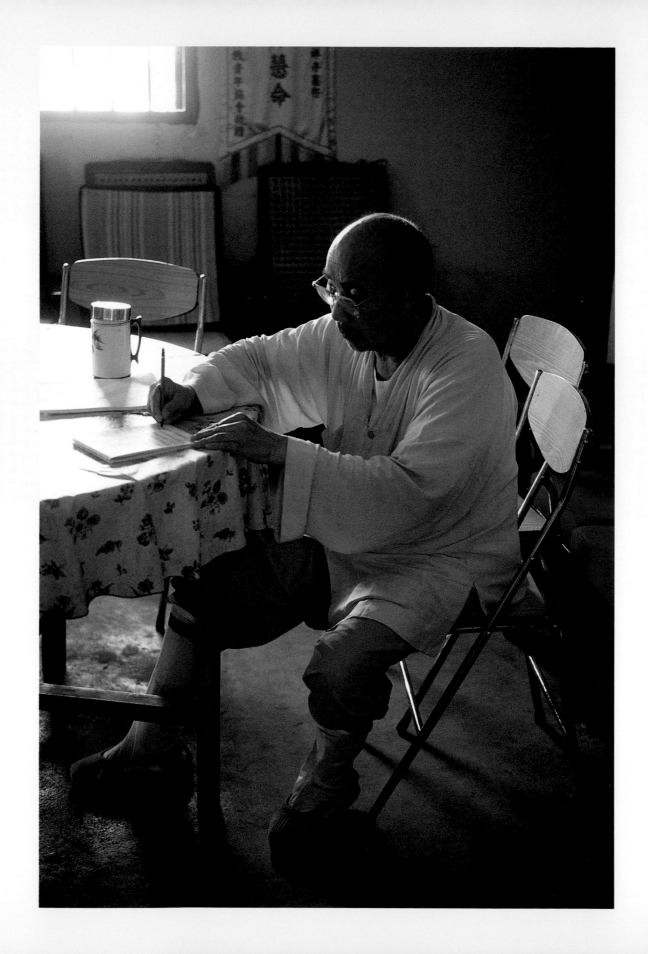

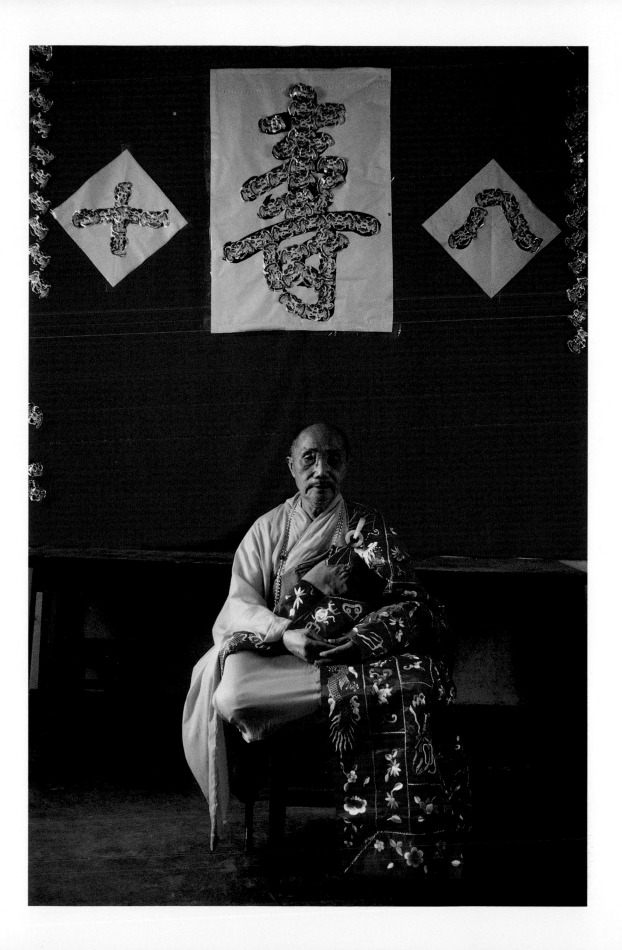

Fo Guang Shan Monastery, Kaohsiung, Taiwan, 1987

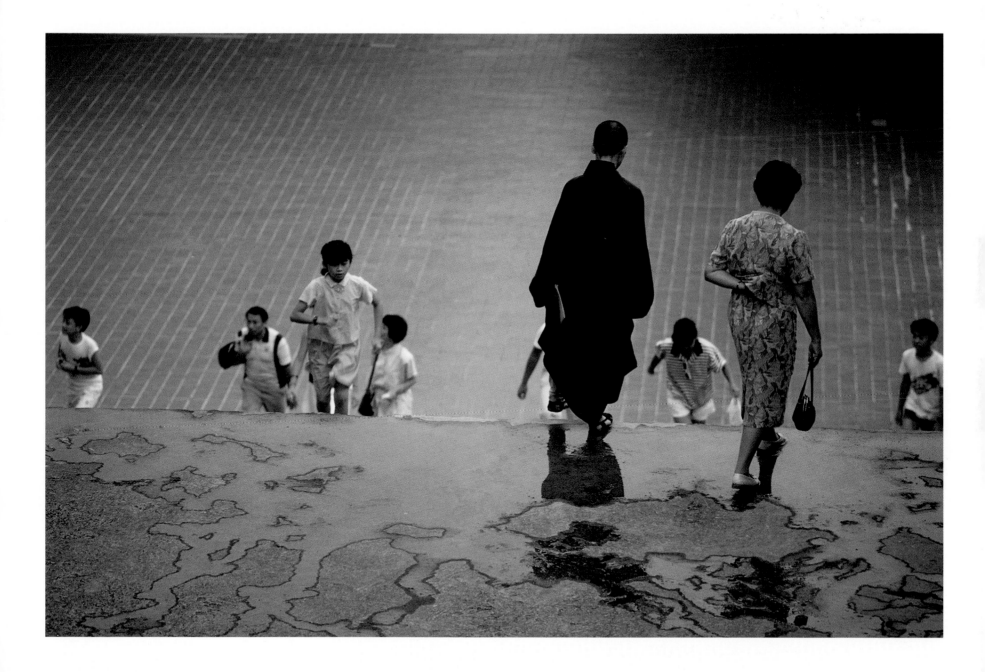

PAGE 37 In 1988 Hsi Lai Temple in Hacienda Heights, California (east of Los Angeles), had its grand opening. Founded by Venerable Master Hsing Yun, it is the largest Buddhist temple in America. During the grand opening, the World Fellowship of Buddhists held its biannual conference there and a full ordination took place, drawing monks and nuns from several countries.

PAGE 38 Master Hsing Yun is the forty-eighth patriarch of the Lin-chi (Rinzai) Ch'an school. He became a monk at age twelve in mainland China and came to Taiwan in 1949. The founder of the Fo Guang Shan Buddhist Order with more than two hundred temples worldwide and the Buddha's Light International Association with over one million members, he is one of Buddhim's most important leaders. While presiding over the ceremony at Hsi Lai Temple (page 39), he held a jade *ruyi* symbolizing peace and harmony.

PAGE 39 During the grand opening of Hsi Lai Temple, the auspicious Water Land Dharma Function was held. The *sangha* chanted sutras to ease the suffering of beings in all realms, symbolically joining in an offering of the Dharma and a great banquet. At the end of the two-week ceremony, a paper "Boat of Liberation" was burned to give those beings a grand send-off to the Western Pure Land.

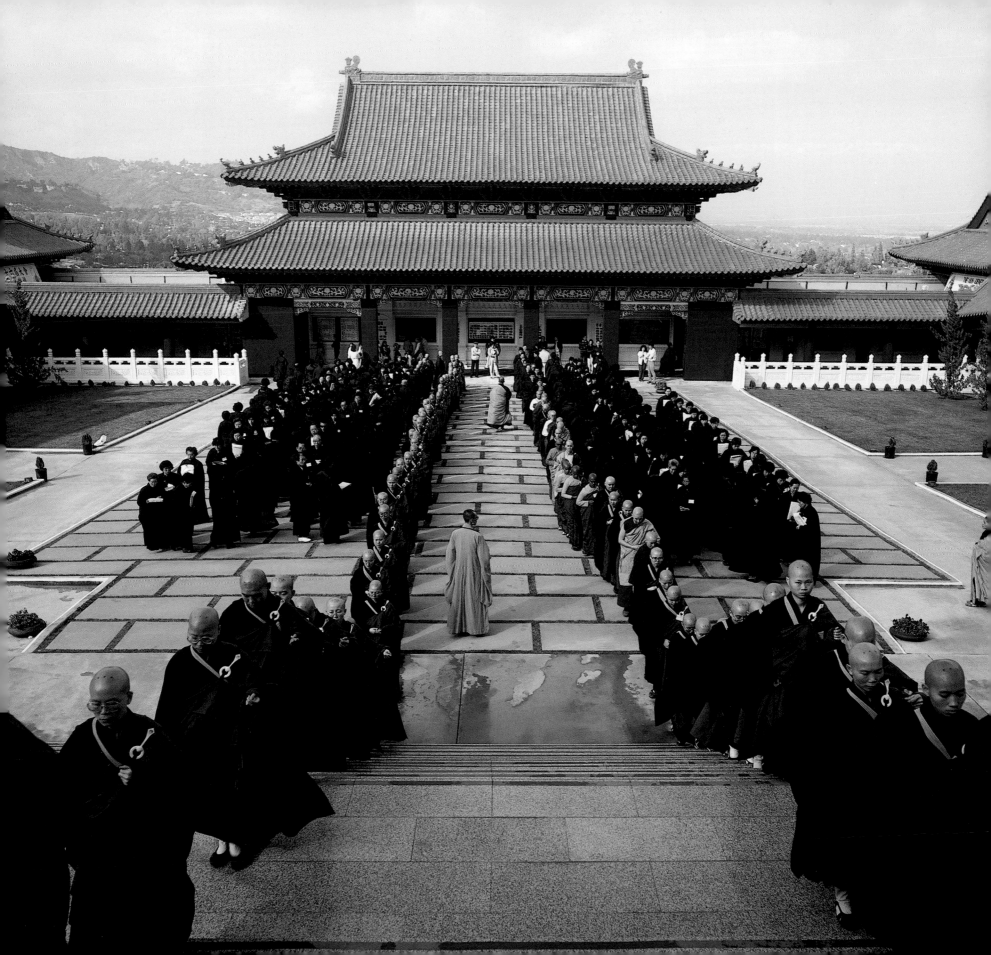

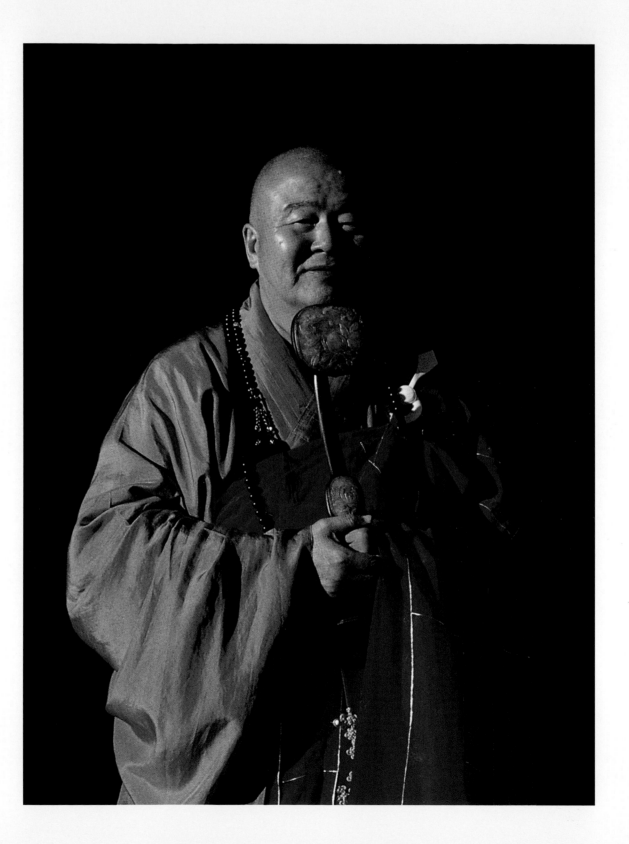

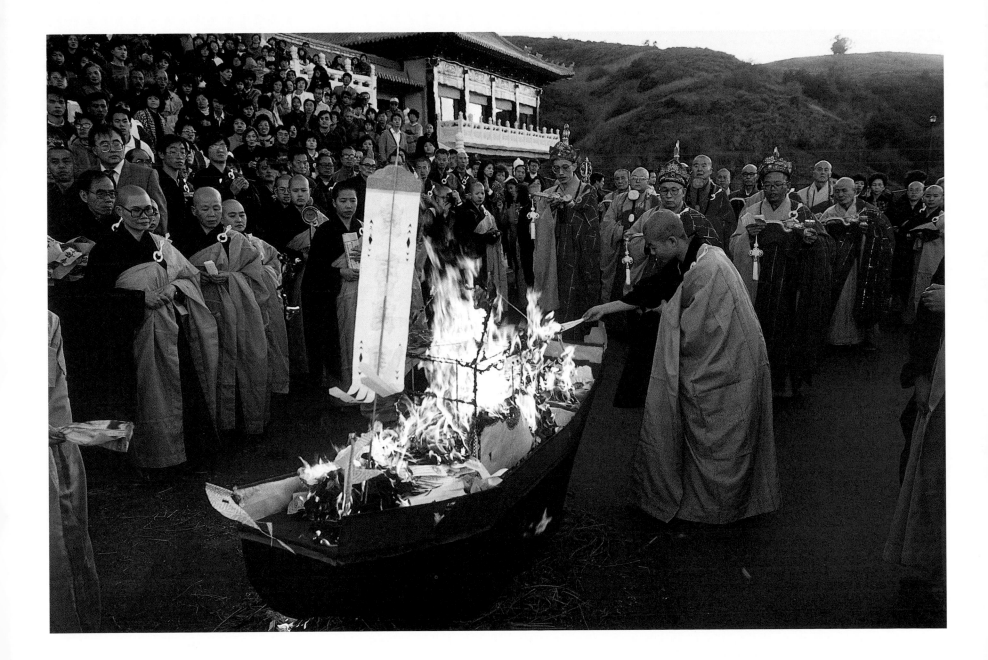

Delegates to the World Fellowship of Buddhists Conference, including these nuns from Taiwan, spent a day at Disneyland in Anaheim, California, in 1988.

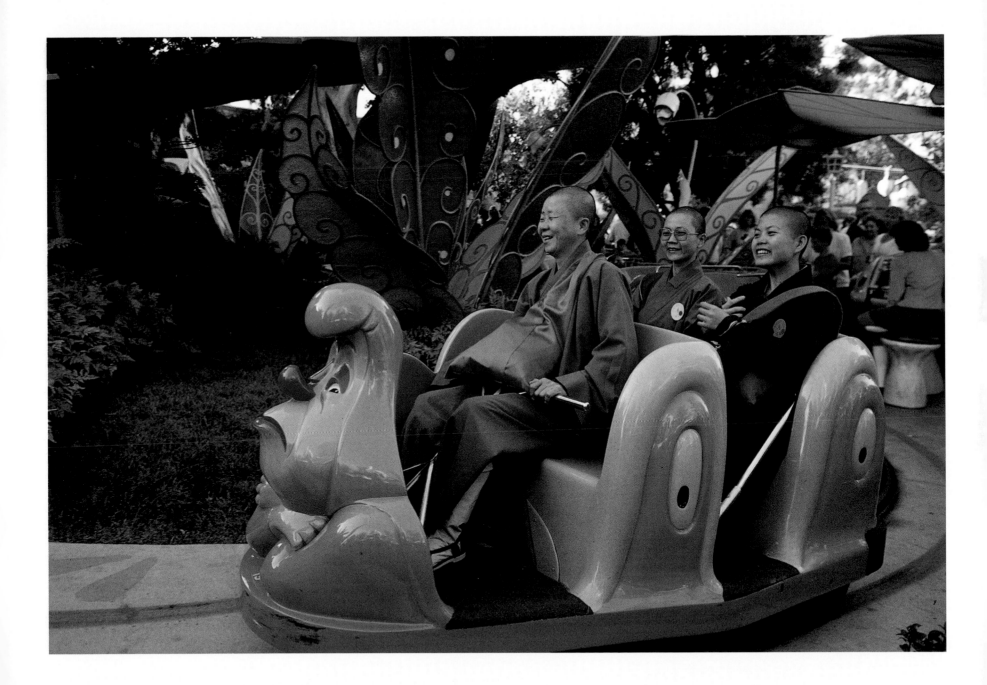

IN 1974 I WAS INTRODUCED TO BUDDHISM WHEN I took a three-day seminar with Chögyam Trungpa Rinpoche at the International Buddhist Meditation Center. From that seminar and other teachings given by Trungpa Rinpoche, as well as by attending ceremonies performed by His Holiness the Karmapa in 1977 and seeing His Holiness the Dalai Lama when he visited the Vietnamese Buddhist Temple in 1979, my connection to Tibetan Buddhism grew. In 1985 I began studying with Venerable Geshe Gyeltsen at his center, Thubten Dhargye Ling, in Los Angeles. Geshe-la is a close disciple of the Dalai Lama, so by studying with Geshe-la, I was connecting to His Holiness.

One night in the winter of 1986 I got a call from my friend and advisor Irv Kramer, an attorney. He told me that while he was lying in bed, trying to sleep, he kept hearing this message—"Call Don Farber." He explained that he and his wife, Rose, were going to Santa Fe the next morning to attend the consecration ceremony of a stupa (a type of Buddhist monument), to be led by Kalu Rinpoche (Irv served as president of Kalu Rinpoche's organization in the West). The message was that I, too, should go to Santa Fe, to photograph Rinpoche. Irv offered to pay for the flight and expenses, so the next morning I boarded a plane to New Mexico.

When we arrived in Santa Fe, there was snow on the ground. Rinpoche was giving teachings in a big tent for a few days before the consecration. The lighting was terrible, so I couldn't do any photography. I decided to attend the teachings and wholeheartedly receive the initiations. It was a rare opportunity to learn from one of the greatest masters of Tibetan Buddhism. This very old yogi was in frail health, yet he spoke with pristine clarity and wisdom.

I wondered, though, if I would be able to take any photographs. The night before the consecration, it snowed, causing the tent in front of the stupa to collapse. As a result, everyone sat on the dry area where the tent had been. Kalu Rinpoche and the other lamas were in clear view in the cold but sunny weather. Although I managed to get only a few exposures, perhaps by the guru's grace, I was able to photograph Rinpoche at the peak moment in the ceremony.

Because Rinpoche was in poor health, his disciples feared that this visit might be his last, but he returned to America in 1988, and I was able to attend his teachings in Los Angeles. Once again Irv called me, and he asked me to photograph Rinpoche at the house he was staying at in Pasadena. I decided to go all out for this portrait, using my Hasselblad camera and strobe lighting. Irv and I headed to the home of Rinpoche's sponsor, the Chinese Feng Shui master Mr. Hsia. When we arrived, we found a gathering of all the lamas that Rinpoche had sent to America to run his centers. Everyone knew this was probably the last chance to be with him. I set up all my equipment and waited.

Then Rinpoche entered the room assisted by some lamas. He sat in a chair covered with elegant Chinese fabric, specially prepared by the host's family. At Irv's suggestion, I had brought, as a gift, a framed, high-quality print of the photograph of Rinpoche from Santa Fe. He seemed pleased to receive it. As I looked through the viewfinder, making exposures as Rinpoche looked toward the camera, I noticed that he seemed distant, perhaps absorbed in his spiritual practice. I wanted to bring out his compassionate nature, so I raised my head slightly to look just over the camera, which was on a tri-

pod, and made direct eye contact, giving a slight smile. He understood and beamed as I exposed the film.

Rinpoche passed away in India a few months after that gathering. As is customary, the forty-nine-day funeral began immediately at his monastery near Darjeeling. I knew I needed to be there, and friends who had seen the portrait agreed. I took up a collection to pay for the flight and film costs in order to photograph the last ten days of the funeral.

After flying to Calcutta and taking the overnight "Darjeeling Mail" train to Siliguri, I traveled by taxi, past the great tea plantations of Darjeeling, up the mountains to Sonada Monastery. When I arrived, there were monks gathered outside the monastery and Tibetan children playing. Inside the main shrine room, young monks were chanting and blowing horns along with older monks. There were nuns and many lay followers including Tibetans, Bhutanese, and Tamangs (a Nepalese hill tribe people), as well as a number of Western disciples.

It was the monsoon season and in this place of natural beauty, with all the rain and fog, there was a feeling of great closeness and concentration of purpose among everyone there. Following the instructions given by Rinpoche before his death, his disciples aimed to collectively recite the mantra *Om Mani Padme Hum* a hundred million times over the forty-nine days. Their prayers would accompany Rinpoche's spirit through the *bardo* to the Pure Land of Amitabha (the Buddha of Infinite Light) and then to rebirth. As the end of the funeral ceremonies neared, the chanting of prayers for Rinpoche's swift rebirth intensified.

The Very Venerable Kalu Rinpoche, shown here leading a ceremony to consecrate a stupa in Santa Fe, New Mexico, in 1986, was considered by His Holiness the Sixteenth Karmapa, who studied meditation with him, as "the Milarepa of the twentieth century." (Milarepa was the great twelfth-century poet-saint of Tibet.)

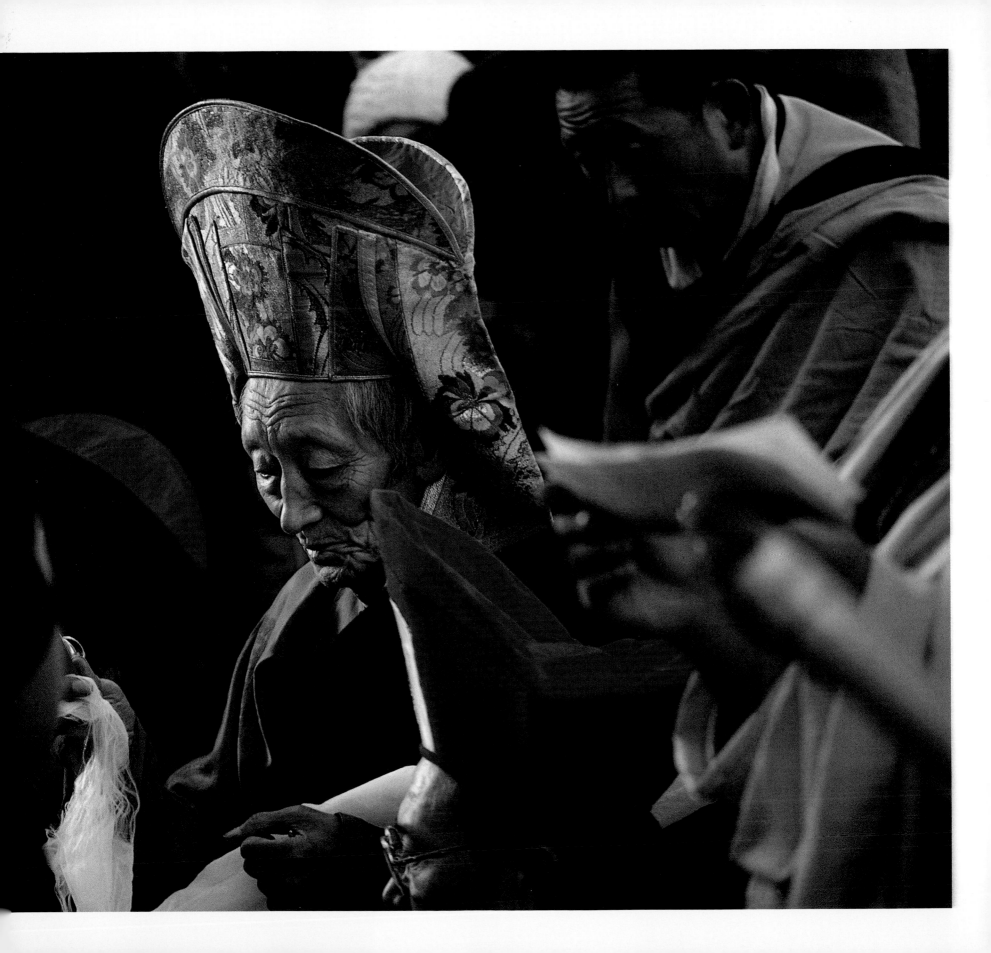

This photograph of children playing by the stupas and all the images to page 63 were made in 1989 at Sonada Tibetan Buddhist Monastery, Darjeeling, India, during the last ten days of the funeral for Kalu Rinpoche.

46

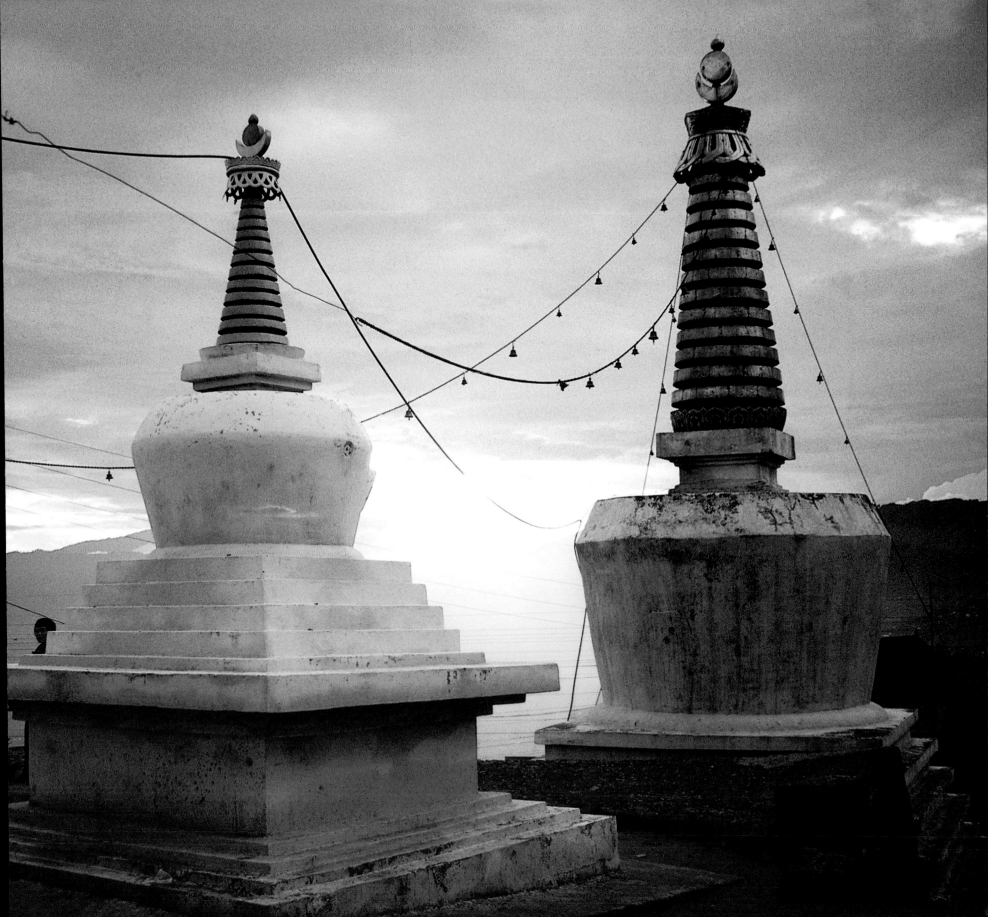

PAGE 49 Disciples of Kalu Rinpoche prayed for his swift rebirth. His body was preserved in salt and kept in a large, beautifully decorated wooden box called a *kudung*, which was placed in front of the altar in the main shrine room.

PAGE 50 Lama Karma has the job of managing the food supply for all the monks at Sonada Monastery.

PAGE 51 The boy in this Tamang family was a monk at Sonada Monastery.

PAGE 52 A break from chanting

PAGE 53 A monk hits a gong to call the *sangha* to attend a ceremony.

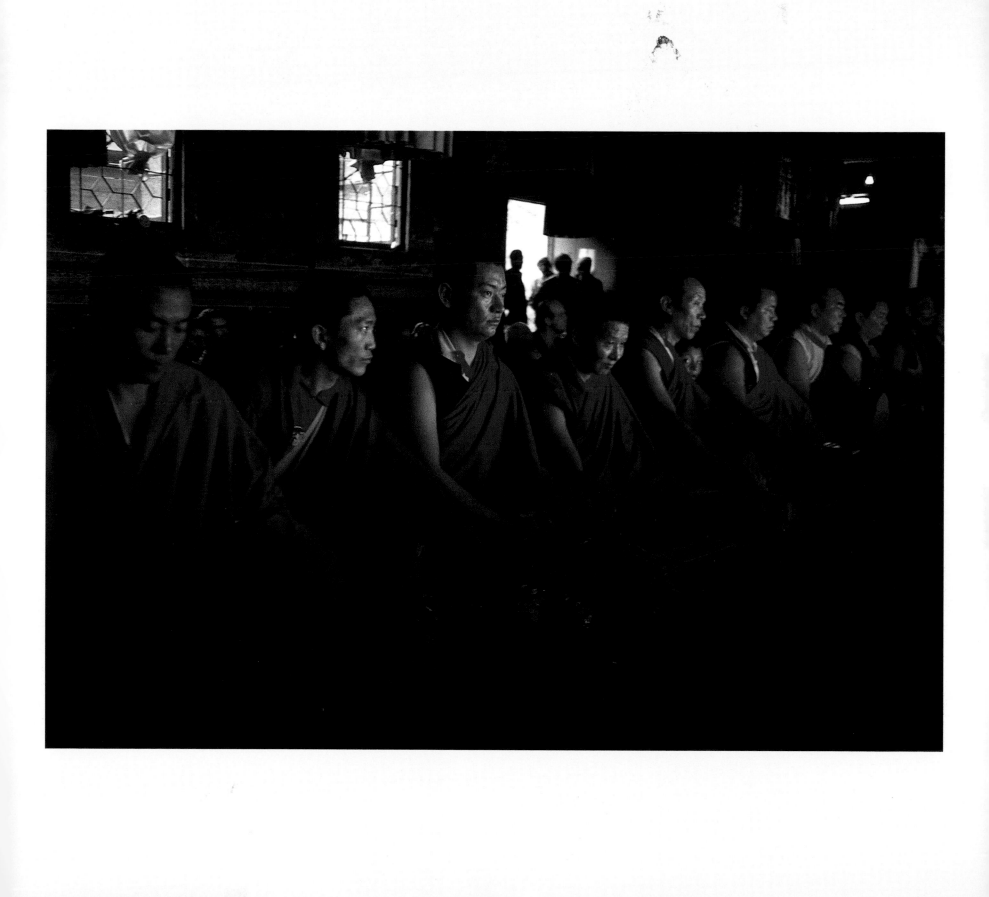

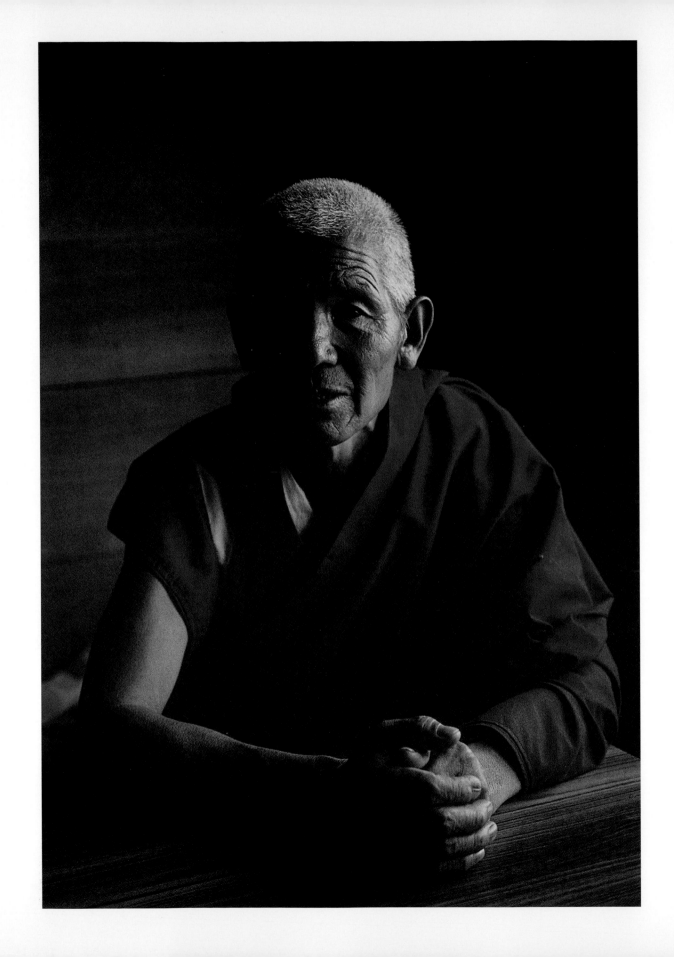

50

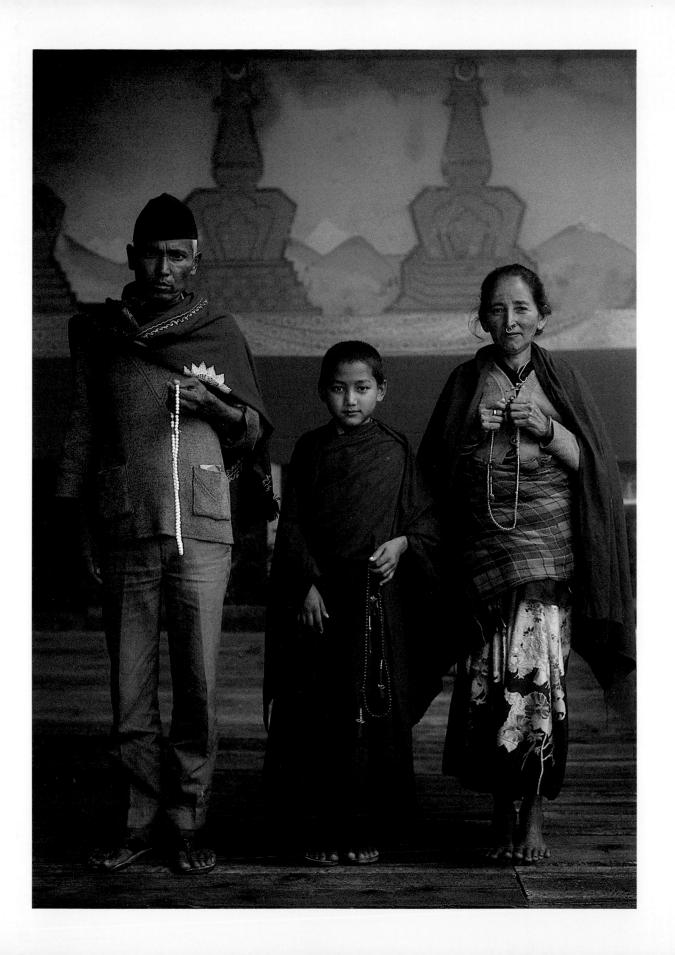

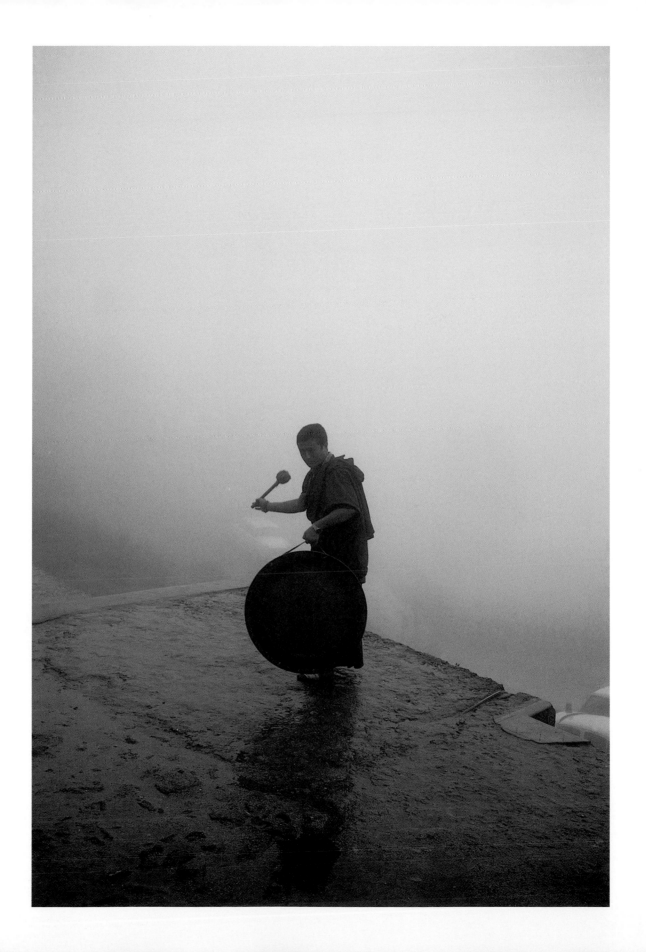

53

About fifty child monks live at the monastery. Traditionally, Tibetan families send at least one of their sons to become a monk. Monasteries also take in orphaned boys. Their days include time for play and for disciplined learning and practice.

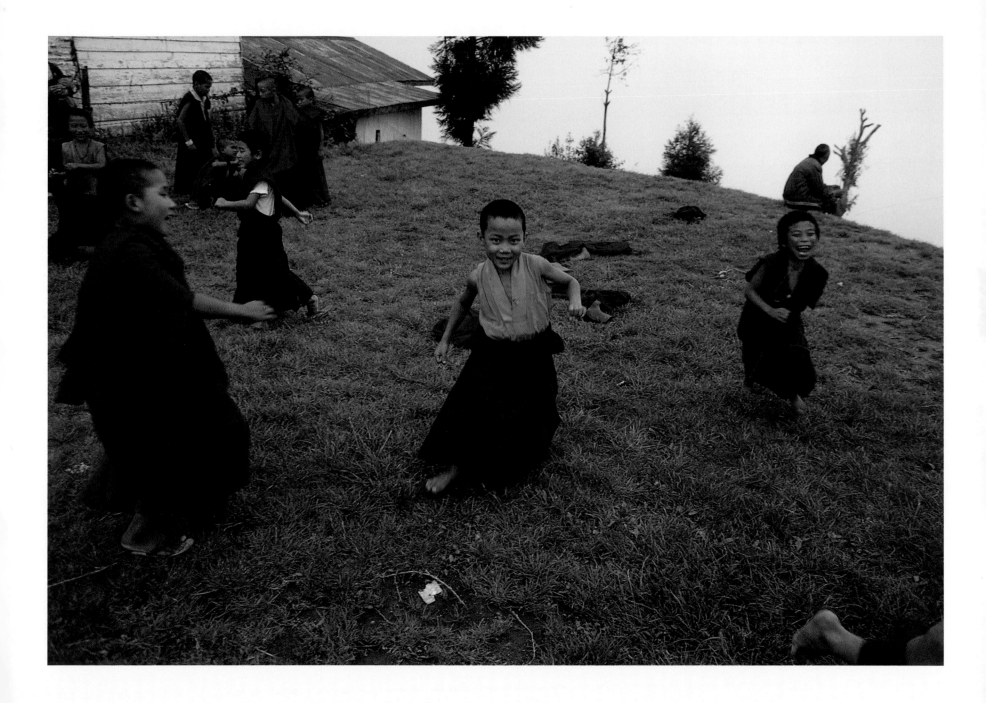

A young monk

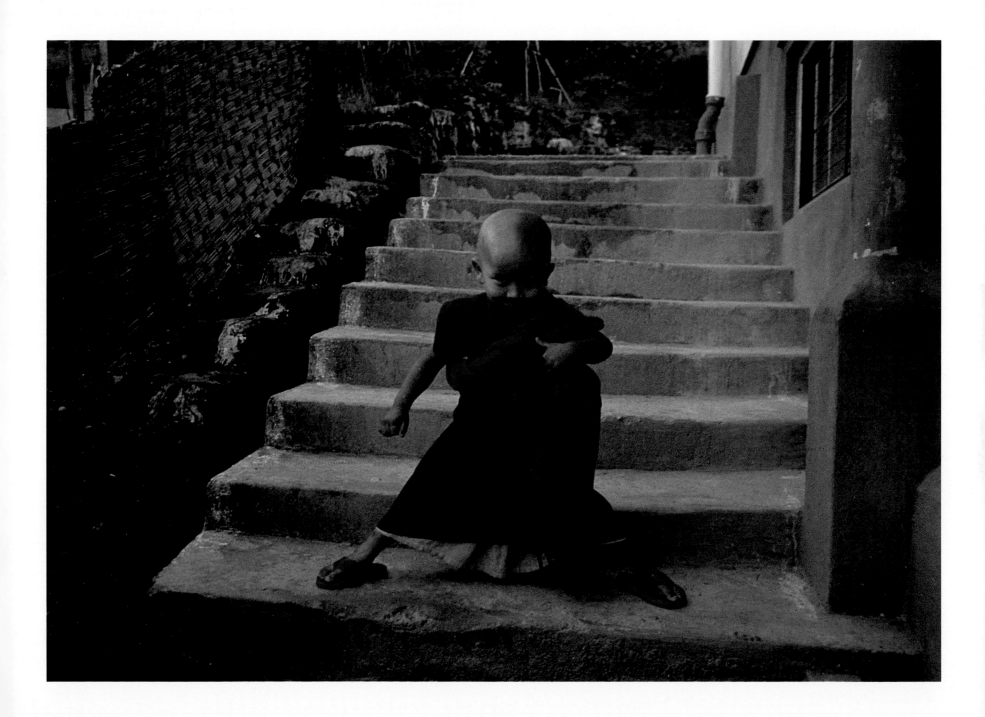

| The young monk and his brother

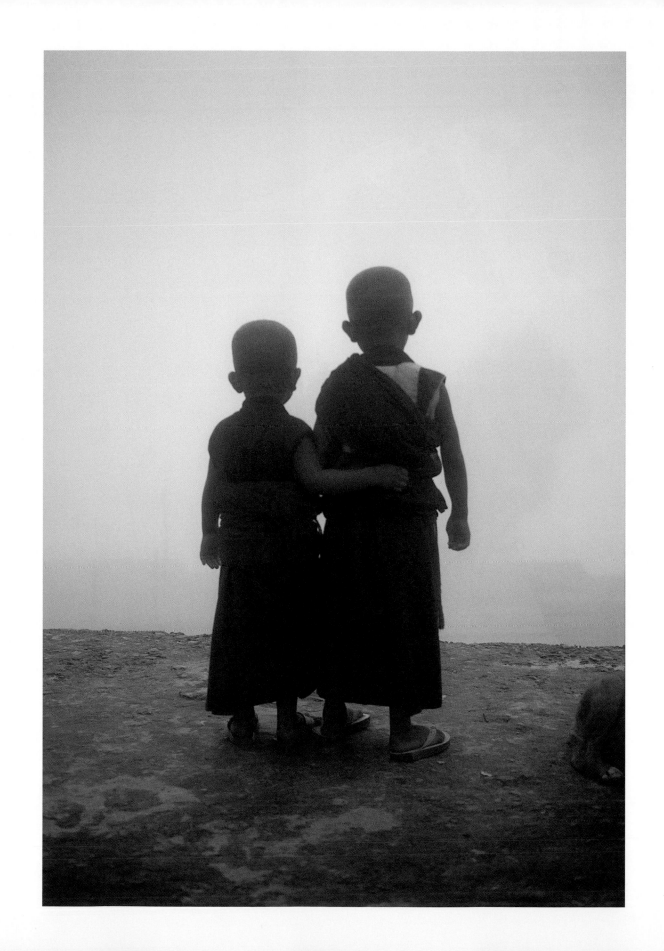

PAGE 61 Butter lamps were lit as offerings to the three jewels—the Buddha, Dharma, and Sangha—and to save all sentient beings by dispelling the darkness of ignorance.

PAGE 62 On the forty-ninth and final day of the funeral, a procession took the *kudung* holding the body of Kalu Rinpoche from the main shrine to his house.

PAGE 63 As the procession moved up the hill, everyone looked up in the sky to see this brilliant circle of light around the sun. Tibetans believe that this was an auspicious sign confirming that Kalu Rinpoche had entered the Pure Land of Amitabha (the Buddha of Infinite Light).

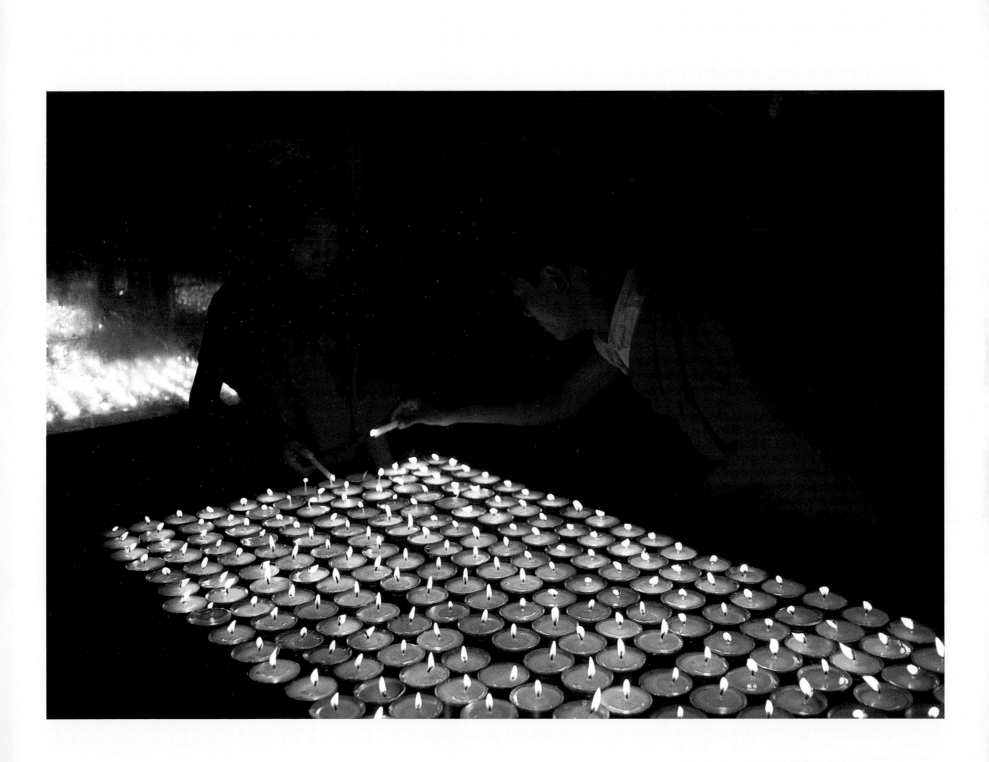

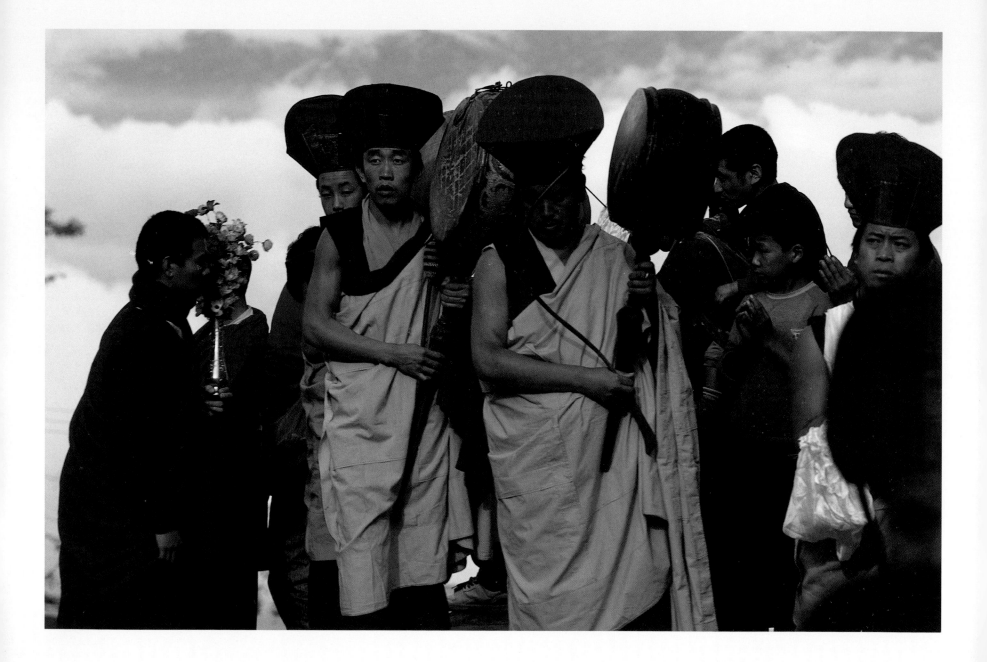

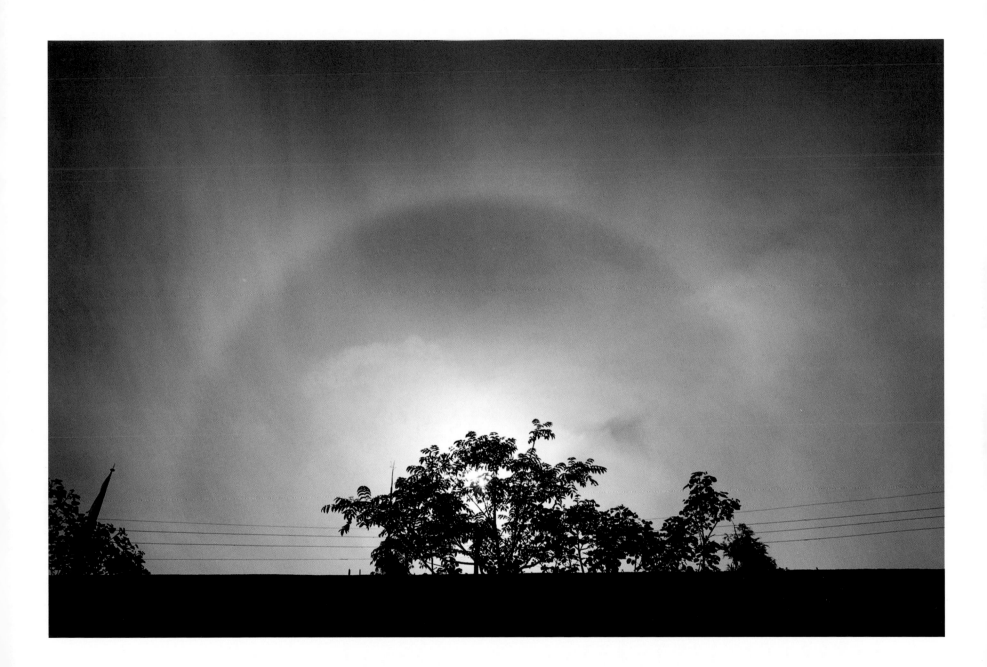

AT KALU RINPOCHE'S FUNERAL I NOTICED ONE woman who was especially sad. I found out later that her name was Drolkar, she was Bhutanese, and she was married to Lama Gyaltsen, a former Tibetan monk who had trained under Rinpoche and was his nephew. They were Kalu Rinpoche's caretakers in his later years. Within a year after he died, Drolkar gave birth to a son who was later recognized as Rinpoche's incarnation. When Lama Gyaltsen learned this, he immediately prostrated himself before his son. His relationship to the boy completely changed from that moment on. Venerable Bokar Rinpoche, the former Kalu Rinpoche's chief disciple and successor, became the boy's principal teacher.

In 1995 Bokar Rinpoche, the young Kalu Rinpoche, and his parents visited Los Angeles. While Bokar Rinpoche gave teachings, this five-year-old sat on a throne, perfectly still, for several hours. Kalu Rinpoche has not been back to America since. He stays at Bokar Rinpoche's monastery near Darjeeling, where he receives concentrated Buddhist training. In 1997 I went there when His Holiness the Dalai Lama visited. It was wonderful to see His Holiness walking with the young Kalu Rinpoche, holding his hand, as the previous Kalu Rinpoche and His Holiness had had tremendous respect for each other.

PAGE 65 Kalu Rinpoche, the boy recognized as the reincarnation of the late Very Venerable Kalu Rinpoche, in Santa Monica, California, in 1995

PAGE 66 Very Venerable Kalu Rinpoche in Pasadena, California, in 1988, a few months before he passed away at age eighty-four

PAGE 67 The young incarnate Kalu Rinpoche in San Dimas, California, in 1995

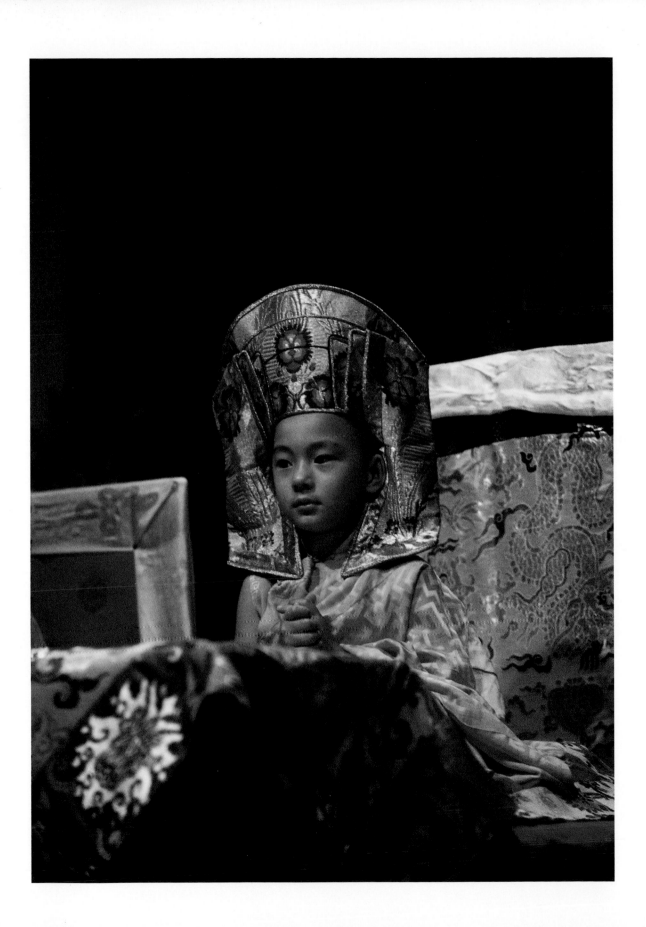

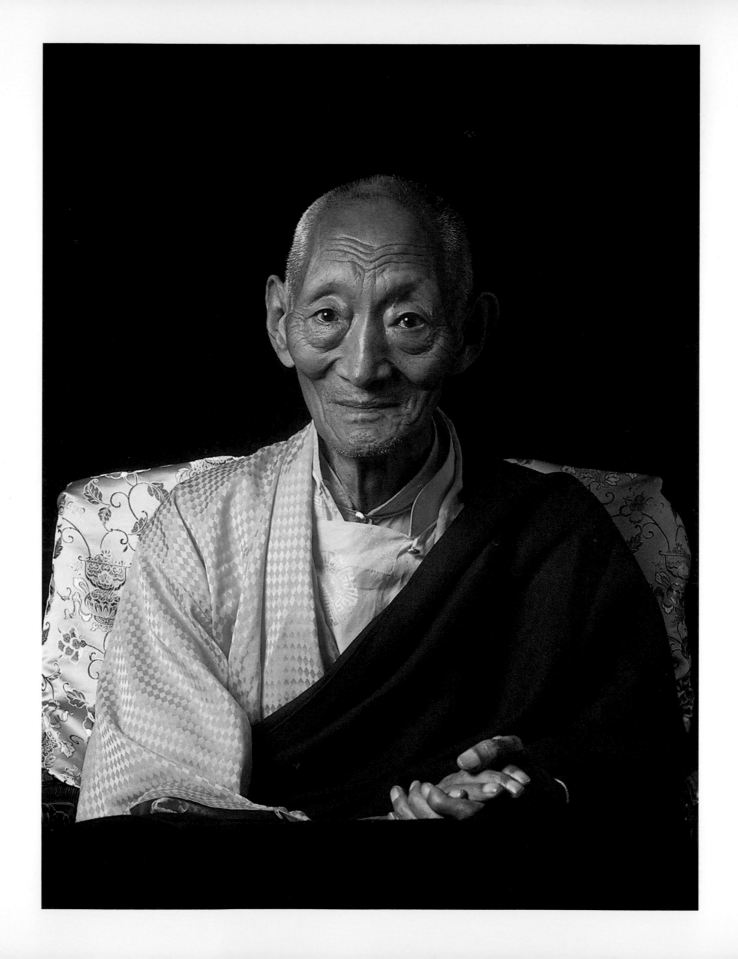

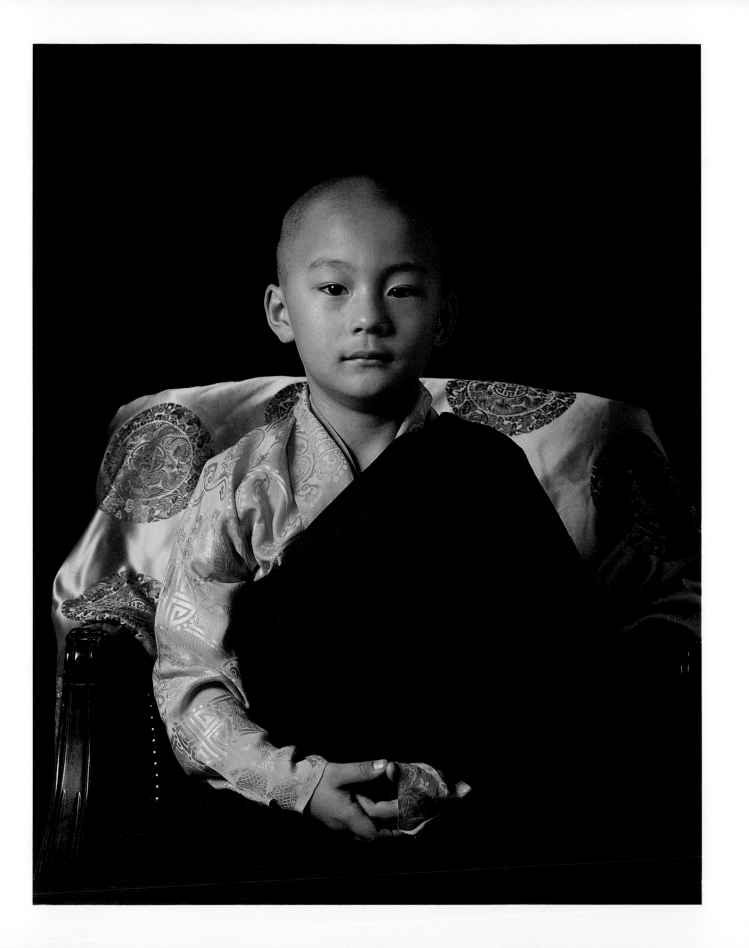

RIGHT AFTER KALU RINPOCHE'S FUNERAL, I RUSHED back to Los Angeles to serve as the photographer for the Kalachakra Initiation and teachings given by His Holiness the Dalai Lama—an event for which my teacher, Geshe Gyeltsen, was the host. For this formal portrait of His Holiness, I set up the backdrop and lighting the night before at the house where he was staying in Santa Monica. The following morning I was told that I would have five minutes to take the portrait. His Holiness came down the stairs and walked in front of the backdrop. As he stood before me and I looked through the camera, I thought to myself, "Your Holiness, please allow me to photograph the enlightened activity that you manifest."

In the years since, I have photographed His Holiness in several American cities, in India, and in South Africa. Along with the Tibetan people, his students, and well-wishers, I pray for his long life.

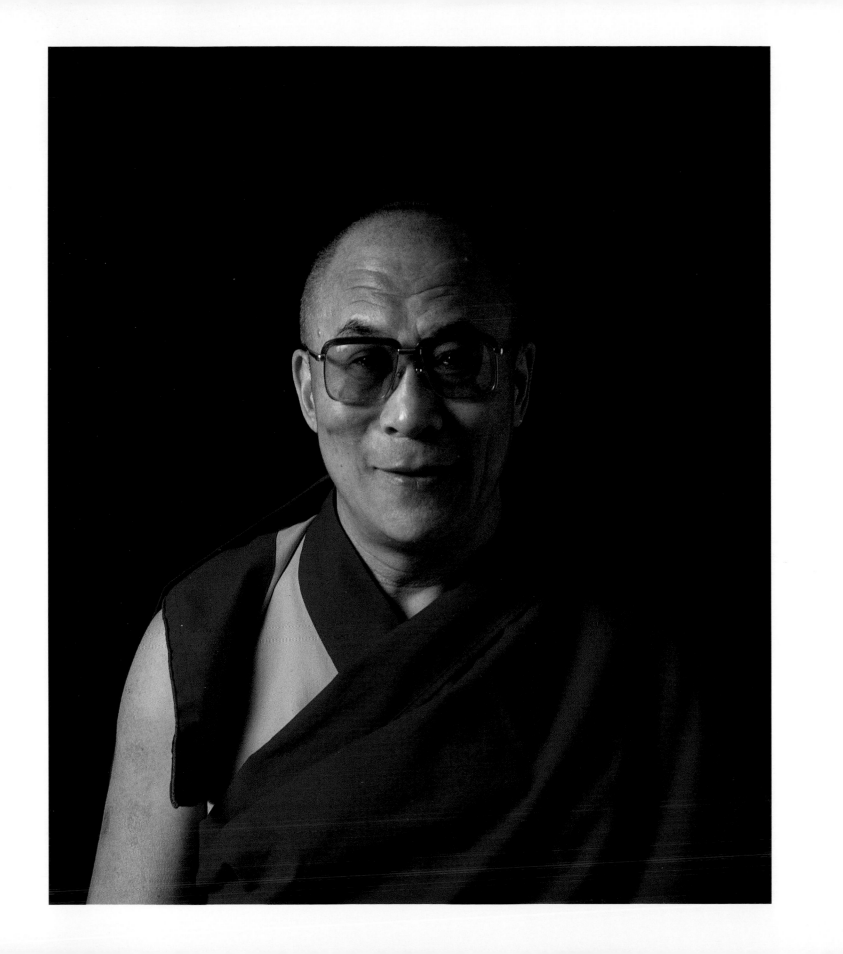

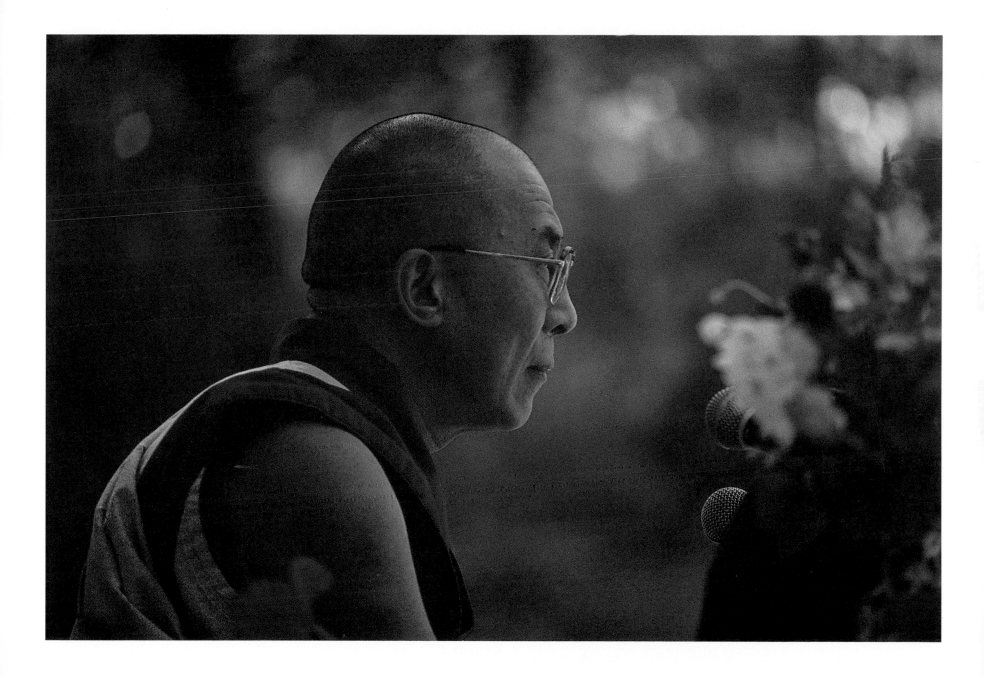

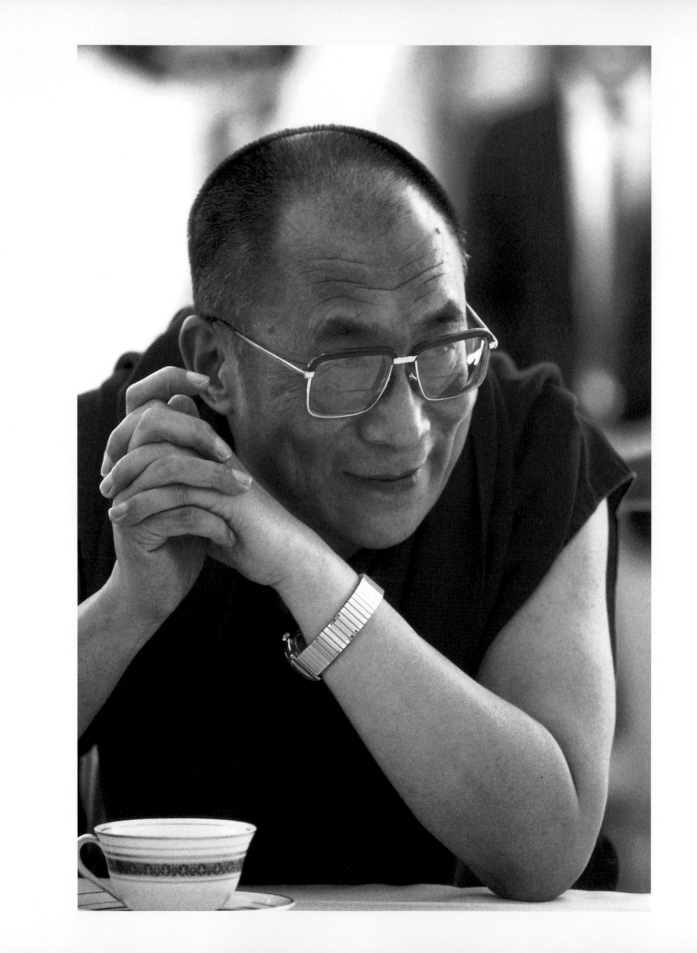

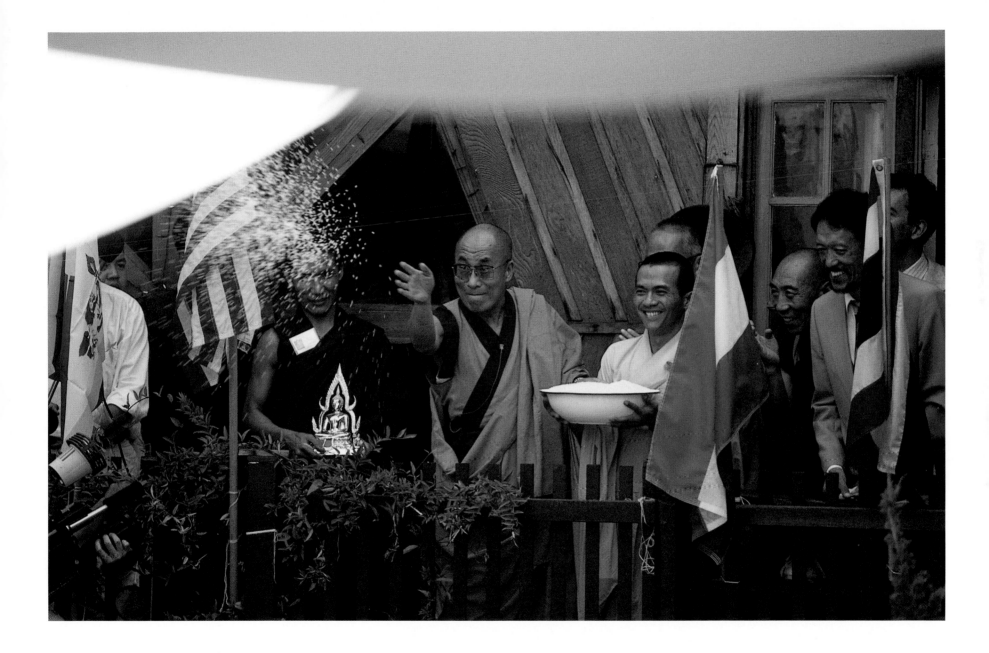

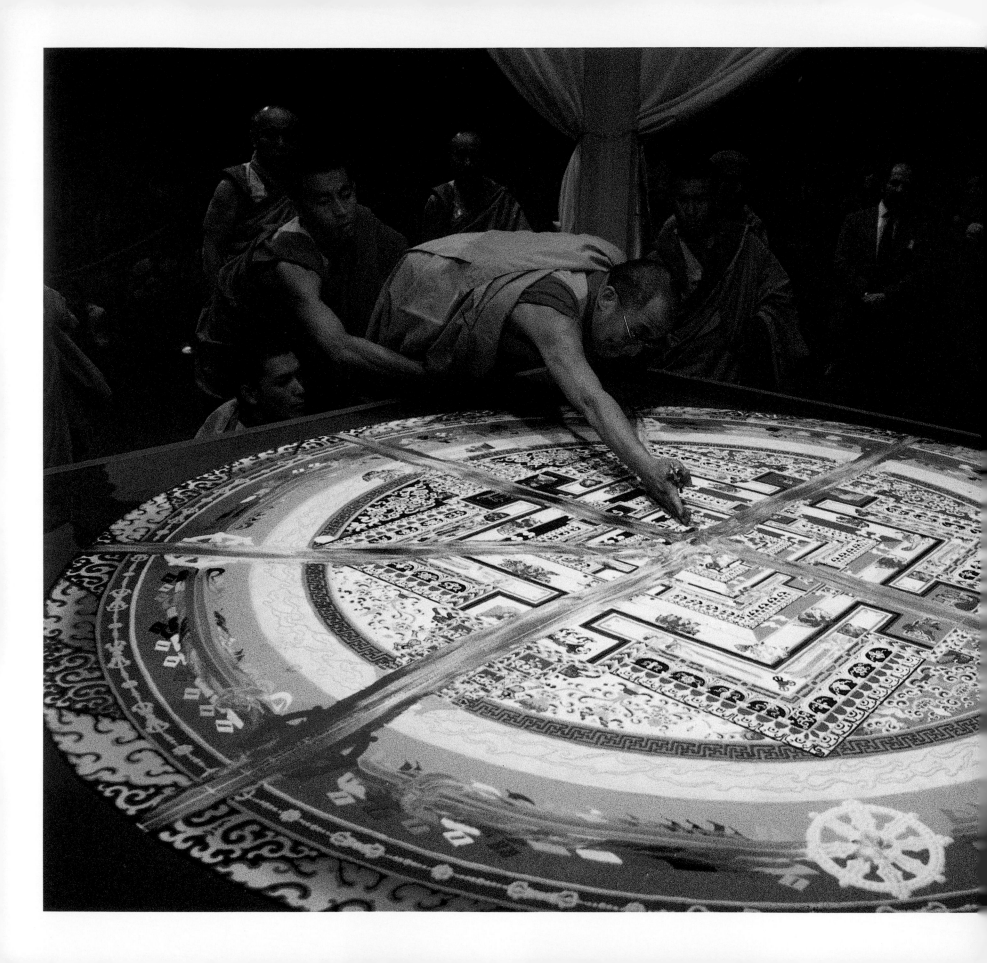

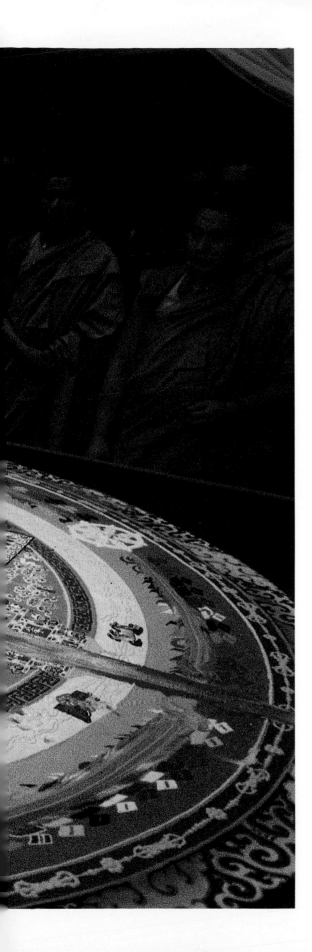

For the Kalachakra (Wheel of Time) Initiation given by His Holiness, monks from Namgyal Monastery made a sand mandala. At the end of the ceremony, His Holiness dismantled the mandala and the sand was swept up and placed in an urn. Quickly, His Holiness and the other monks rushed by car to the local marina, where the sand was poured into the sea to benefit the *nagas* who roam the waters. (Santa Monica, California, 1989)

AFTER PHOTOGRAPHING KALU RINPOCHE AND His Holiness, I began making formal portraits of other Tibetan Buddhist masters when they came to give teachings in Los Angeles. Since many of these teachers, known as *rinpoches* (precious jewels), are the last masters to have received their training in Tibet before the Chinese occupation, they embody the traditional Tibetan culture. When they are gone, a precious part of the culture will go with them. This is why I have felt compelled to photograph them.

I often think of the portraits of American Indians by Edward S. Curtis, Adam Clark Vroman, and others, made around the turn of the twentieth century. I think of the similarities between the situation of Tibetans today under Chinese rule and that of Native Americans a century ago or more, when their way of life was decimated by European settlers. In those early American Indian portraits, we see their lives and times in their faces. In the same way, portraits of Tibetans reveal a time-honored way of life that will be lost unless Tibetans are allowed to control their own destiny in their homeland.

As the tragedy in Tibet unfolds, we in the West have been blessed with the presence of masters who have escaped from Tibet. Thanks to these masters, Tibetan Buddhism is profoundly affecting the lives of millions of people in the West.

Immediately after going into exile in 1959, His Holiness the Dalai Lama and other Tibetan Buddhist leaders inspired and guided a major effort to reestablish—in India and Nepal—the monasteries destroyed by the Chinese regime. These monasteries form the center of the cultural life of Tibetan communities in exile, and many refugees have chosen to live in the settlement where their guru lives.

In addition to having one or more monasteries in India or Nepal, some masters have monasteries in Tibet that they are in the process of rebuilding. Through the money they raise from giving teachings, they support the monks and nuns under their care, many of whom are children, and provide activities for elderly Tibetans. Supporting a rinpoche through contributions thus directly supports the continuation of Tibetan culture.

Not all rinpoches reach the level of master in the same way. Some show exceptional understanding of the Buddha's teachings while advancing to the highest levels of monastic education. Others are yogis who attain realization by living for years in solitary retreat in caves or huts. Still others, known as *tulkus,* are recognized at a young age as reincarnations of masters who have died. They took the bodhisattva's vows to help free all sentient beings from suffering and promised to return to the world after dying to continue this effort. These vows are integral to Mahayana Buddhism in general, but unique to the Tibetan system is the process of identifying a child believed to be a reincarnate master. The child undergoes a battery of tests to see if he or she remembers certain aspects of the previous incarnation. Once found, the child comes under the guidance of the chief disciples of the previous master and enters an intense training. Chagdud Tulku Rinpoche, for example, started the first of two three-year retreats at age eleven.

His Eminence Chagdud Tulku Rinpoche, a revered master of the Nyingma tradition, inspires his many Western students to practice diligently and to learn and maintain traditional Tibetan Buddhist arts and rituals. After many years in Northern California, he now lives in Brazil. (Los Angeles, 1990)

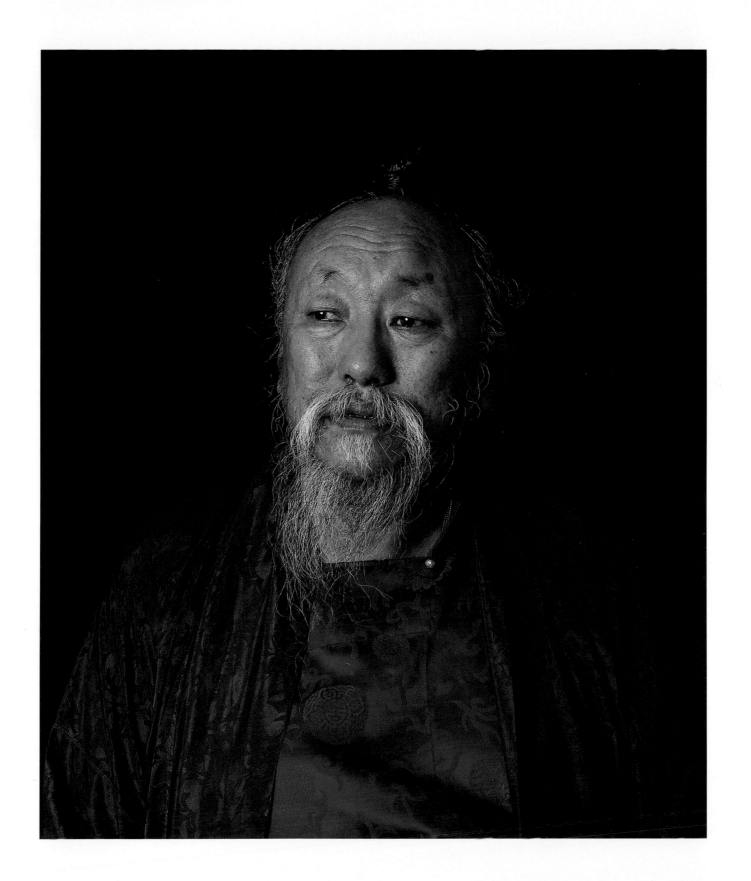

PAGE 79 His Holiness Sakya Trizin is the head of the Sakya lineage and one of Tibetan Buddhism's most important spiritual leaders. He lives in Rajpur, India. Here he is doing preparatory rituals for an empowerment he gave in Los Angeles in 1989.

PAGE 80 Her Eminence Jetsun Kushok Chimey Luding, the sister of His Holiness Sakya Trizin, is one of the foremost female masters of Tibetan Buddhism. She lives near Vancouver, Canada. (Los Angeles, 1990)

PAGE 81 Venerable Khandro Rinpoche, the daughter of His Holiness Mindrolling Trichen Rinpoche, was recognized by His Holiness the Sixteenth Gyalwa Karmapa as the incarnation of the renowned practitioner and the consort to the Fifteenth Karmapa, also named Khandro. Living in Mussoorie, India, she has many Western disciples. (Los Angeles, 1994)

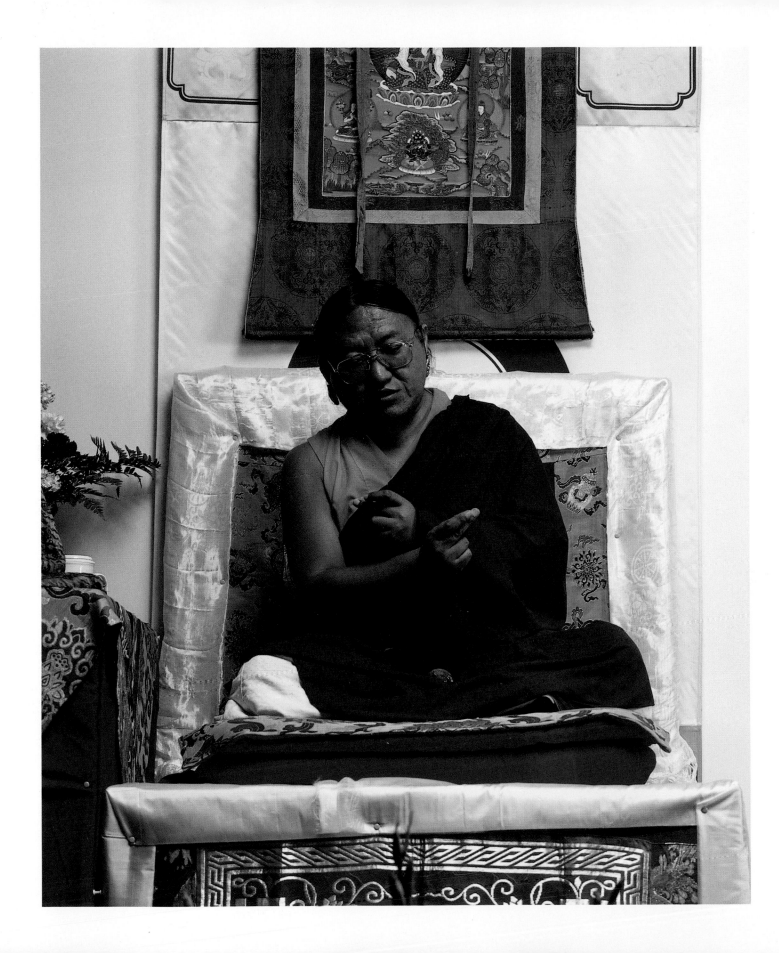

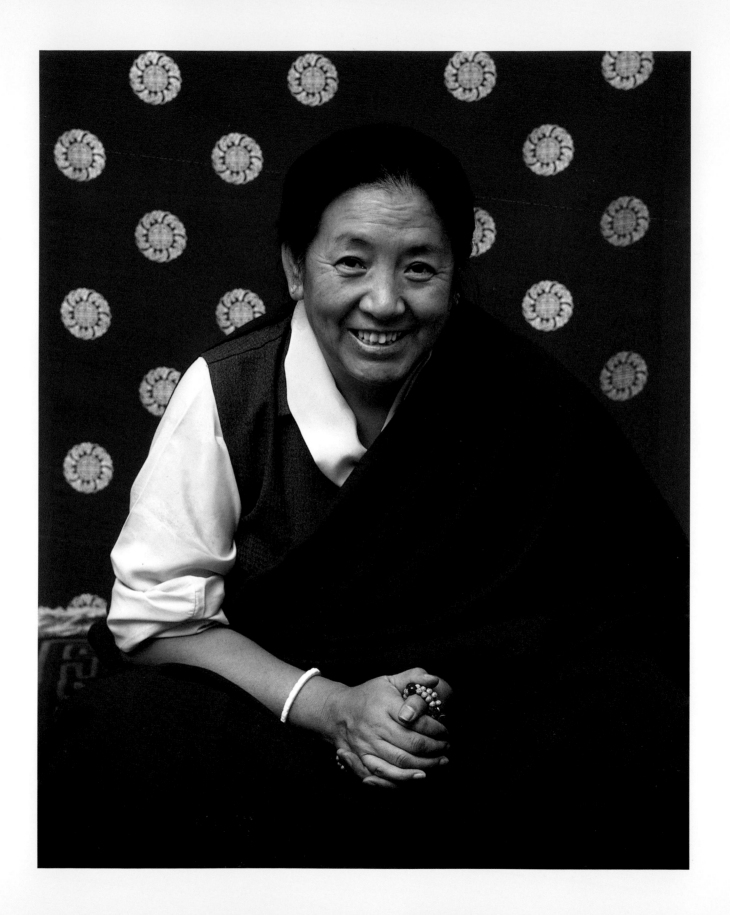

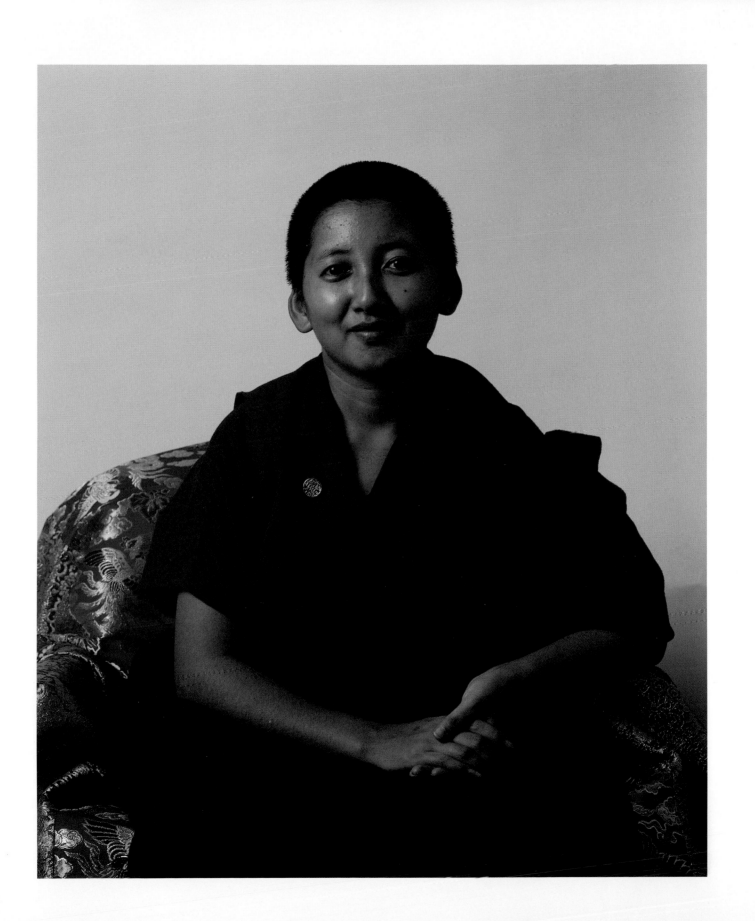

PAGE 83 Venerable Geshe Tsultim Gyeltsen received the highest level of monastic education in the Gelugpa tradition, the Geshe Lharampa degree. He is the founder of Thubten Dhargye Ling Buddhist Monastery in Long Beach, California. Geshe-la has been a friend for twenty-five years and was my first Tibetan Buddhist teacher. He and my teacher Thich Thien-An were close friends. (Los Angeles, 1995)

PAGE 84 His Eminence Kyabje Lati Rinpoche, who serves as a spiritual assistant to His Holiness the Dalai Lama, is one of the greatest living masters of the Gelugpa tradition. He holds the rare distinction of being both an incarnate master and a Geshe Lharampa. He lives at Ganden Shartse Monastery in Mundgod, India. (Long Beach, California, 1998)

PAGE 85 Venerable Trulshik Rinpoche, who lives in Nepal, is a highly revered master of the Nyingma tradition. He is the spiritual heir to the great Dilgo Khyentse Rinpoche. (New York City, 1999)

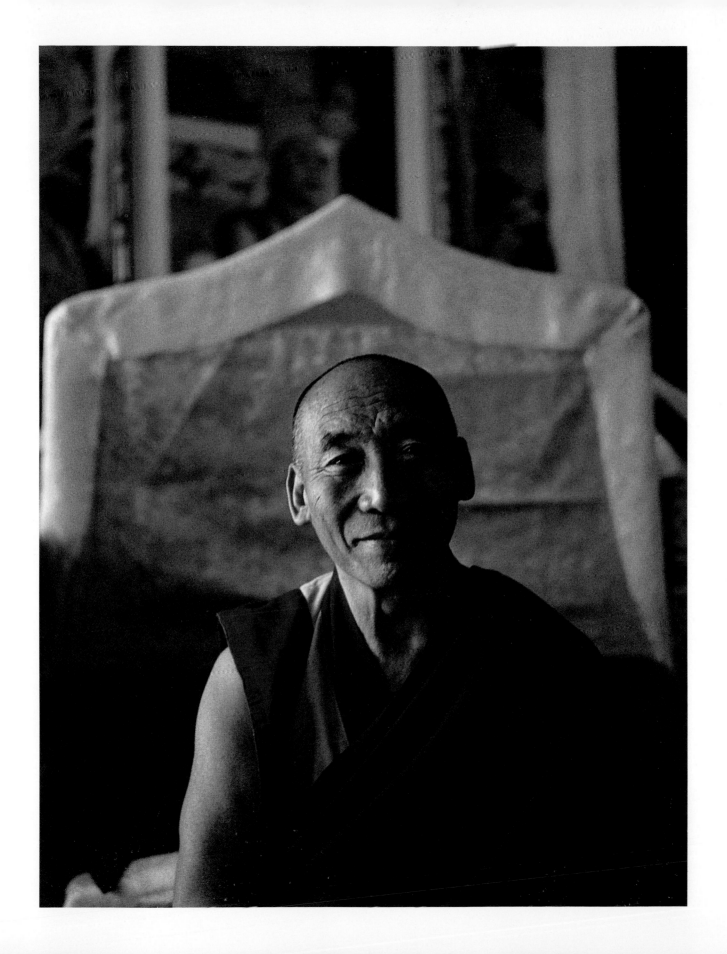

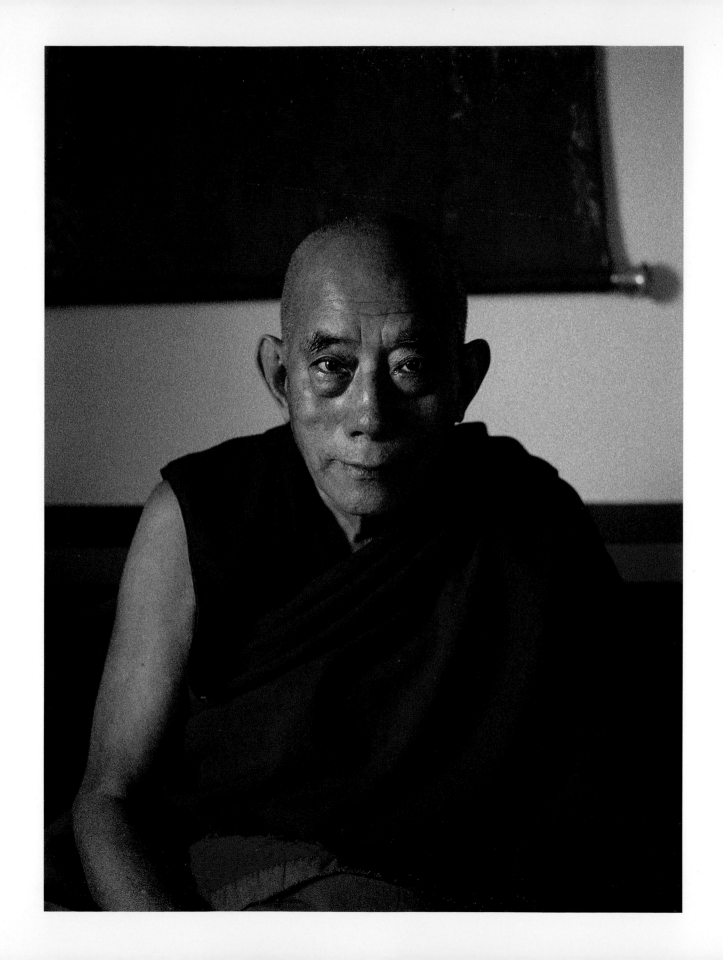

84

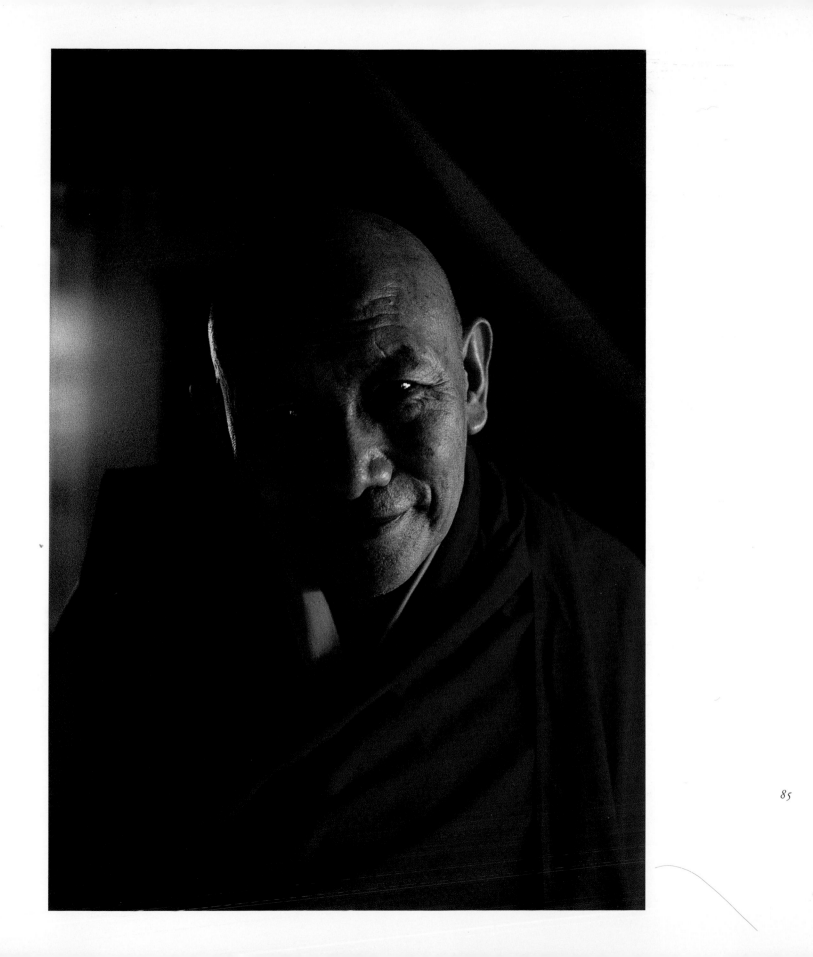

Venerable Lama Tharchin Rinpoche is the tenth lineage holder of the Repkong Ngakpas, or yogis. He trained under the great Nyingma master Dudjom Rinpoche for more than forty-five years, beginning when he was eight years old. He spent five years in solitary retreat in the forest and completed a three-year retreat under Dudjom Rinpoche's guidance. A remarkable teacher, Dzogchen master, and traditional Tibetan artist, he is the founder of Vajrayana Foundation College of Buddhist Studies and Pema Osel Ling Retreat Center in Watsonville, California. (Santa Monica, California, 1994)

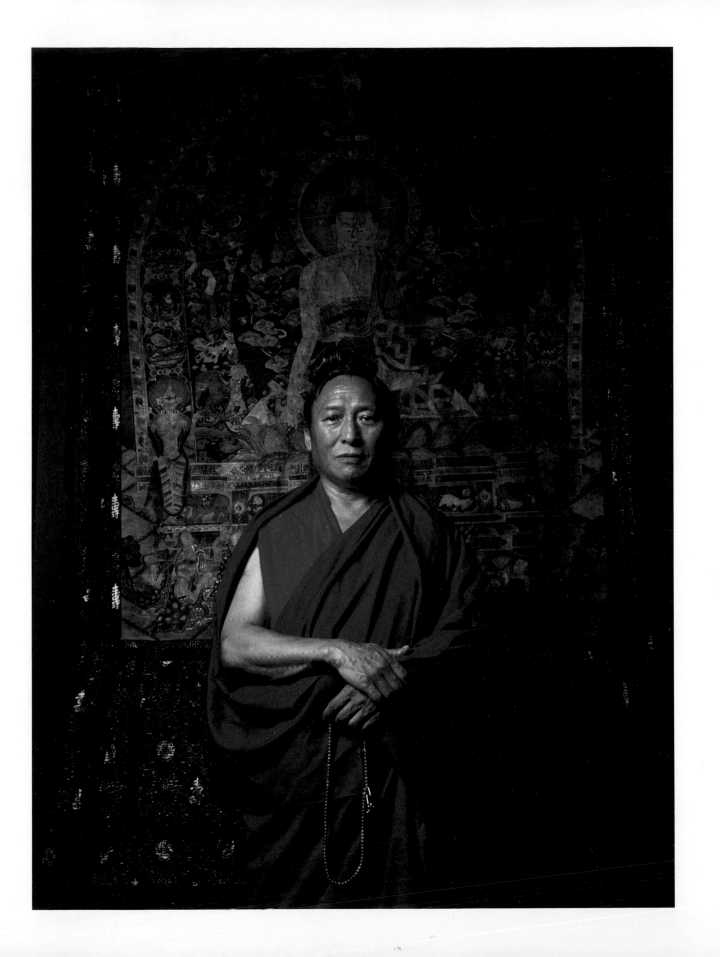

For peacefully protesting and refusing to concede that Tibet is part
of China, Venerable Palden Gyatso was imprisoned in Tibet for
thirty-three years by the Chinese government. He is seen holding
electric cattle prods used as instruments of torture against Tibetans.
He lost all his teeth when a cattle prod was inserted in his mouth.
He smuggled these ones out of Tibet when he escaped in 1996.
Throughout his imprisonment, the main practice of this monk of
the Gelugpa tradition was *tong-len* (receiving and giving), a form of
visualization that does not require special initiation to practice. This
practice, he says, helped him maintain his inner calm and compas-
sion. Living today in Dharamsala, India, he is active in the struggle
for Tibet's freedom and lectures on the conditions in Tibet's prisons.
(Los Angeles, 1998)

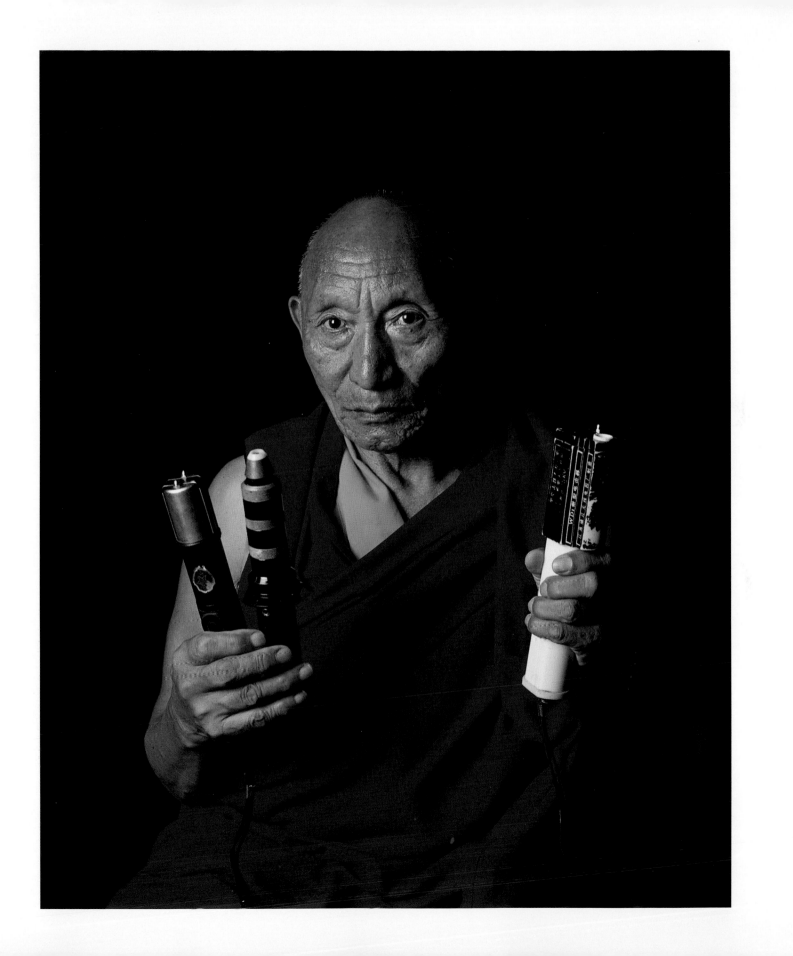

BETWEEN 1989 AND 1993 I LIVED PART OF THE year in Santa Monica and part in Tokyo. Through friends in the Los Angeles Buddhist community, I had made contact with Buddhist groups in Japan and found sponsors there. One was the owner of a security patrol company, who kept an apartment for several people he sponsored, including an adventure skier and an explorer. I was able to live there for part of the time I was in Japan. In exchange for slide lectures on Buddhist life for his employees, he gave me donations to carry out my photography.

Two groups in Japan, the Japan Buddhist Federation and Bukkyo Dendo Kyokai (Society for the Promotion of Buddhism), also supported my work. I worked out of the Japan Buddhist Federation's headquarters at Zojoji Temple in Tokyo and stayed at the temple. The federation's members were priests from the main sects of traditional Japanese Buddhism, including Rinzai Zen, Soto Zen, Tendai, Shingon, Jodo, Jodo Shinshu, and Nichiren. Under the federation's sponsorship, I was invited to photograph major ceremonies of each sect. This gave me unusual access. In addition, my friend the Rinzai Zen priest I had met on my first visit to Japan, Bunkei Yamamoto, took me to many ceremonies at Rinzai temples. From Tokyo, I would travel to Kyoto, often by the overnight bus, and I would go by train to other parts of Japan to photograph Buddhist life.

My own practice drew from various Buddhist traditions. In photographing Buddhist life, I found that following the practice of the particular tradition I was photographing helped me connect with that tradition on a deeper level.

I loved living in Japan. In the Gagaku music, in the *shakuhachi* flute, in the Obon Dance, in the wind blowing through a bamboo forest, the spirit of Japan is ever-present. I wrote the following words while staying at Zojoji Temple in Tokyo in 1991:

"The differences between Japanese or Japanese Americans and non-Japanese continue to raise suspicions and prejudices from both sides. However, when we sit in *zazen,* chant *namu amida butsu* or *nam myoho renge kyo,* we come to a universality of humanness that makes such ethnic differences seem insignificant. These spiritual practices are at the heart of Japanese Buddhist life. They are the peace in the eye of the hurricane of life, whether it's the crush of the subway cars in Tokyo or the bumper-to-bumper traffic on L.A. freeways. These practices and others can bring us to the same spiritual vistas that Dogen saw at Eiheiji, Nichiren saw at Mount Minobu, or Kukai saw at Mount Koya. Differences of the shape of one's eyes or the color of one's skin seem so unimportant when we have a glimpse of such vistas—whether it's staring at a wall in *zazen* or contemplating by a stream in Yamaguchi Prefecture.

"I don't see the need for 'Japan bashing' or for distrusting *gaijin.* Rather, let's appreciate each other's cultures and discover what is most beautiful about Japanese and American life —whether it's sipping green tea looking out on a Zen garden or taking a deep breath while looking up at the redwoods in the Sierras."

Tea ceremony, Tokyo, 1992

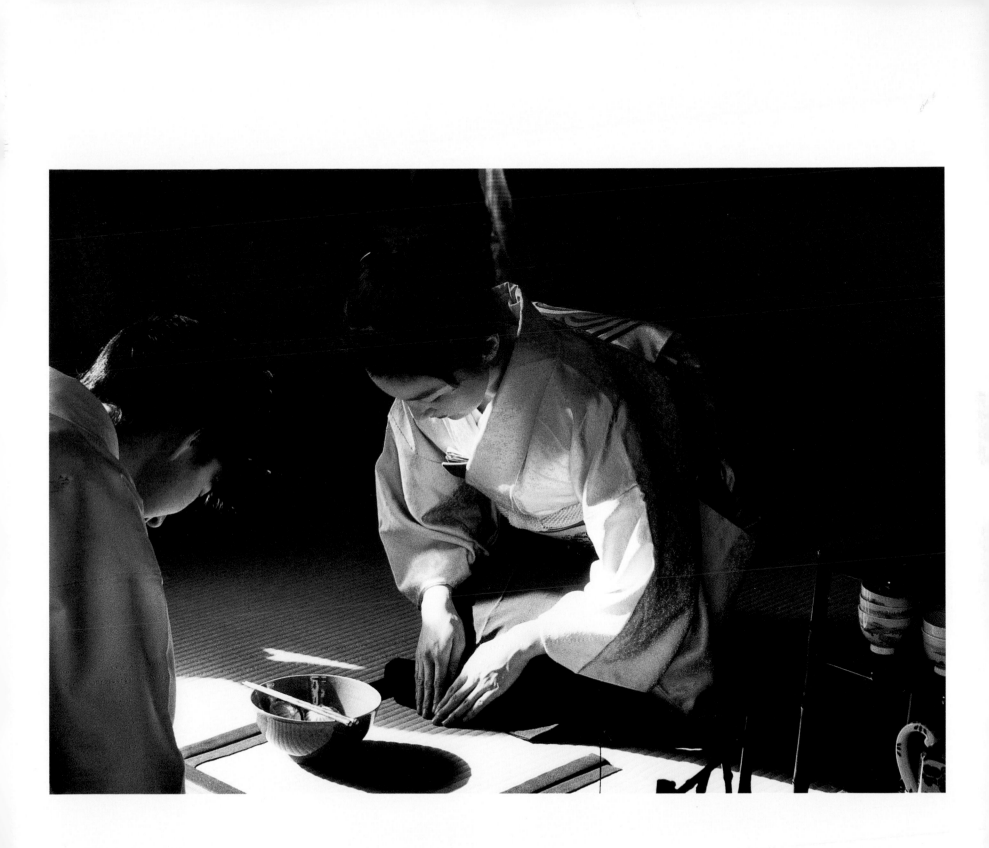

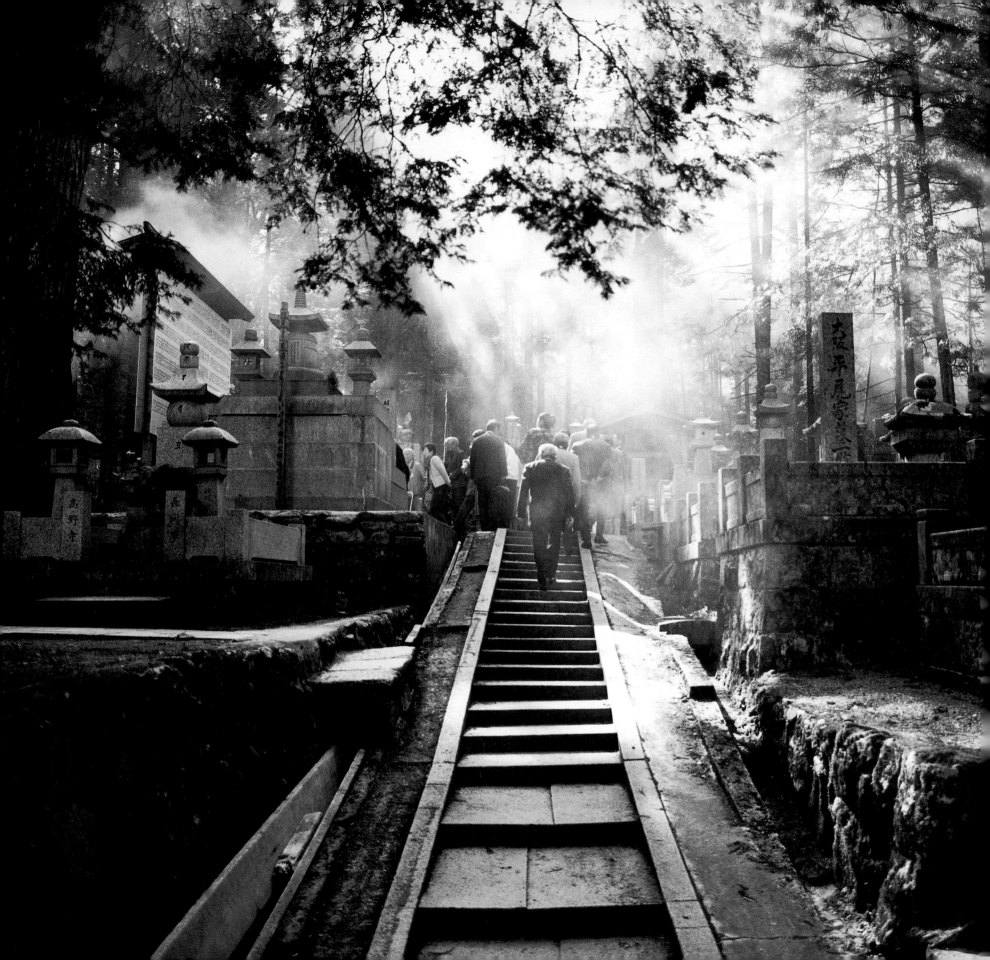

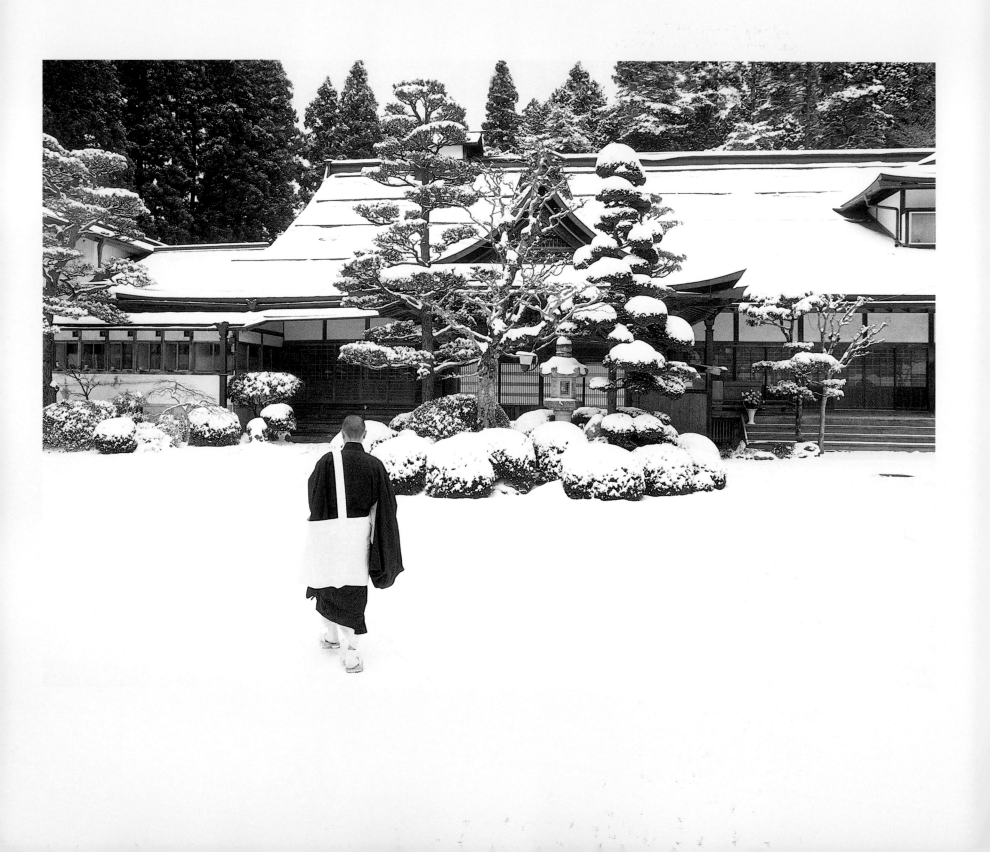

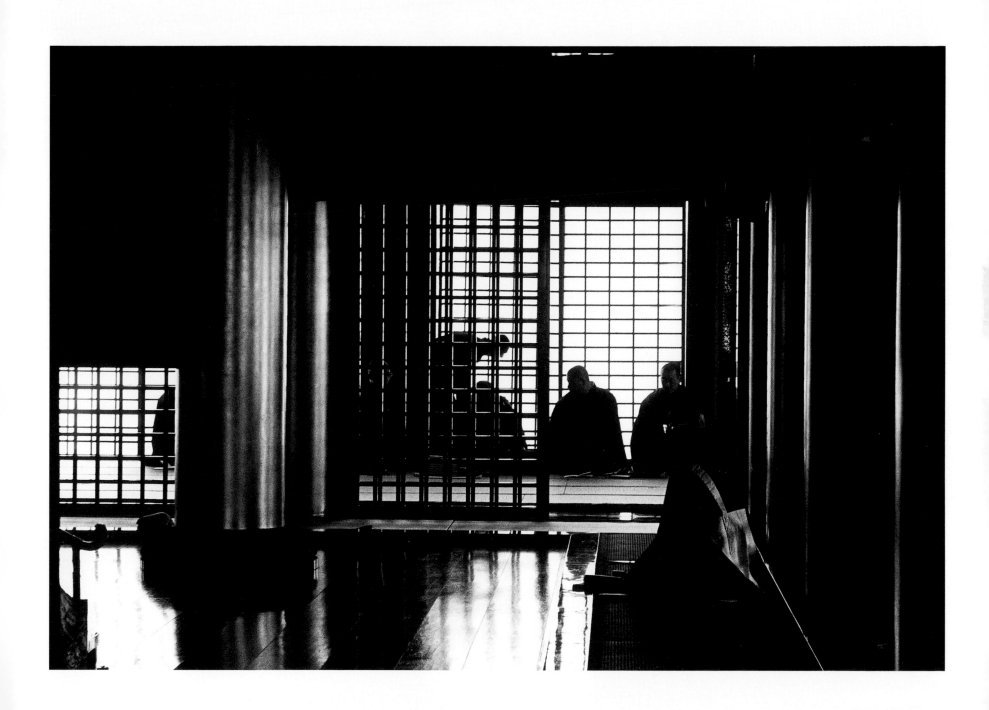

Konpon Daito pagoda, Koyasan, Japan, 1989

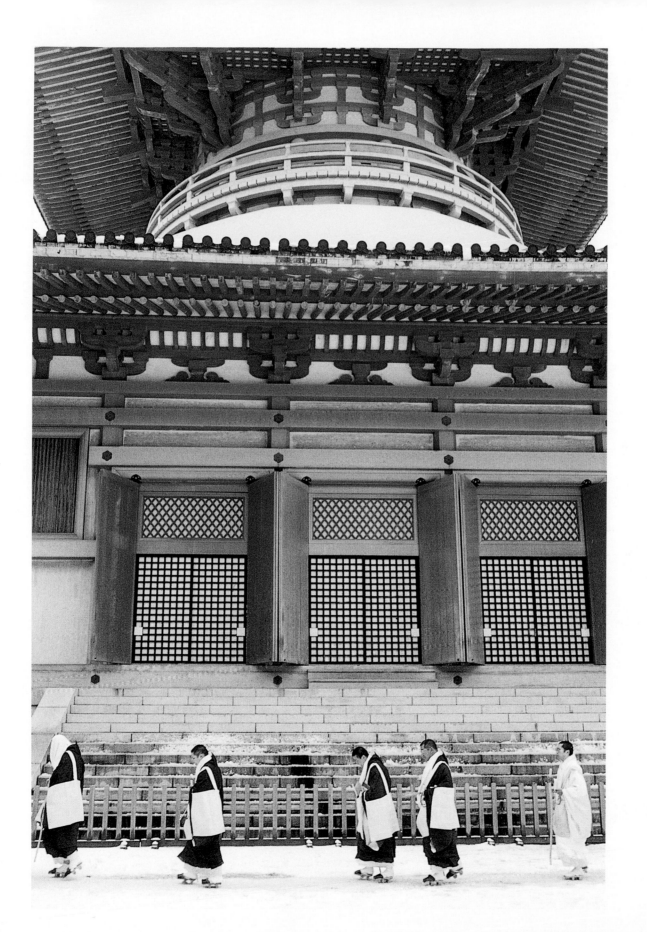

PAGES 99–101 Eiheiji Monastery, one of two headquarters for the
Soto Zen sect, Fukui Prefecture, Japan, 1990

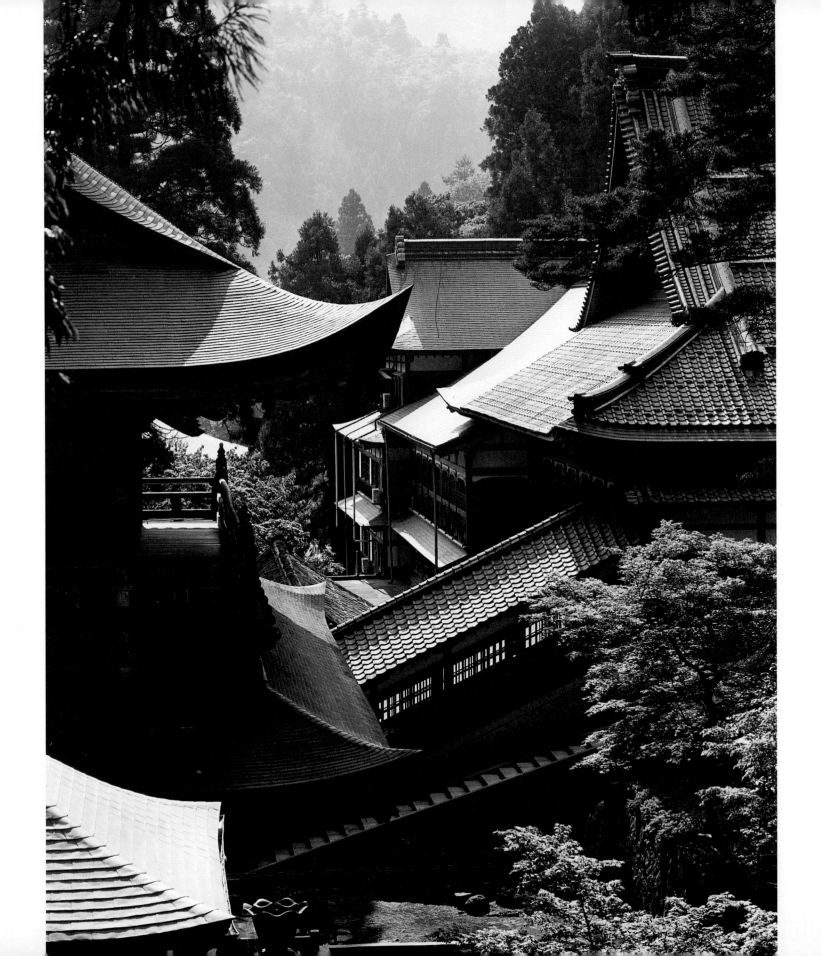

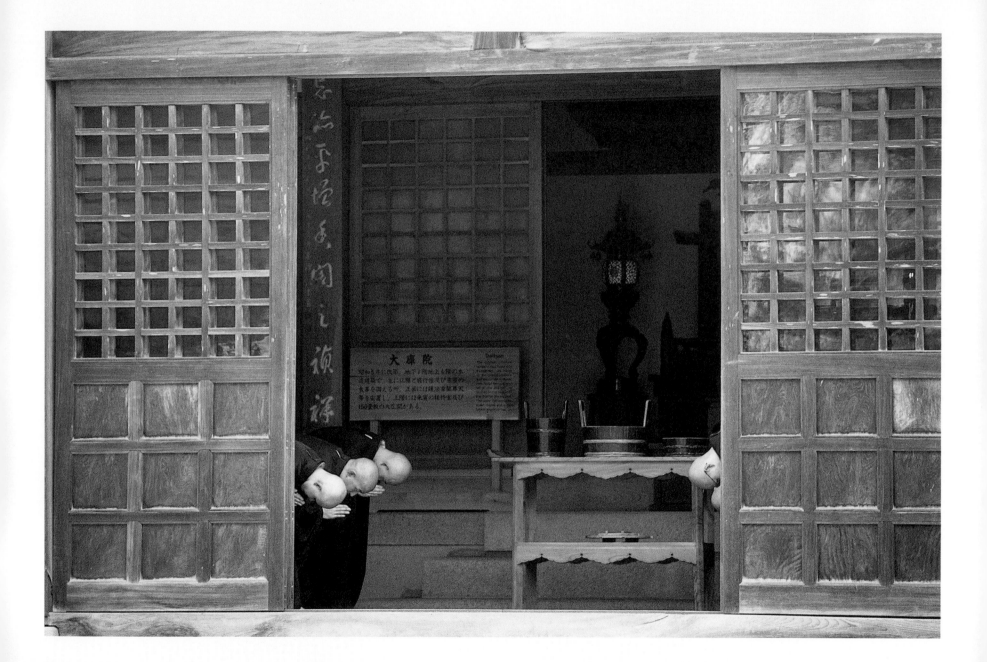

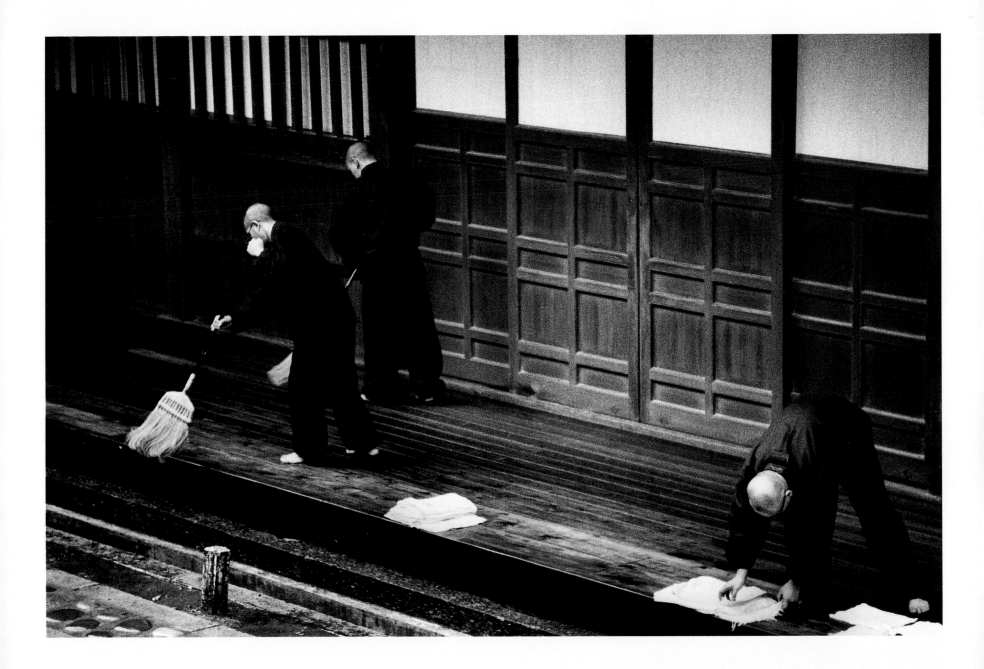

A monk hits a drum at the beginning of a ceremony at Kotokoji, a
temple of the Rinzai Zen sect, Tokyo, 1991.

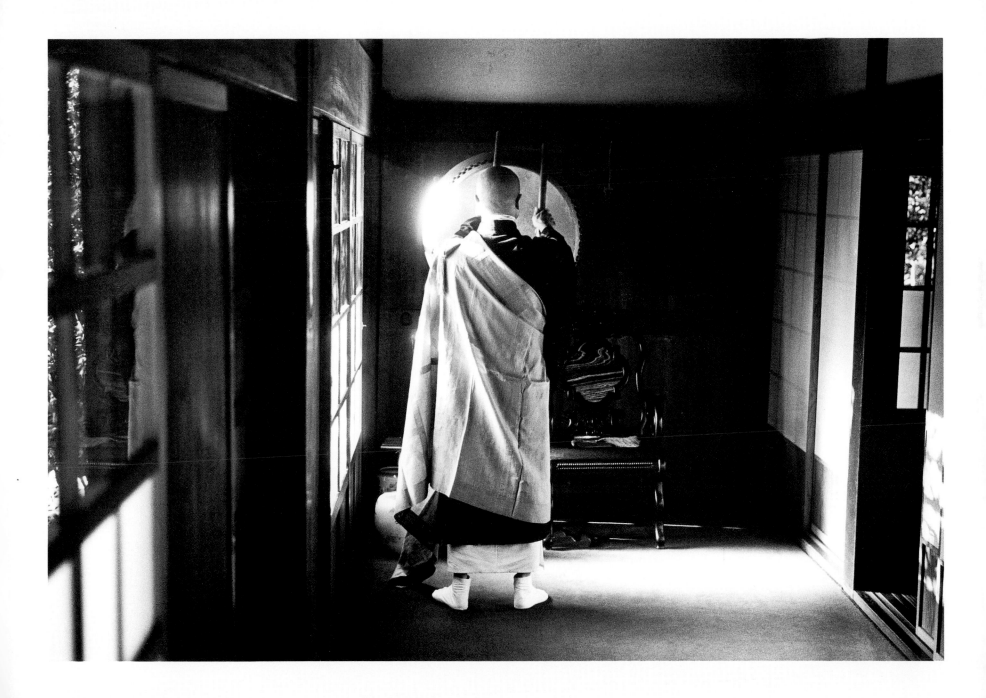

PAGE 105 Joshu Sasaki Roshi, one of the most revered masters of the Rinzai tradition, has been living and teaching in the United States since the 1960s. (Mount Baldy Zen Center, San Bernadino County, California, 1994)

PAGE 106 Students of Joshu Sasaki Roshi practicing *kinhin* at the Mount Baldy Zen Center, 1994

PAGE 107 Going for alms at the Rinzai Zen monastery Tofukuji, Kyoto, 1992

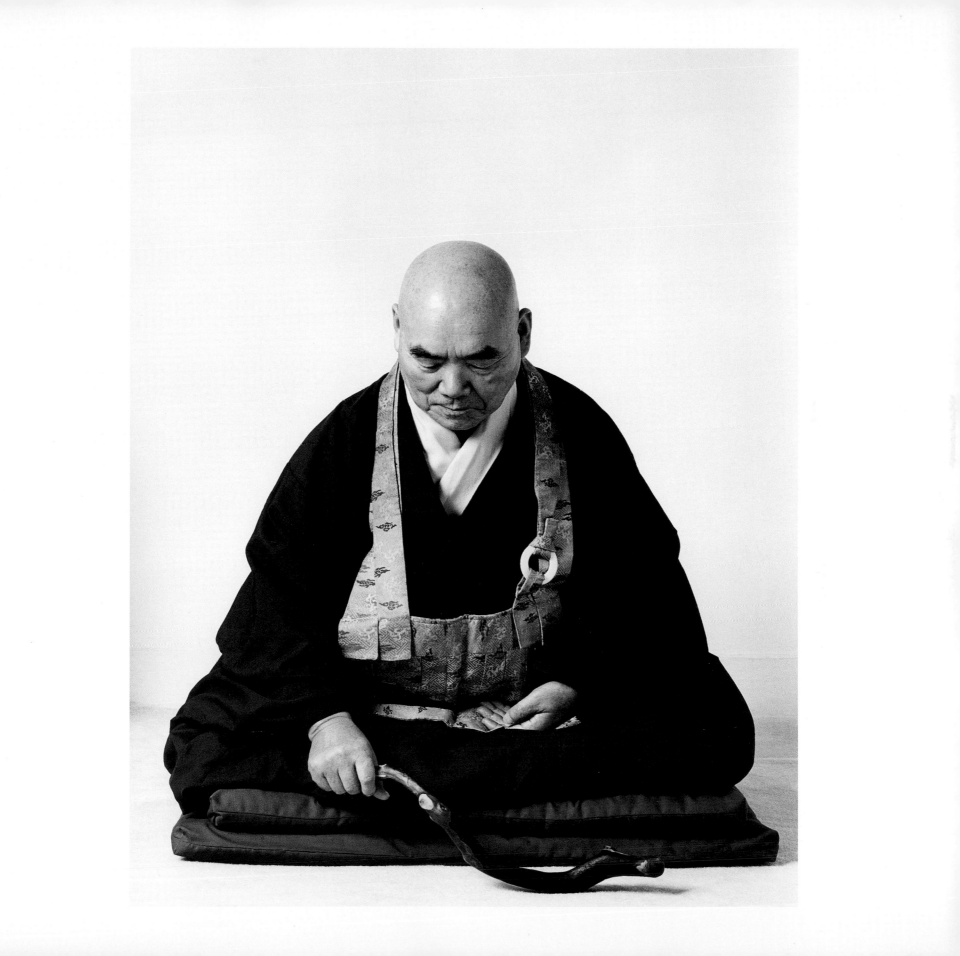

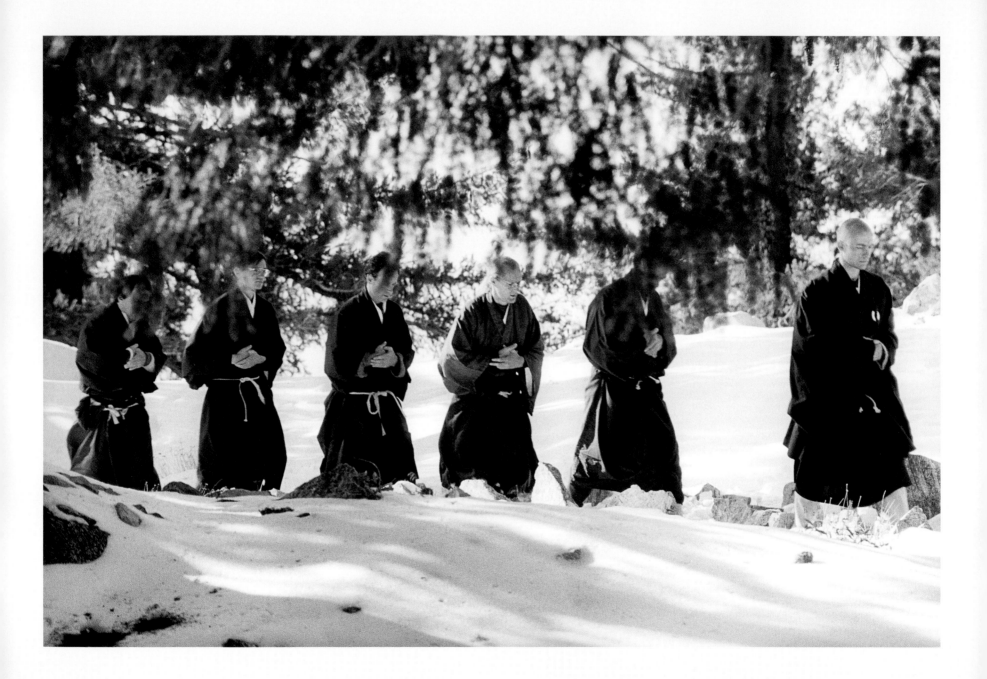

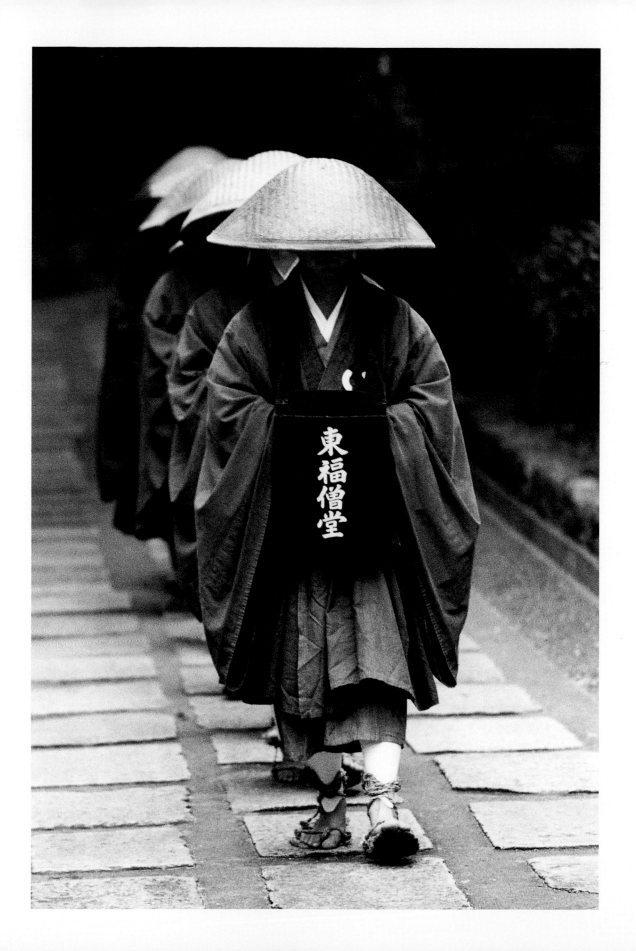

At a day-long training in Zen meditation for laypersons at a Rinzai Zen temple in Tokyo, a man requested and received a light hit on the shoulder to help him keep awake and mindful. (1991)

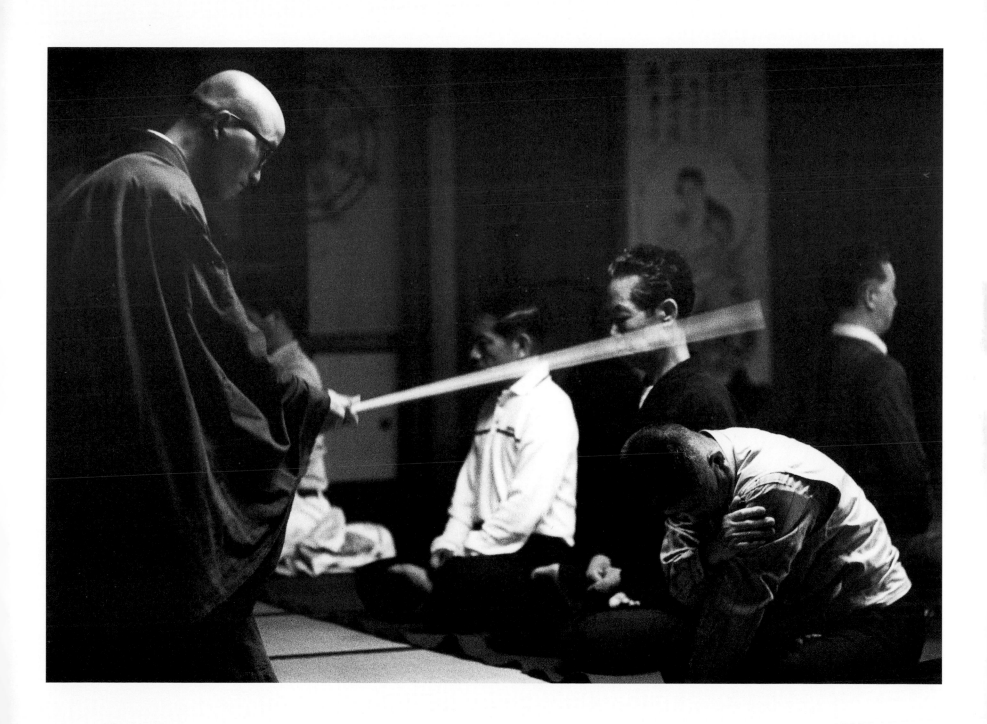

The annual Hoonko ceremony at Higashi Honganji Temple honors
Shinran, the founder of the Jodo Shinshu sect. (Kyoto, 1991)

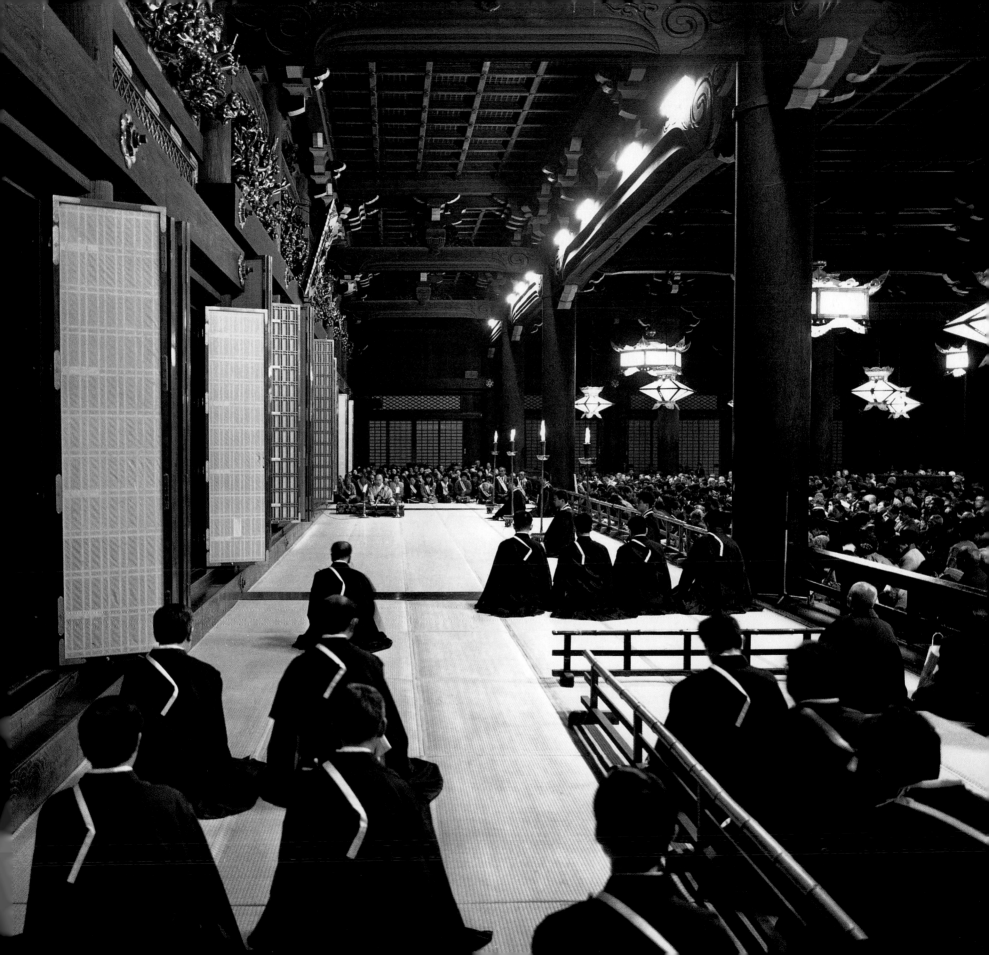

The statue of Amida Buddha, known as Daibutsu (Great Buddha), at the Jodoshu temple, Kotokuin, during "Golden Week," Kamakura, Japan, 1991

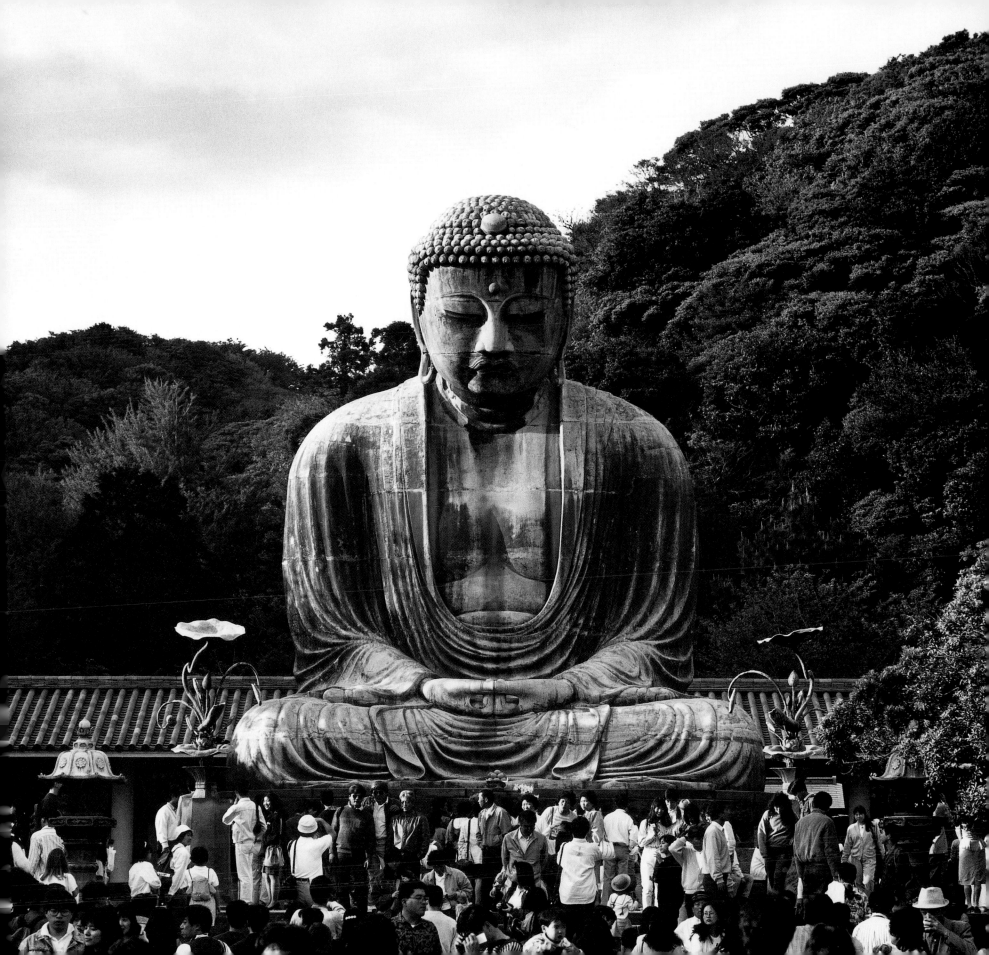

A priest of the Nichiren sect on Mount Minobu pays respect to
Mount Fuji, 1992.

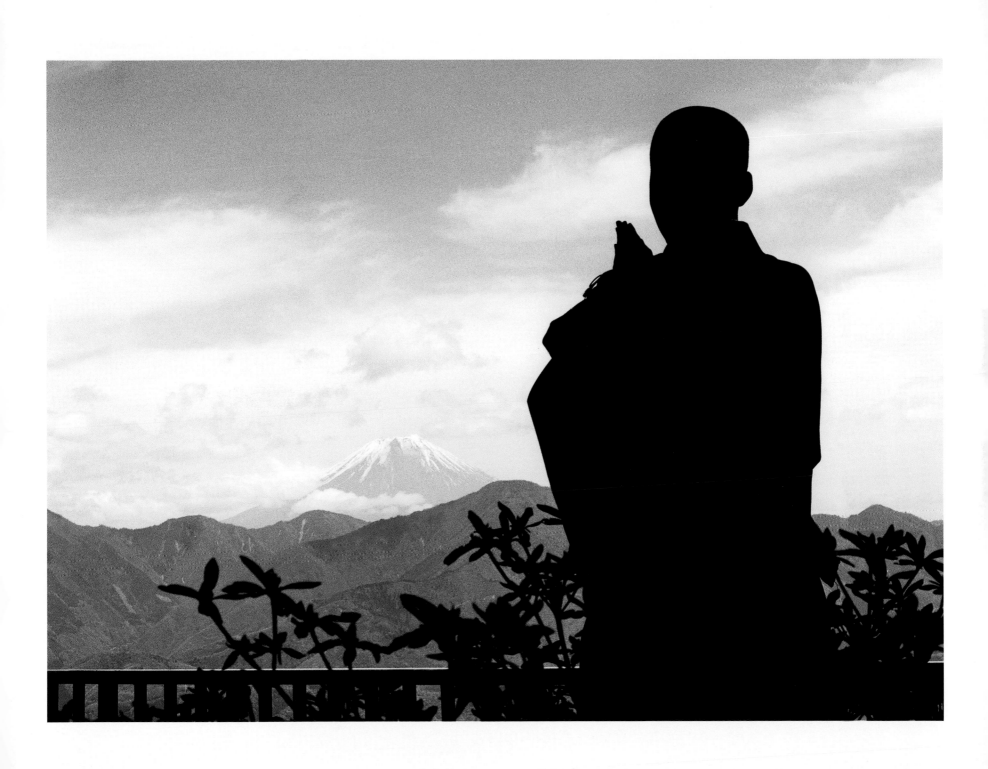

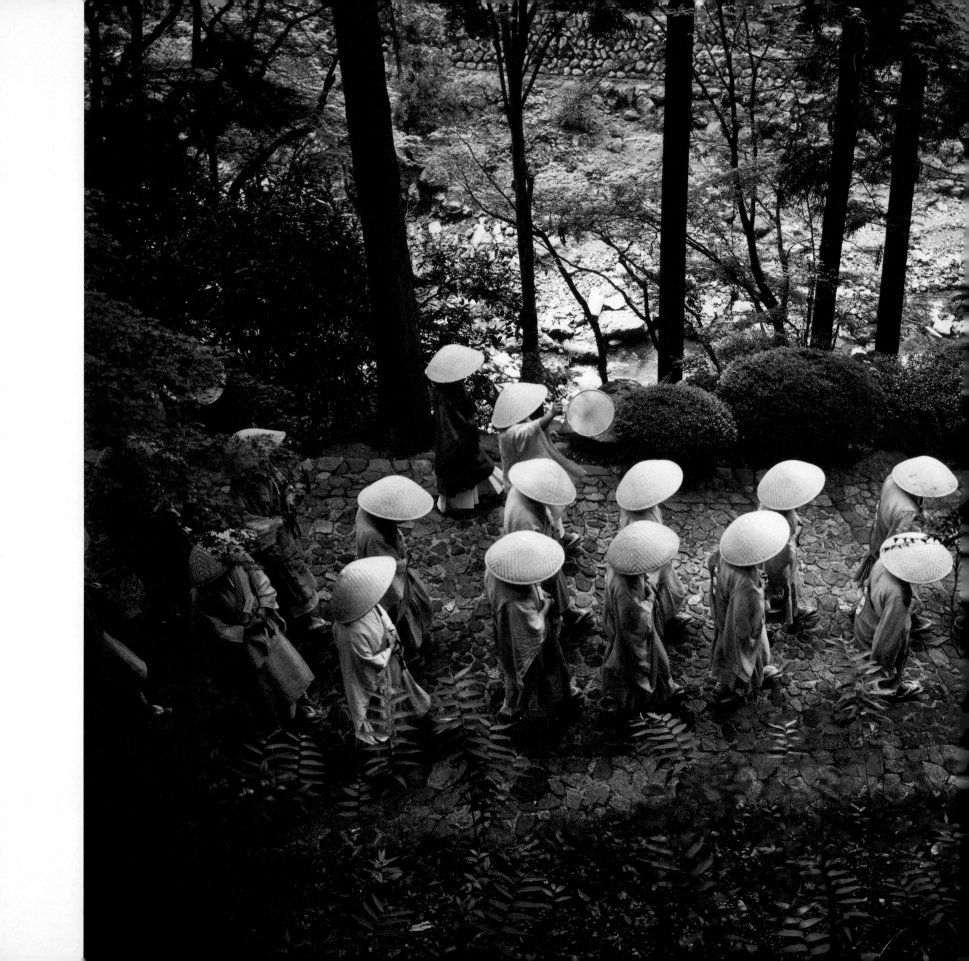

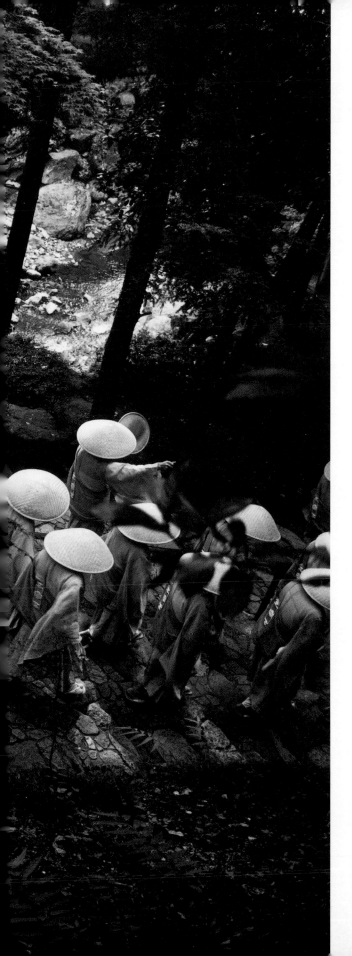

Priests in training at Minobu, headquarters for Nichiren
Buddhism, 1992

WHILE I WAS WORKING WITH THE JAPAN BUDDHIST Federation, I had the opportunity to go to Seoul, South Korea, for the 1990 World Fellowship of Buddhists Conference as part of the Japanese delegation. In addition to attending meetings and events in Seoul, we visited beautiful ancient monasteries and newer Buddhist institutions in various parts of the country. Large crowds of Buddhist devotees, many wearing their best traditional clothing, greeted the busloads of delegates wherever we went. I was very impressed by the beauty of the countryside and the hospitality of the people.

The sight of many thousands of Buddhists gathered by the waterfront in Seoul was a testament to the strength of Buddhism in South Korea. Standing on a scaffold looking out at the vast crowd of Korean Buddhists was an awesome experience. While missionaries have succeeded in making Christianity the religion of half the South Korean population today, Buddhism remains alive and well among the other half. Korean Buddhism is mostly of the Zen and Pure Land traditions, which originated in China and then spread to Korea as well as to Vietnam and Japan.

I went with a group of Japanese priests to the demilitarized zone (DMZ), where one senses the stress created by constant worry about the outbreak of war. Whichever religion the Korean people choose, a spiritual life offers a peaceful balance as an antidote to the constant anxiety. I only had a taste of this country, but I look forward to seeing much more of Buddhist life in South Korea.

Chickchi-sa Temple, Kimchon, South Korea, 1990

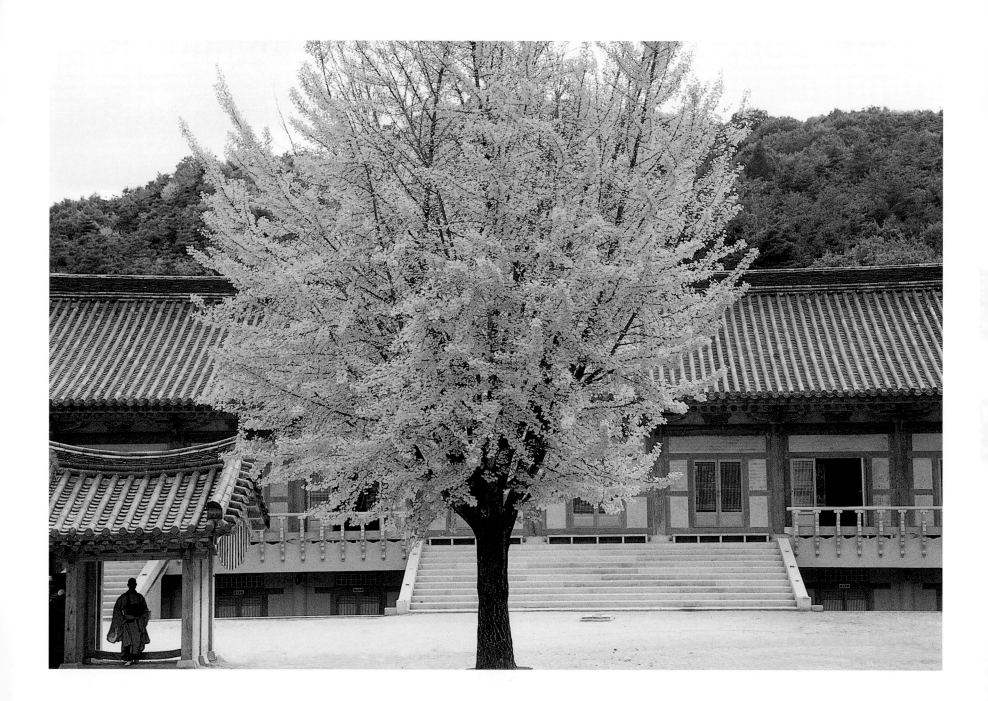

A delegate from Sri Lanka to the World Fellowship of Buddhists Conference among a group of Koreans who came to greet the delegates arriving from many countries, Seoul, 1990

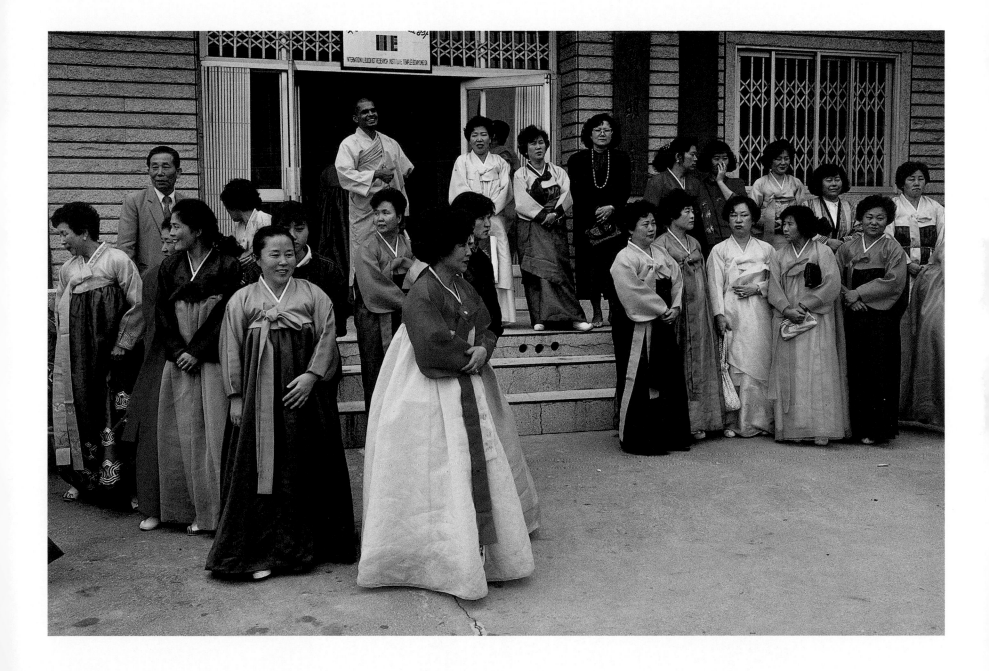

Each Buddhist country has its own traditional dances and music, which are often performed in the temples by youth groups. This dance was performed for the conference delegates by a leading professional dance group of South Korea. (Seoul, 1990)

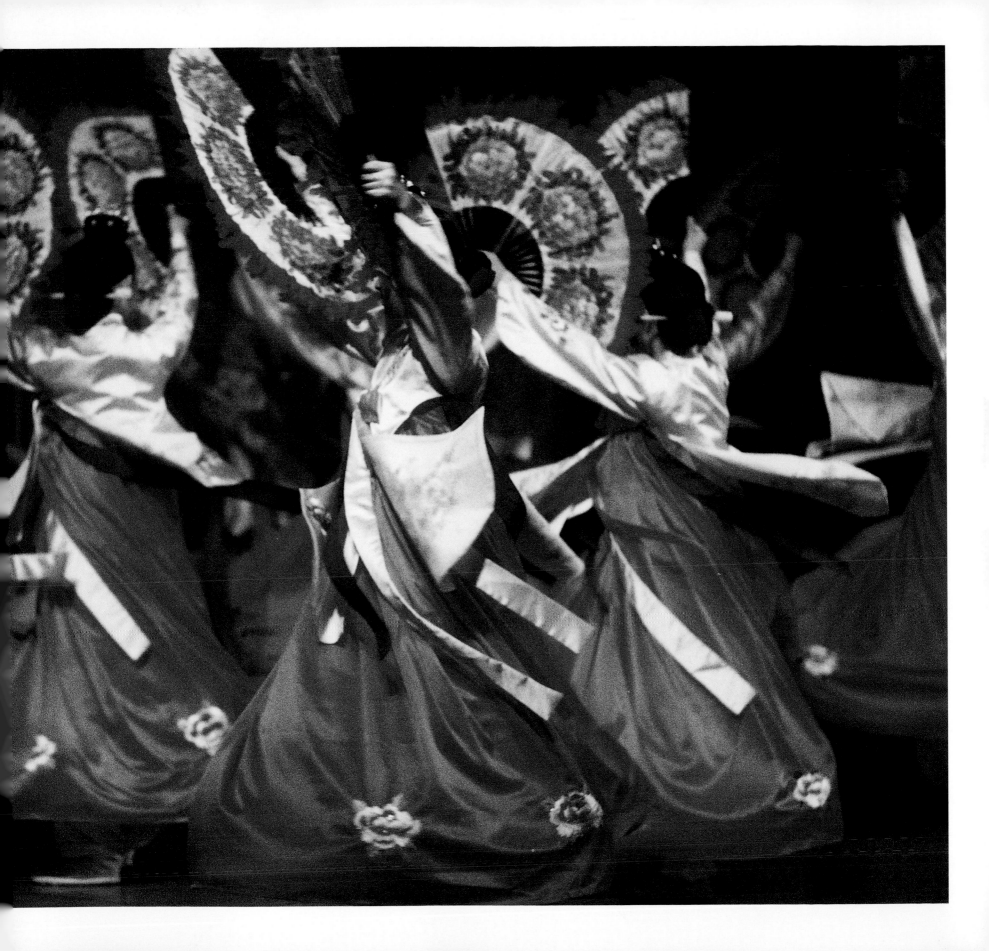

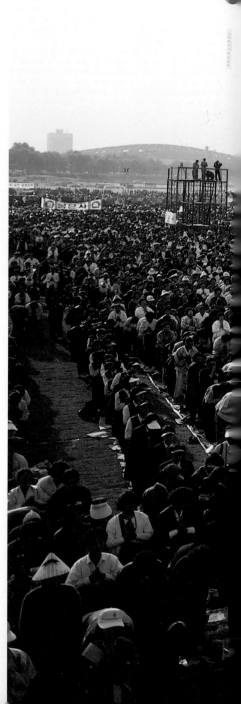

These Korean Buddhists came to celebrate Buddha's Birthday and the international gathering of the World Fellowship of Buddhists, Seoul, 1990.

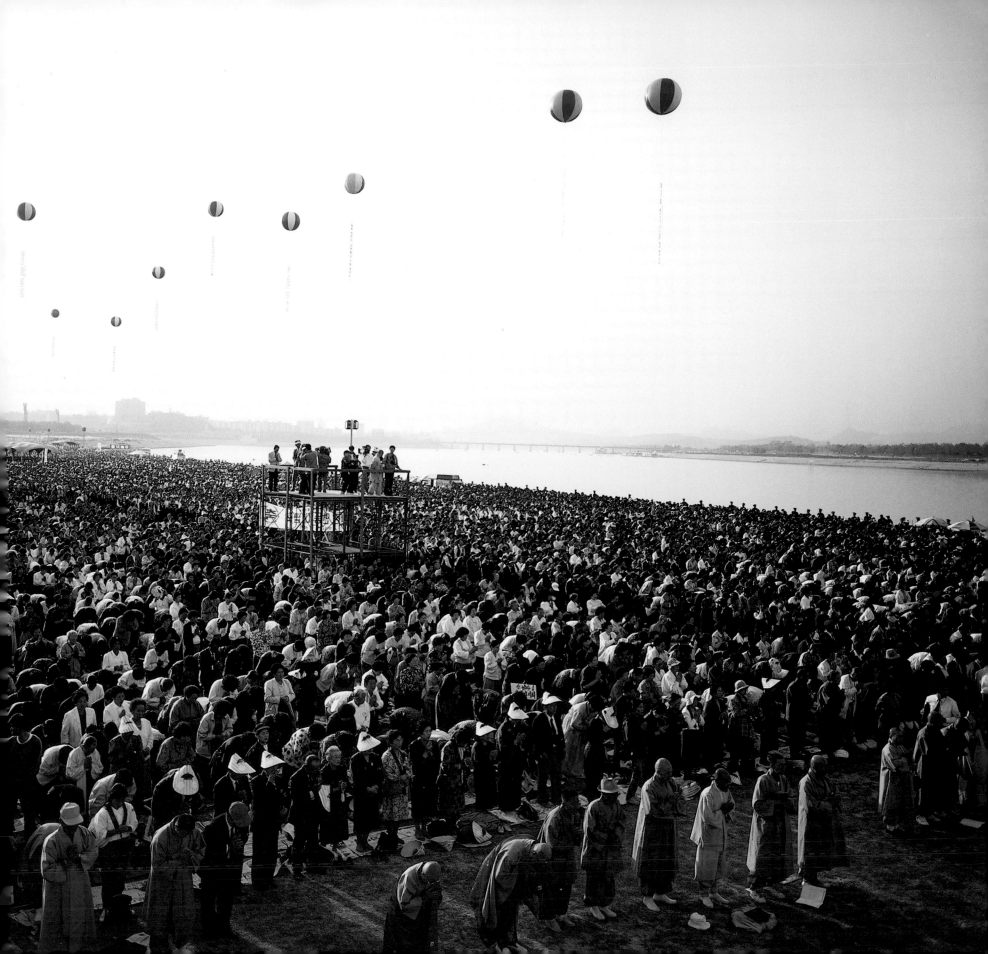

The international effort to build unity among Buddhists is active in the United States as well as in Asia. In Los Angeles, for example, on Buddha's Birthday each year, members of the Los Angeles Sangha Council gather for a ceremony and festival. In 1992 the Japanese Buddhist community hosted Buddha's Birthday activities in Little Tokyo. The chairs were set up to represent the Dharma Wheel, with each spoke representing different traditions, including those from Sri Lanka, Thailand, Vietnam, Tibet, China, Korea, and Japan. The groups all took turns circling the Buddha images and chanting in their own languages.

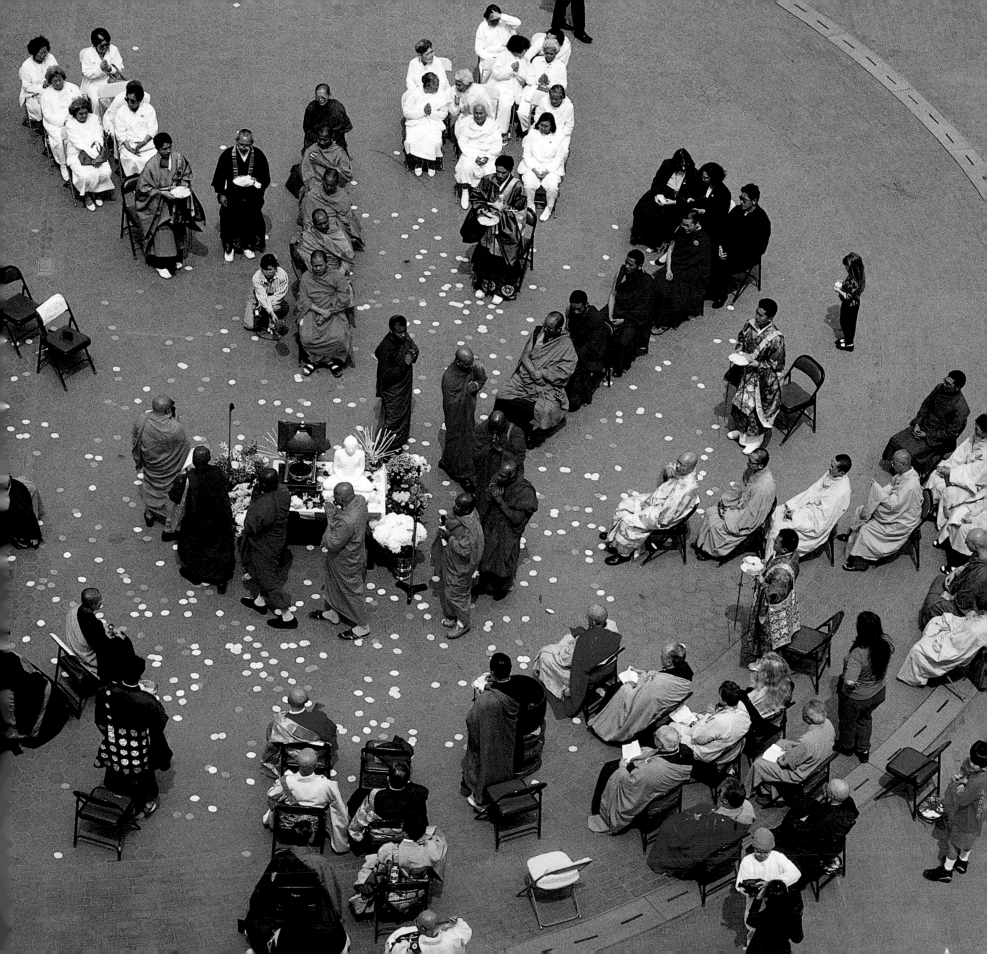

I ARRIVED AT WAT PHRA DHAMMAKAYA OUTSIDE Bangkok on an evening in 1991. I had already been there once to get an introduction to this large, vital Buddhist community. Now, my goal was to photograph the annual Makabucha ceremony. The members of Dhammakaya include lay renunciates living an austere lifestyle, free of material attachments. That night I slept as they do, on my back on a wood bed. I was awakened at about 4 A.M. Quickly pulling myself and my camera gear together, I went out to where some two thousand monks and ten thousand lay members would participate in this ceremony at dawn. The monks had already gathered on a small grass-covered hill and were sitting with their begging bowls. At a certain point they got up and walked in lines across and then down the hill to receive food from laypeople. The sun was not yet up when I photographed the monks walking.

One night I caught the overnight train from Bangkok to Nongkhai in northeastern Thailand, on the Mekong River bordering Laos. I remember feeling just great riding the train, lying in my berth with its clean sheets, listening to the rumble on the tracks, and enjoying the simple comfort and service of an efficiently run train.

From Nongkhai, I set out for Wat Ba Ban Tat, the forest monastery of the master Venerable Achan Boowa. As I traveled in northeastern Thailand, I felt that a particular quality of spirituality permeated the region. I guessed that the great Theravada meditation masters who have had forest monasteries in the area for centuries have had such a profound impact on the culture that the serenity generated from their practice, and from that of their disciples, has made the whole region feel like a temple. When I arrived at Wat Ba Ban Tat, the master was giving a

Dharma talk to laypersons in a wooden temple that had no walls. It was raised above the ground a few feet so as not to be flooded in the monsoons, and it was covered by a roof of wood and straw. Later, I watched as a monk took two halves of a coconut husk and polished the wood floor, using the husk's fibrous insides like brushes. The floor had an extraordinary silky sheen from being polished every day for fifty years.

Most of the land in Thailand has been cultivated for rice production, so it is hard to find areas of wilderness. The forest monasteries are little sanctuaries where the indigenous vegetation thrives. Every day the monks sweep the leaves off the dirt pathways, creating a sense of order but also reducing the chance of accidentally stepping on insects while walking on the path.

Every morning at dawn the monks go for alms. Laypeople stand holding bowls of hot, steaming food waiting for the monks to pass by. Silently, one by one, each monk stops and receives food in his bowl. The practice of laypeople giving food to monks is ideally an expression of *dana*—giving without any thought of getting anything in return.

I visited a temple outside Bangkok where monks and nuns on a weekend retreat were receiving instruction in *vipassana* (insight meditation). The teacher spoke slowly as the participants followed each instruction. This practice involves maintaining awareness of every subtle body movement and every thought, moment to moment, while moving extremely slowly. The mind then settles and enters a state of clarity and penetrative awareness, which can lead to insight.

Bangkok, 1989

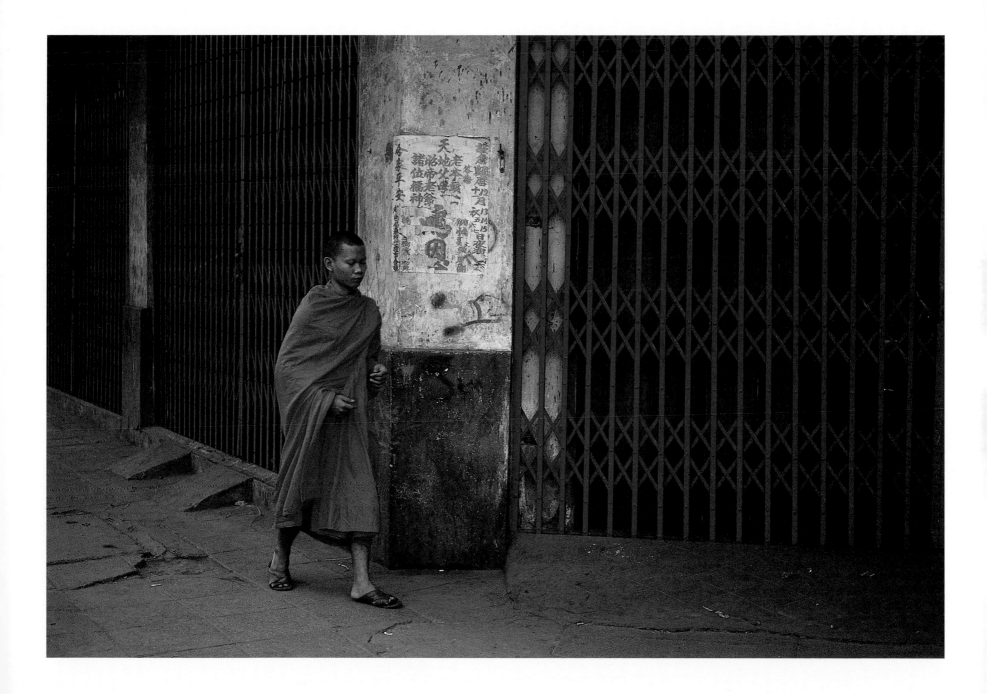

Monks going for alms during the Makabucha ceremony, commemorating the great assembly of the disciples of Buddha, Wat Phra Dhammakaya, near Bangkok, 1991

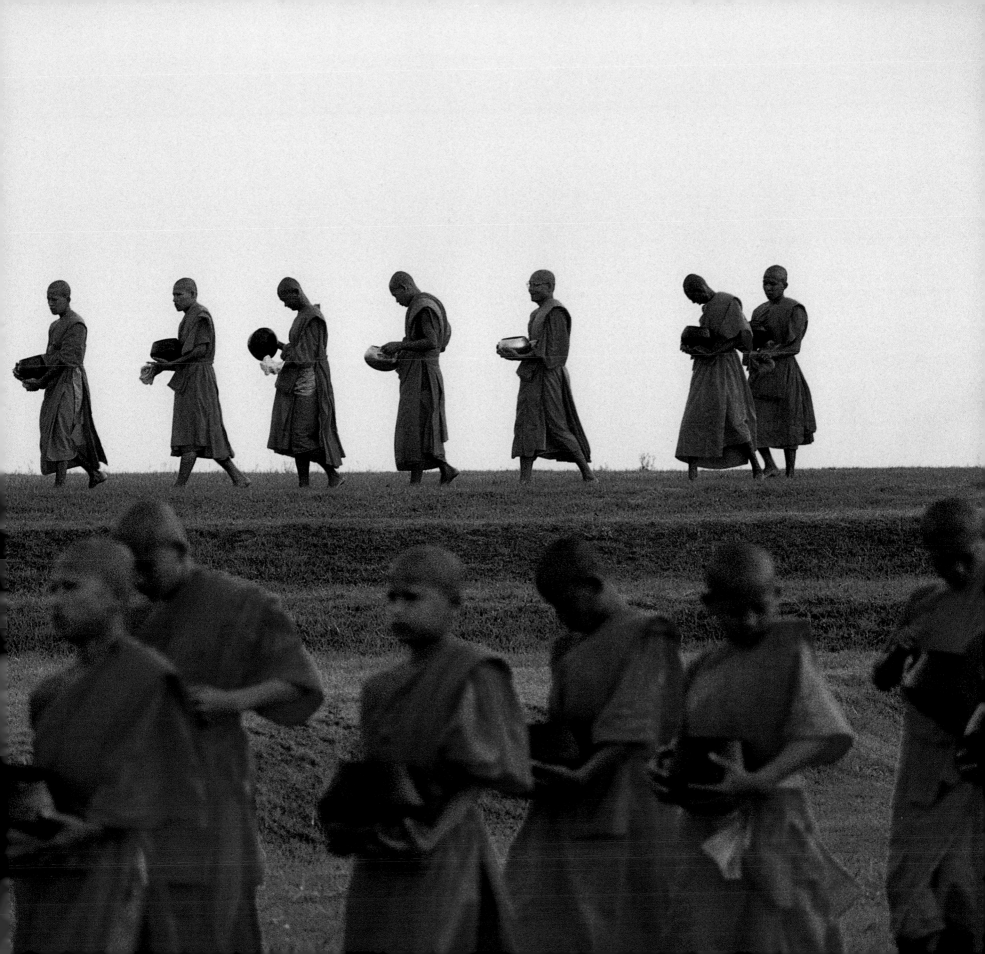

PAGES 133–135 Monks of Wat Ba Ban That forest monastery going for alms, northeastern Thailand, 1991

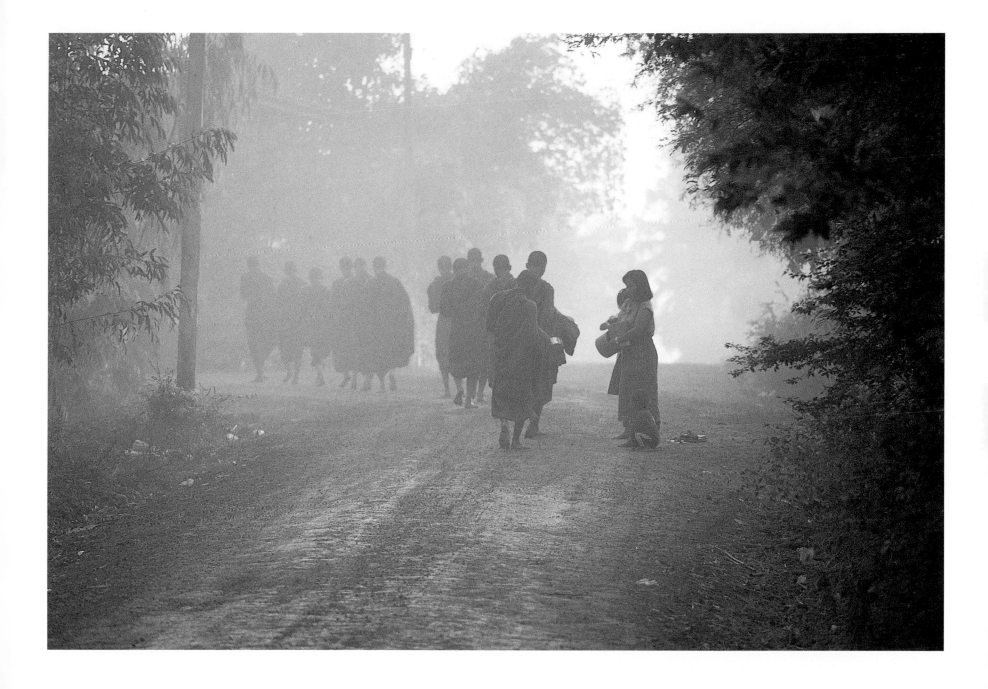

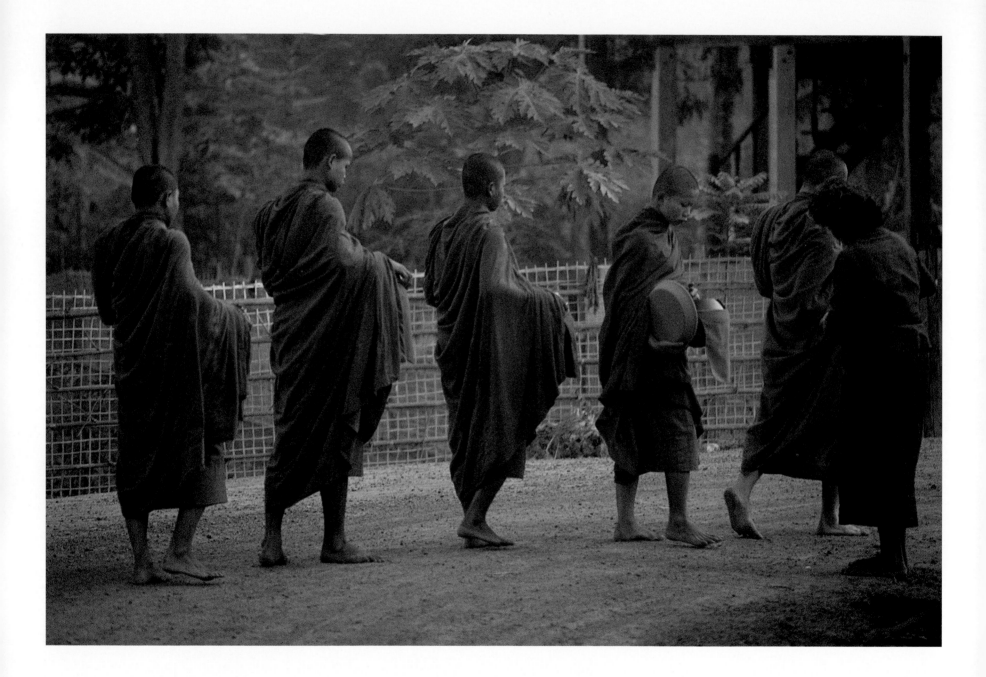

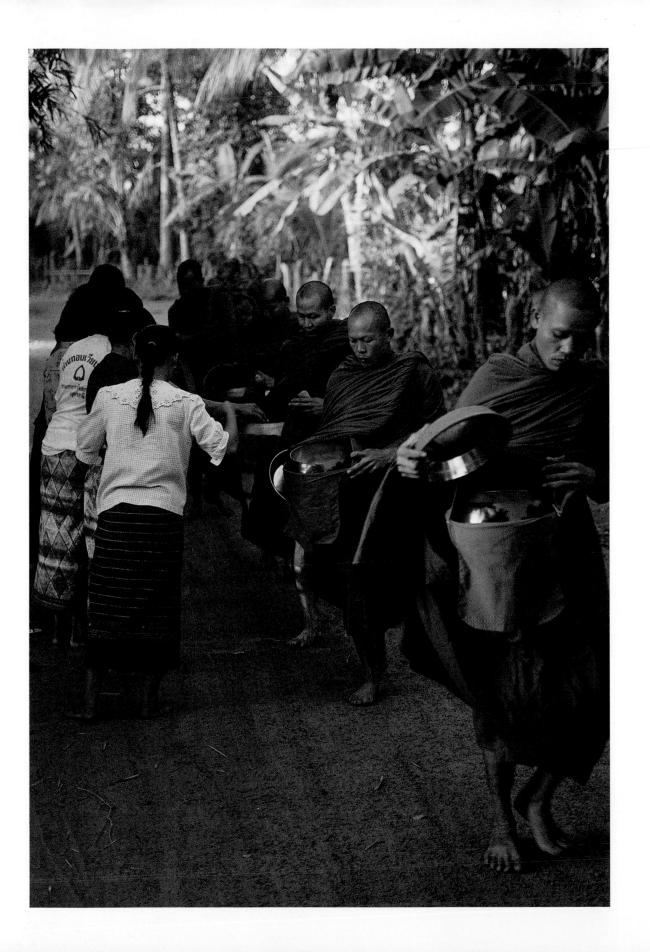

PAGE 137 A monk sweeps the pathways at Wat Ba Ban That forest monastery, Udon Thani, northeastern Thailand, 1990.

PAGE 138 Using coconut husks, a monk polishes the floor of the temple (which has no walls) at Wat Ba Ban That forest monastery, 1990.

PAGE 139 Monks receive training in the practice of *vipassana* at a temple outside Bangkok, 1991.

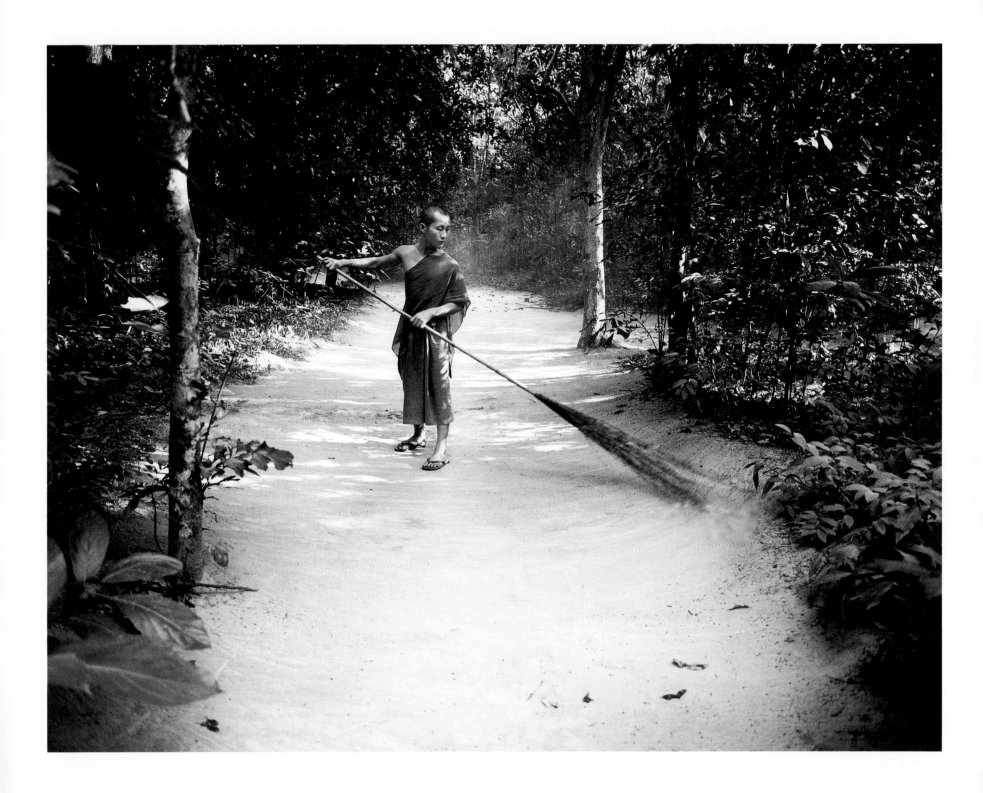

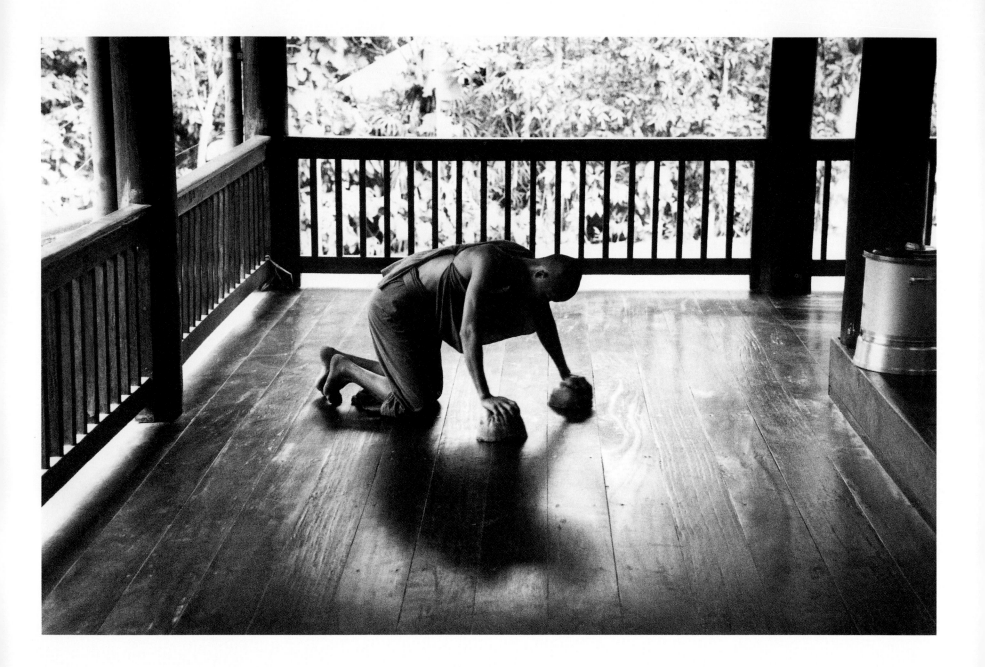

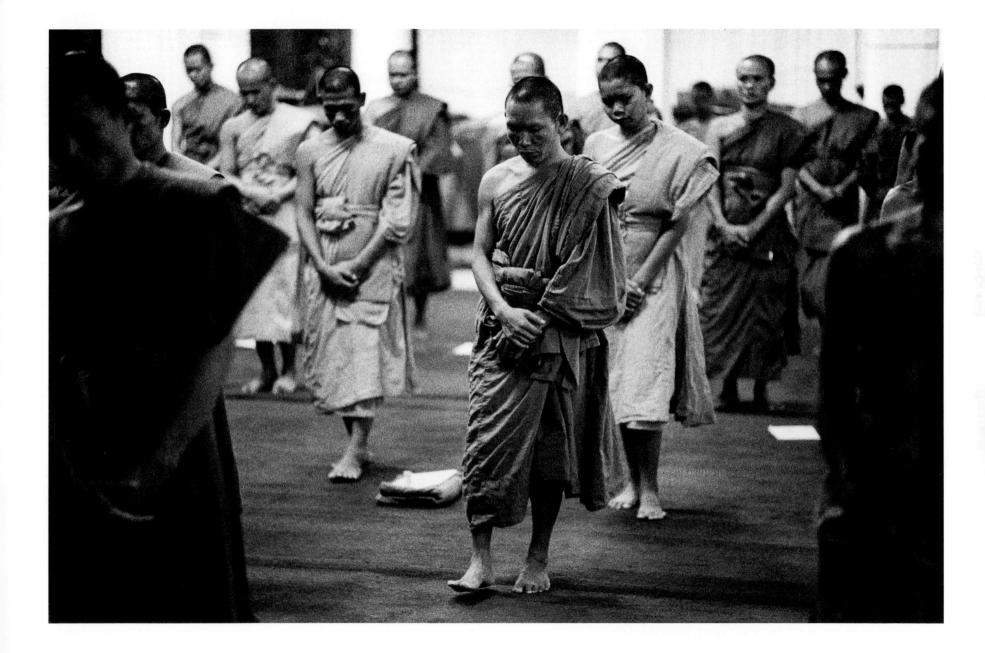

Loy Krathong Festival in the ancient city of Sukhothai, Thailand, 1990

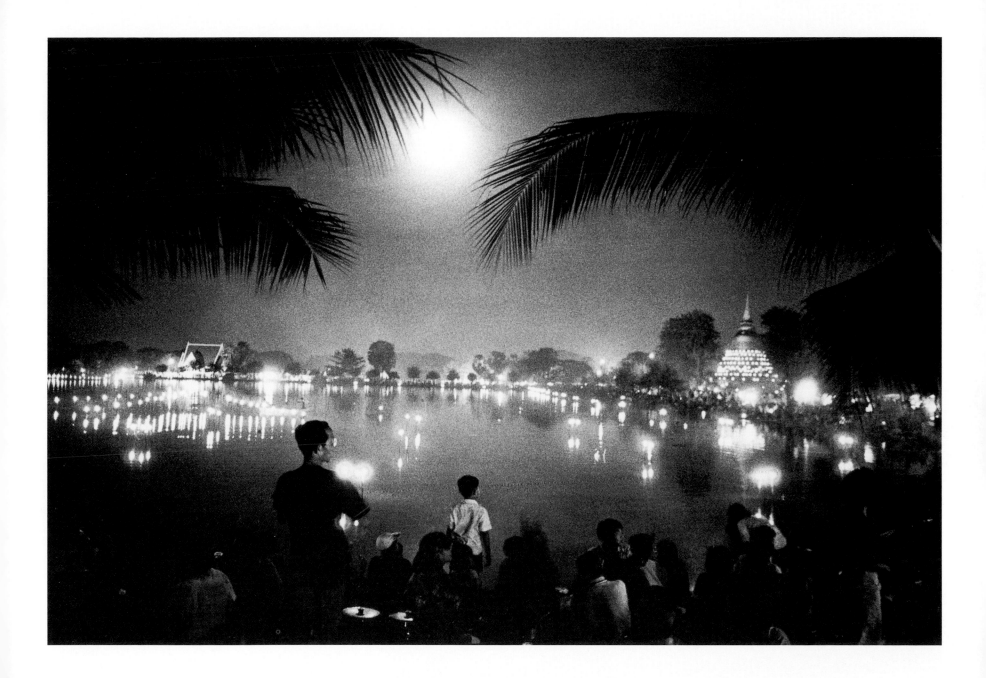

WHEN I SPOKE WITH MY THAI FRIENDS, THEY WOULD tell me about the great master Venerable Buddhadāsa Bhikkhu, who lived in a forest monastery in the south of Thailand. By the great respect they expressed for him, I knew he was someone I needed to photograph. Before going I read his book, *Handbook for Mankind,* in which he shares his philosophy, including his commitment to maintaining ecological balance. When he was young, Buddhadāsa lived at a monastery in Bangkok, but he was frustrated by the corrupt influences in the city and their effect on monastic life. In 1932 he left for southern Thailand, where he established Wat Suan Mokkh forest monastery.

When I arrived there, he was in a chair, with chickens surrounding him and sitting on his lap. Laypeople came and knelt before him, holding their hands together as they spoke to him.

I was provided with a hut to sleep in during the four days I stayed at the monastery. One morning I was outside the hut, washing my clothes in a bucket with some laundry soap from a little packet. I poured the soapy water into a drainage ditch covered by a large flat stone. Suddenly, from under the stone, a frog popped out and stared up at me. It looked like Buddhadāsa! It was as if the frog were admonishing me for so carelessly dumping chemicals on him, an esteemed member of the monastery. All life forms in the monastery were treated with great respect, and I sure got told off by that frog! Protecting the natural environment and avoiding harming living beings are an important part of Buddhist practice.

Buddhadāsa sat each day, blending listening to the BBC news on the shortwave with reading, writing, and moments of meditation. He allowed me to hover around him, photographing him with no words spoken between us. Laypeople came by now and again, and he gave teachings to them and to the nuns. I felt close to him, as if he were my grandfather. Like all the forest monasteries I visited, this was a remarkable, harmonious community, where the master and his disciples created ideal conditions for spiritual practice.

PAGE 143 Nuns listening to Venerable Buddhadāsa Bhikkhu giving teachings, at Wat Suan Mokkh forest monastery, Surat Thani, Thailand, 1990

PAGES 144–145 Buddhadāsa Bhikkhu, Wat Suan Mokkh, 1990

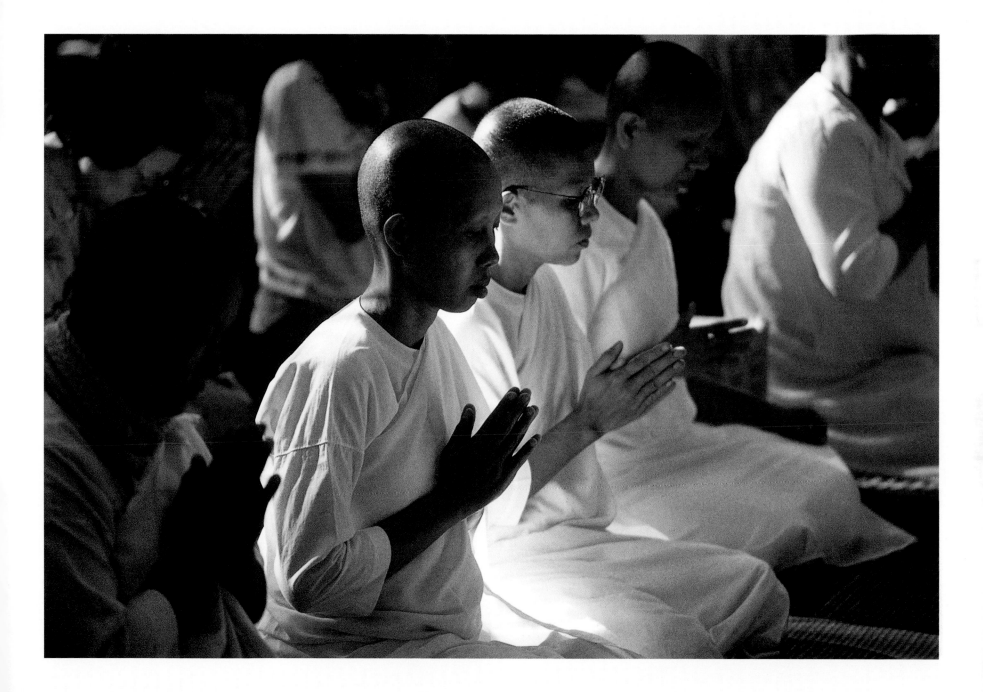

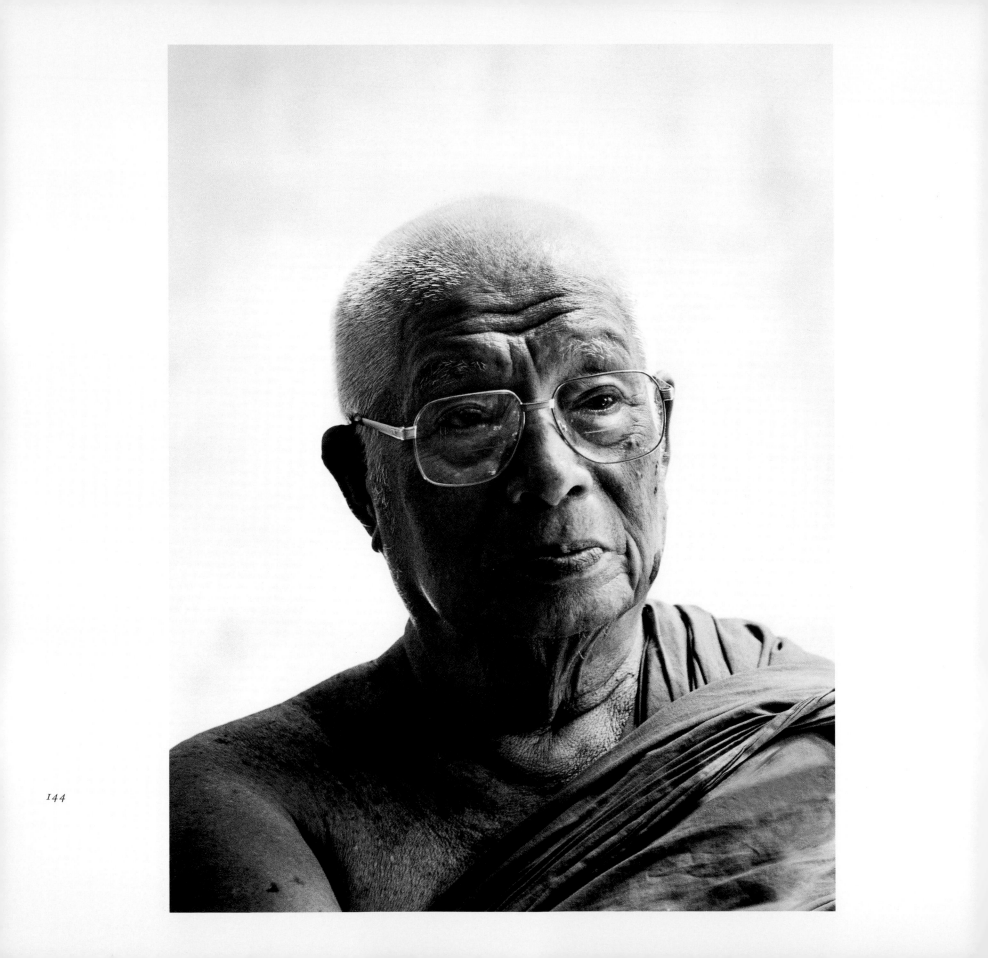

144

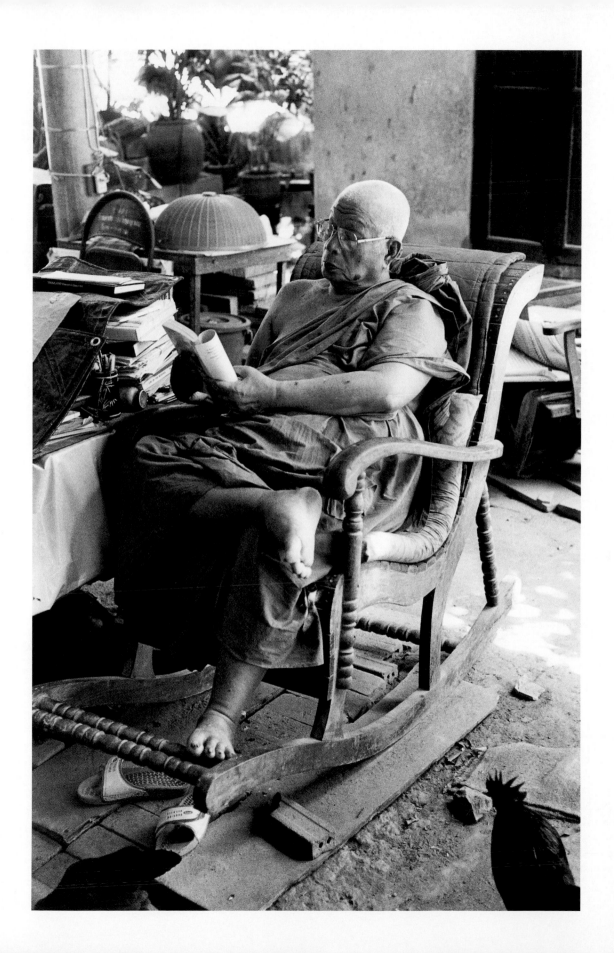

145

A monk sweeping leaves, Wat Suan Mokkh, 1990

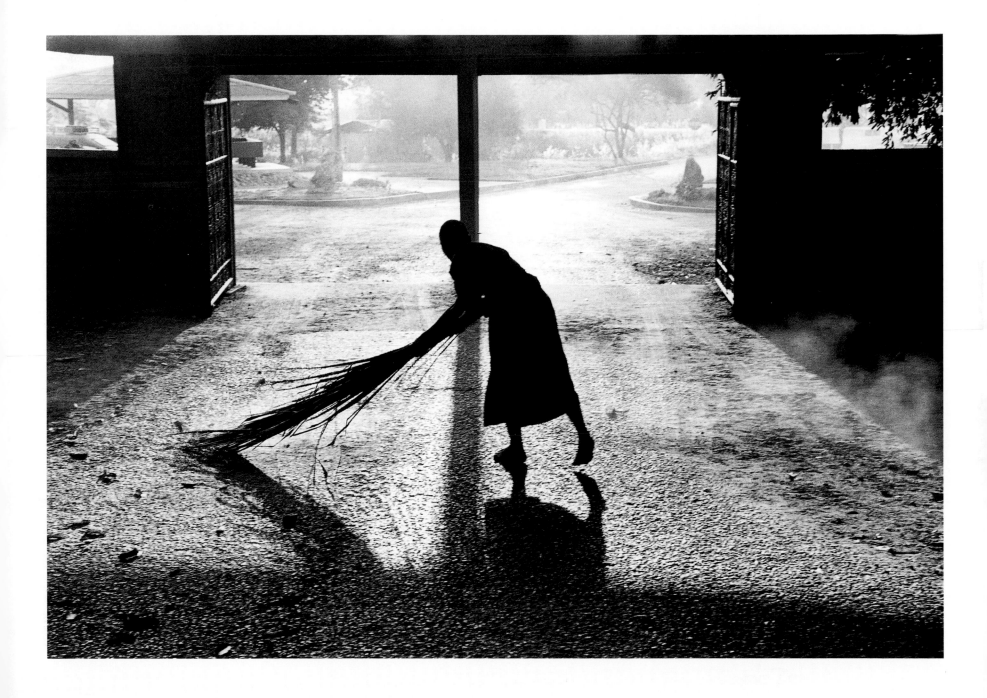

In 1966 Venerable Master Cheng Yen, a Buddhist nun living in Hualien, Taiwan, entered a hospital to visit a sick friend and saw a pool of blood on the floor by the front entrance. She was deeply saddened to learn that an aboriginal Taiwanese woman who had suffered a miscarriage was turned away from the hospital because she did not have enough money for a deposit. She immediately resolved to build a modern hospital where no one would be turned away. That same year she founded the Tzu Chi (Compassionate Relief) Foundation, and in 1986 the first Tzu Chi Buddhist Hospital was built. Master Cheng Yen has inspired over five million people to follow her example of great compassion and to volunteer to help those in need, including providing disaster relief and free medical care internationally. (Hualien, Taiwan, 1993)

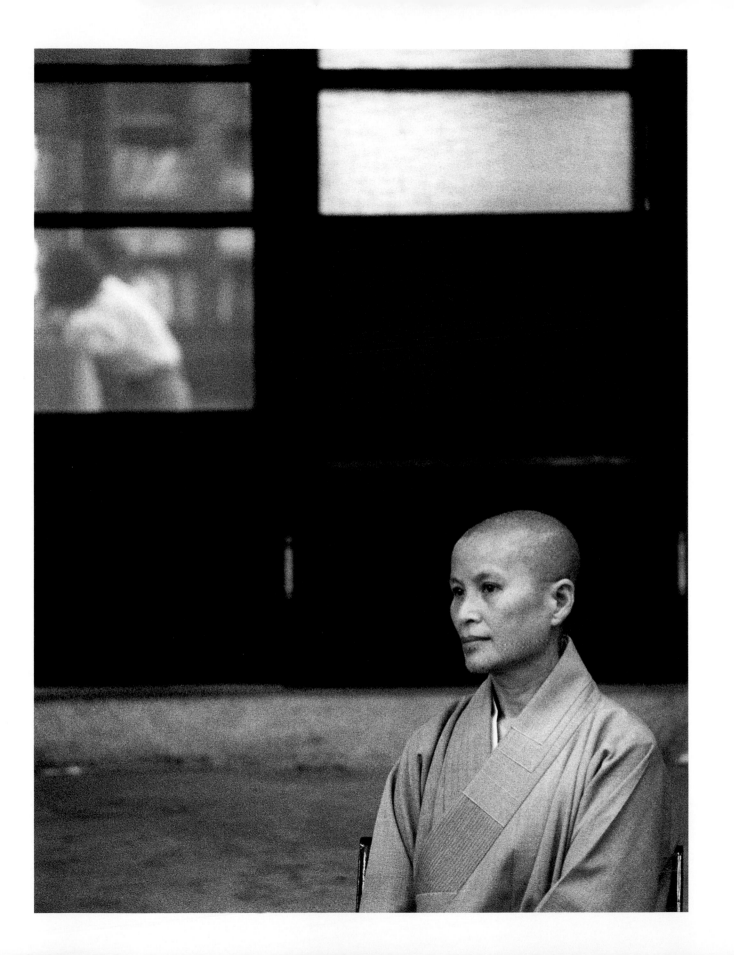

Venerable Master Hsin Tao, who is Burmese of Chinese descent, was orphaned as a young child. After fighting as a child soldier in Burma and then going with the retreating army to Taiwan, he was eventually inspired to become a monk. He lived for years in solitary retreat, including in a cave on a mountain overlooking the north coast of Taiwan. After he had completed his retreat, Ling-Jiou Mountain Monastery was built at the site of the cave. Committed to the promotion of religious tolerance and understanding, he and his many disciples established the Museum of World Religions, which opened in 2001 near Taipei. (New York City, 1997)

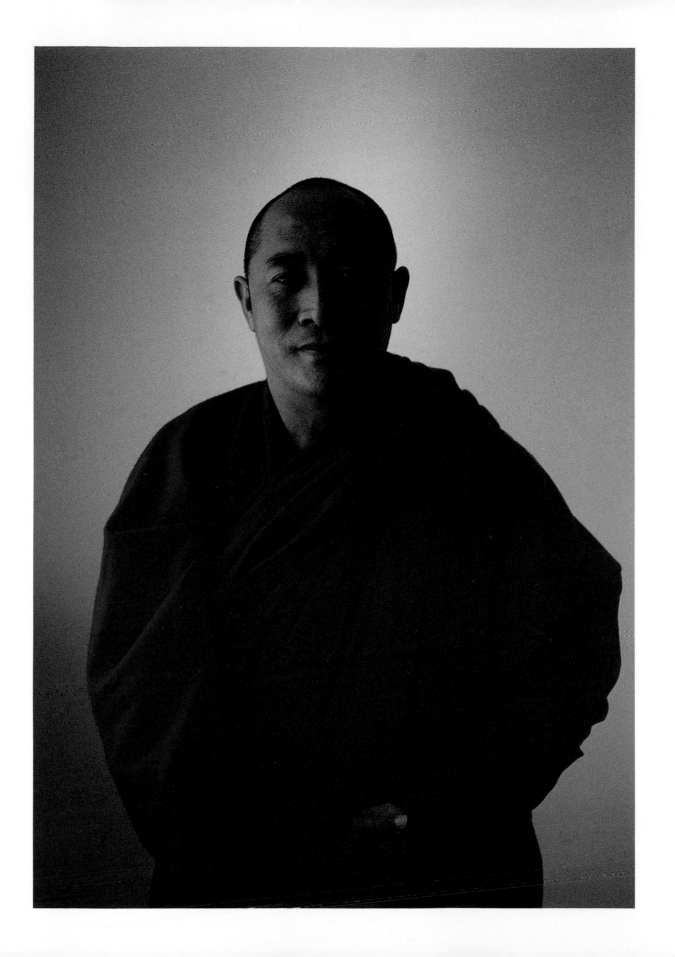

PAGE 153 Venerable Master Miao Lien became a monk in 1930 at age nine and received his training at some of China's most important monasteries. The founder of Ling Yen Shan Temple in Puli, Taiwan, he is one of the most accomplished and respected masters of the Pure Land school. Since most of the Buddhist monasteries in China were destroyed and their masters imprisoned under Communism, those masters who found sanctuary—mainly in Hong Kong and Taiwan—have played a critical role in preserving Chinese Buddhism. (Monterey Park, California, 1993)

PAGES 154–155 At Ling Yen Shan, Venerable Master Miao Lien has continued a tradition of training monks from an early age, thereby establishing a solid foundation in the monastic practice. (Puli, Taiwan, 1993)

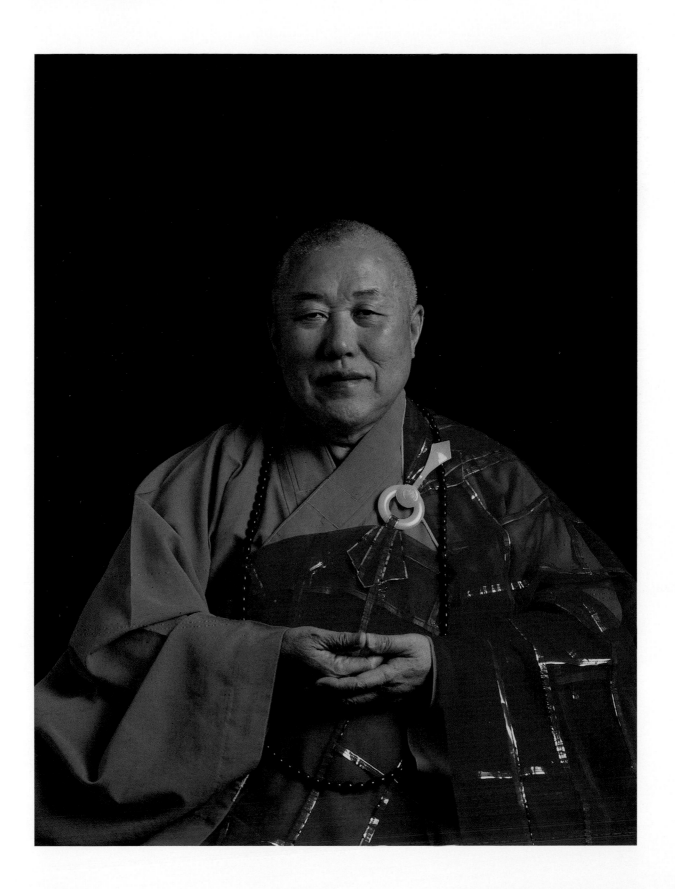

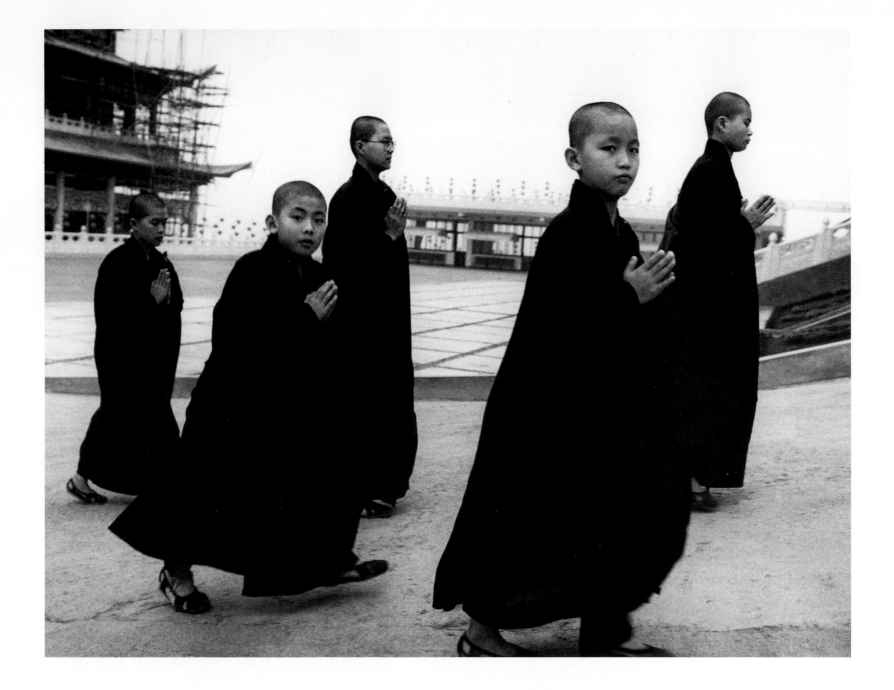

The Vietnamese Zen master Venerable Thich Nhat Hanh was a leading peace activist during the Vietnam War and was nominated for the Nobel Peace Prize by Martin Luther King Jr. Based in the south of France at the Plum Village community, he has written more than seventy-five books and leads retreats internationally. Thich Nhat Hanh inspires his many students—Vietnamese and Westerners alike—to practice mindfulness moment to moment, generating peace and compassion in society through "engaged Buddhism." (Malibu, California, 1994)

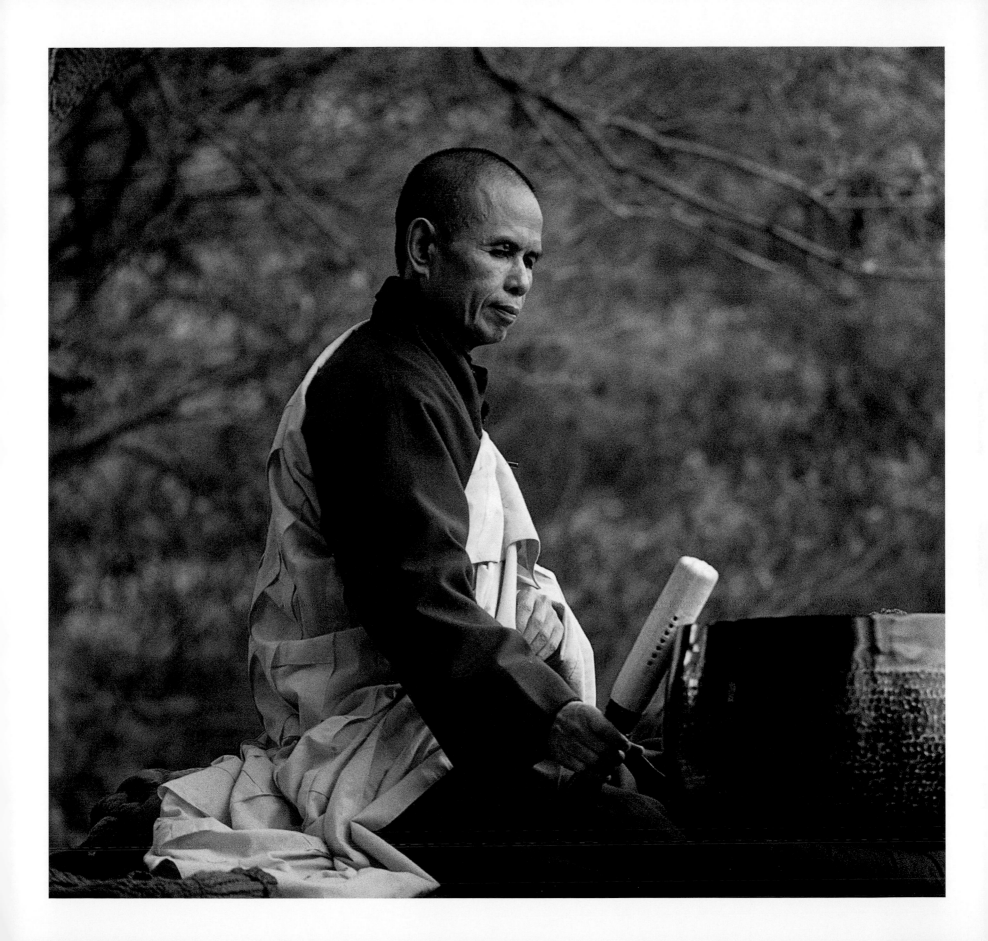

Venerable Dr. Havanpola Ratanasara, a Buddhist monk and scholar from Sri Lanka, earned a master's from Columbia University and a Ph.D. in education from the University of London. A renowned Buddhist scholar and educator in his home country, he moved to Los Angeles in 1980 and in following years helped found the American Buddhist Congress, the Buddhist Sangha Council of Southern California, and the College of Buddhist Studies. His enthusiasm and dedication to building unity among the many Buddhist traditions represented in America, as well as to promoting cooperation between Buddhists and those of other faiths, won him many admirers. (Los Angeles, 1994)

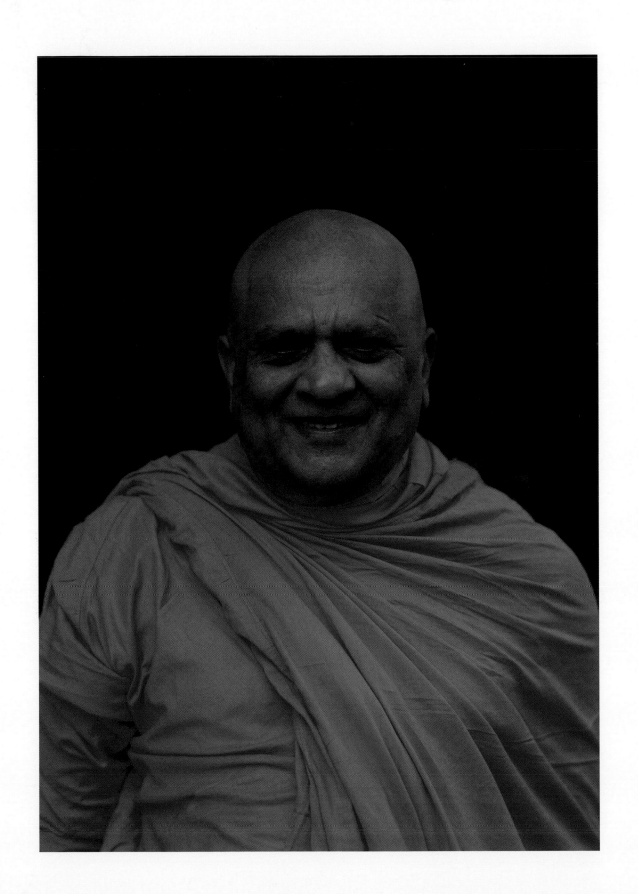

Venerable Maha Ghosananda's parents and siblings were killed by the Khmer Rouge, yet he did not lose his great compassion. While nearly every Buddhist monk in Cambodia was being executed, his master advised him to stay in the forest. He reemerged in 1978, after the fall of the Pol Pot regime, and began leading peace marches through the countryside. He also set up Buddhist temples in refugee camps on the Thai border. As he walked among the refugees, most of whom were Khmer Rouge families, he would bow to each one and offer a piece of paper with the teaching of the Buddha: "Hatred is not overcome by hatred; hatred is overcome by love. This is a law eternal." His efforts to bring healing to his country, including tree planting and protection of the forests, earned him a nomination for the Nobel Peace Prize in 1994. He serves as the Supreme Patriarch for Cambodian Buddhism. (New Delhi, 1997)

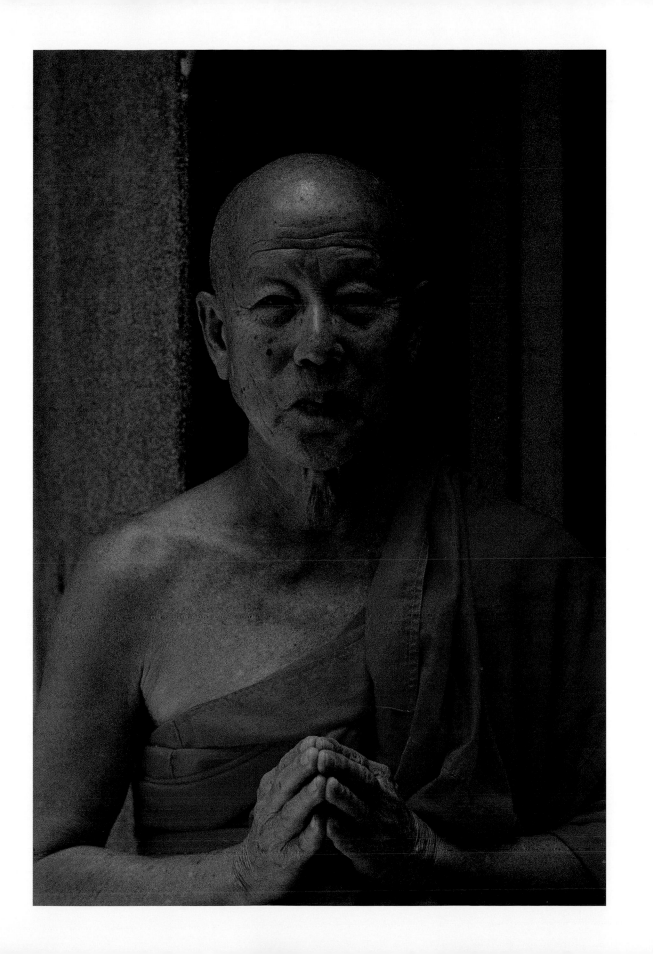

Borobudur, Java, Indonesia, 1993

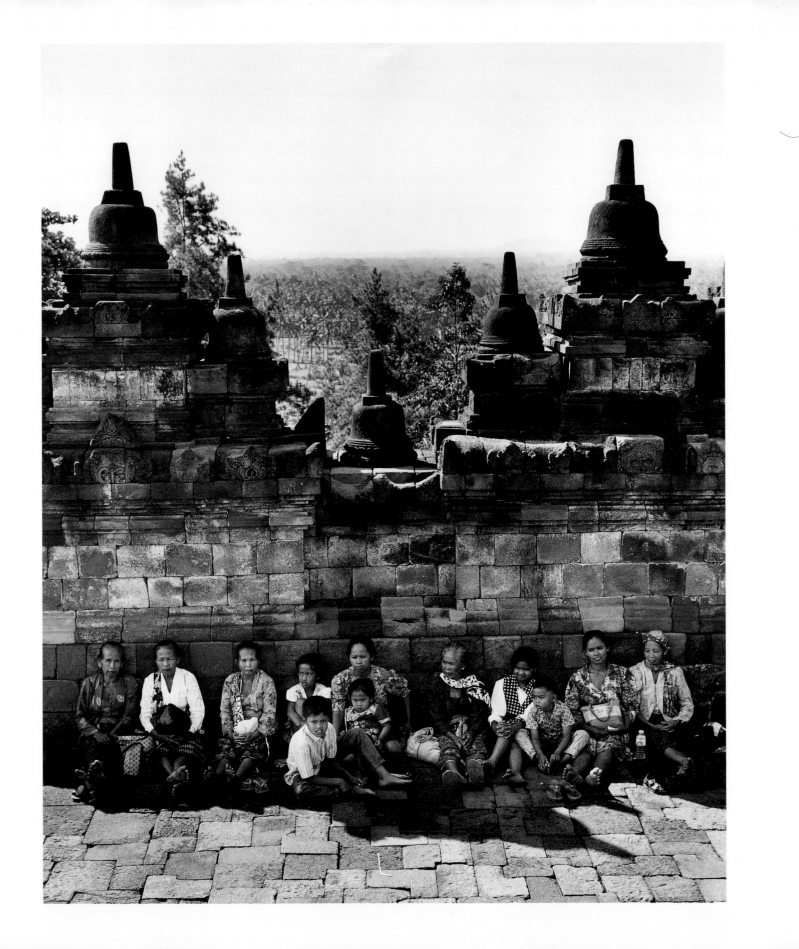

THROUGH MY INVOLVEMENT WITH TIBETAN BUDDHISM and my friendships with Tibetans in Los Angeles, I met my wife, Yeshi, who is Tibetan. She wanted to go back to India to spend time with her mother and brother in the Tibetan refugee settlement where they lived in Himachal Pradesh. I thought it would be a good opportunity to photograph Tibetan Buddhist life in India, so I applied (successfully) for a Fulbright grant. Our daughter, Tsering Palmo, was just fifteen months old when we left for India in December 1996. After three years apart, it was an emotional reunion for my wife and her mother (Lhaga) and her brother (Lhundup), especially since her father had died in India while she was in California.

After a few days to settle in the village, I left with Lhundup to photograph His Holiness the Dalai Lama giving the Kalachakra Initiation near Siliguri. Then we followed His Holiness to Venerable Bokar Rinpoche's monastery in Mirik, which is near Darjeeling. From there, we went to Bodhgaya, where the Buddha attained enlightenment and where the Nyingma Monlam, a major gathering of the Nyingma lineage of Tibetan Buddhism, was being held. Bodhgaya is in Bihar, the poorest state of India. Although I could appreciate the spirituality of Bodhgaya, the extreme poverty was painful to see, especially outside the Mahabodhi Temple, where Indians suffering from leprosy lined up to beg for donations. From Bodhgaya we went to Sarnath, where the Buddha gave his first teachings, the Four Noble Truths. Seeing the sunrise at the ancient monument and ruins was awe-inspiring.

Our next trip was to the Tibetan settlements in the south of India. In Bylakuppe, which is near Mysore, we stayed in His Holiness Penor Rinpoche's monastery, where it was inspiring to see elderly Tibetans living and doing their practice together. Also in Bylakuppe, we went to Sera Monastery, where we observed some lively debates. From there we journeyed to Mundgod, where I photographed at the Jangchub Choeling Nunnery, Drepung Loseling Monastery, and Ganden Shartse Monastery, the home temple of my teacher Geshe Gyeltsen.

On the next trip my wife and daughter joined me for a three-week stay in Kathmandu, Nepal. I concentrated on photographing around the Bodhnath Stupa. We then went to Sikkim, where we stayed at Rumtek Monastery, the main temple of His Holiness the Sixteenth Karmapa, and I photographed the lama dances during Tsechu, a festival dedicated to Padmasambhava. We then returned to our village.

Lhundup and I made several more trips, including ones to Ladakh and to monasteries near Dehra Dun. Wherever we traveled, Lhundup ran into friends he had gone to school with who were "selling sweaters" in little Tibetan bazaars. With all the connections to friends, relatives, and Buddhist masters, we seemed to jump from one stepping stone to another.

PAGE 165 Sarnath, the place where the Buddha gave his first teachings, near Varanasi, India, 1997

PAGE 166 Nepalese Buddhists circumambulating Bodhnath Stupa, Kathmandu, Nepal, 1997

PAGE 167 A Tibetan monk feeding birds, Bodhnath Stupa, Kathmandu, Nepal, 1997

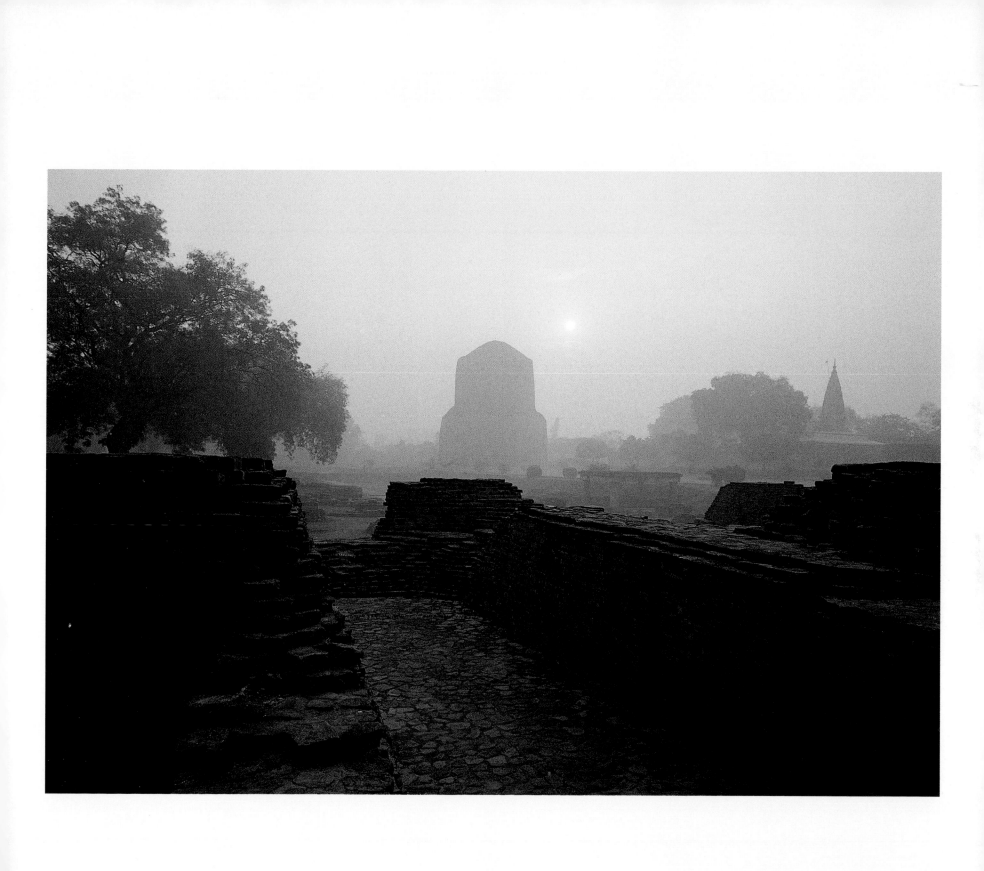

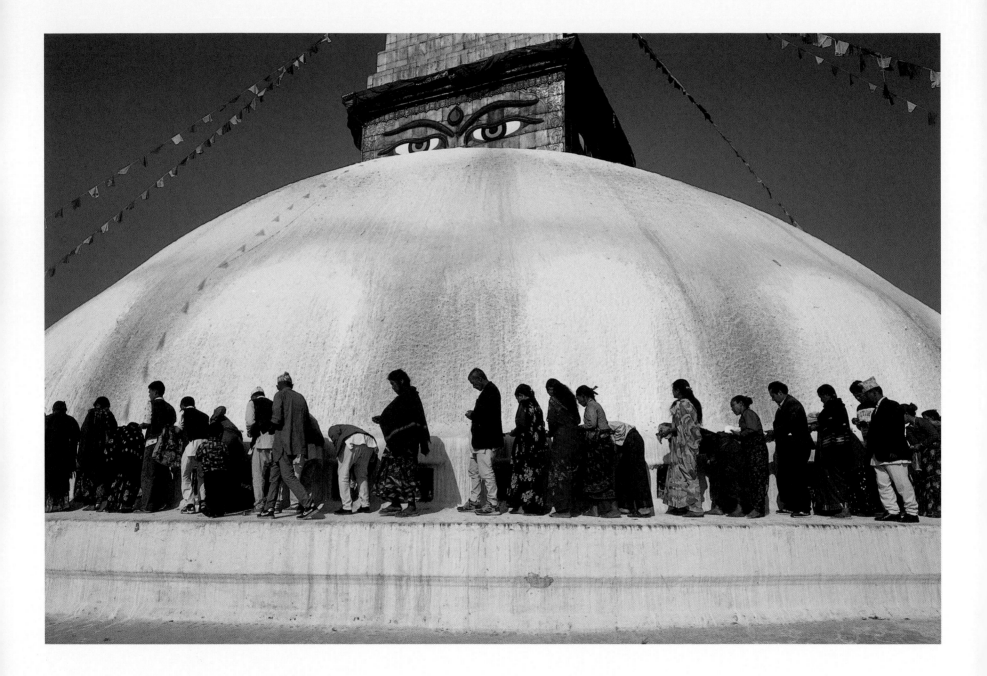

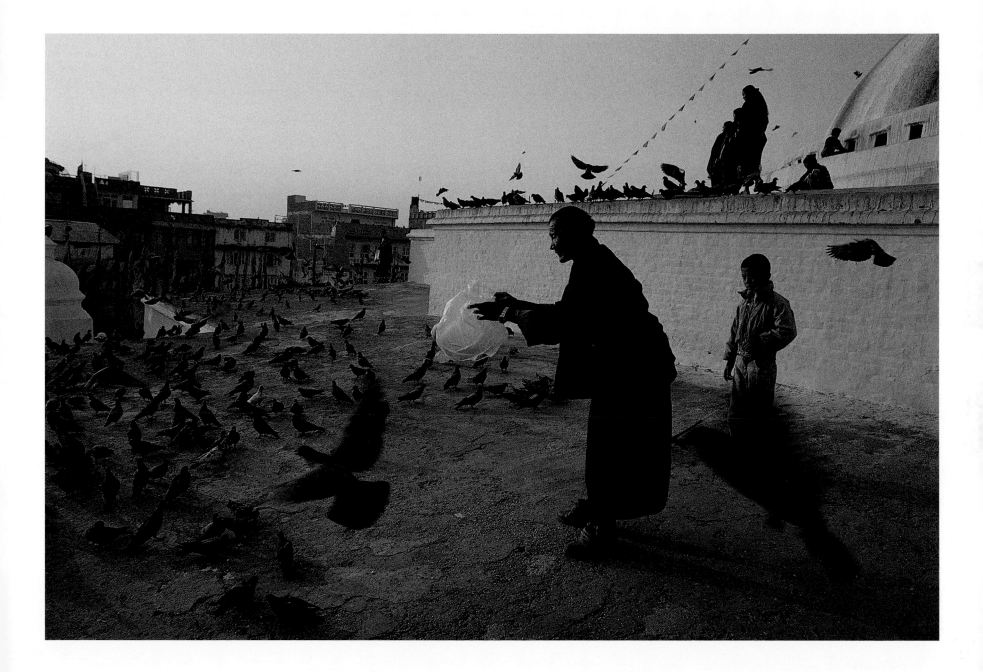

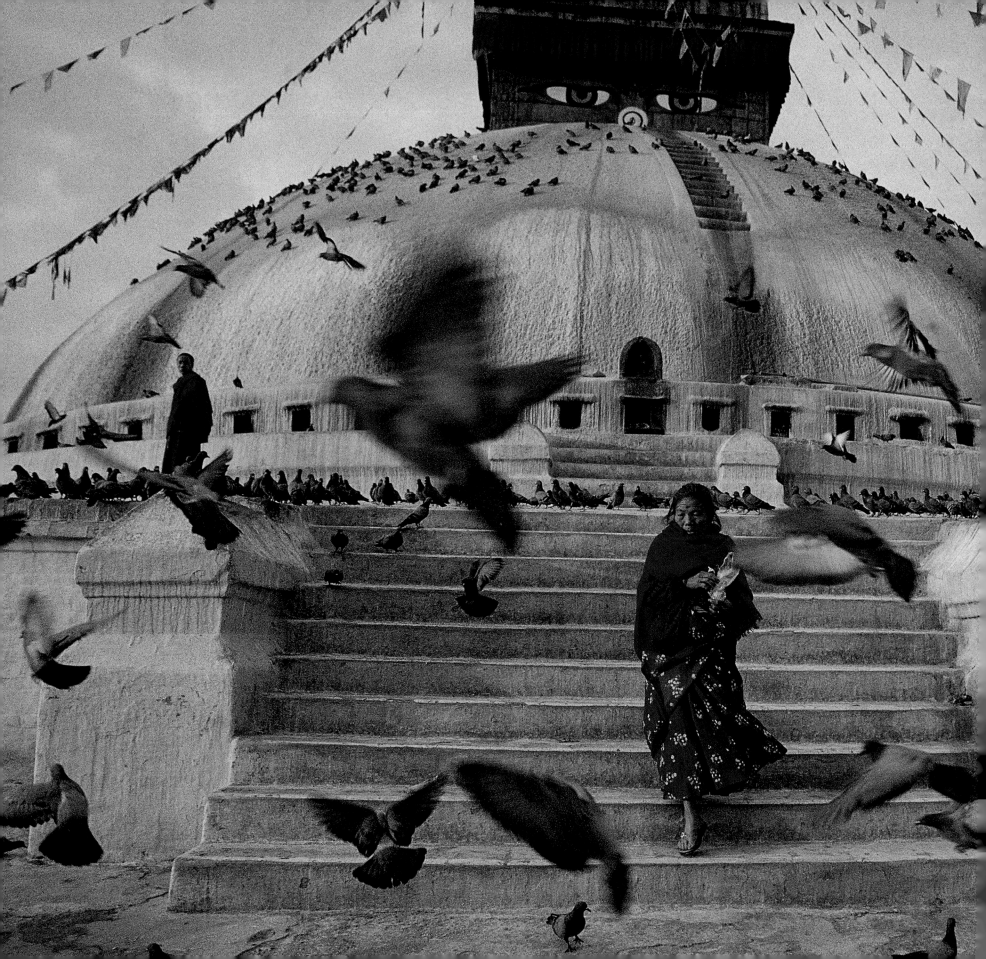

A Nepali woman who came to feed the birds at dawn at Bodhnath
Stupa, Kathmandu, Nepal, 1997

169

ALL OF THE PHOTOGRAPHS FROM THIS IMAGE TO THE END OF THE BOOK WERE MADE IN INDIA IN 1997.

A woman expresses her devotion to Padmasambhava, also known as Guru Rinpoche, as she prostrates herself before a *mani* stone at Tso Pema (Lake Rewalsar, Himachal Pradesh), believed to be the birthplace of this Indian master who brought Buddhism to Tibet.

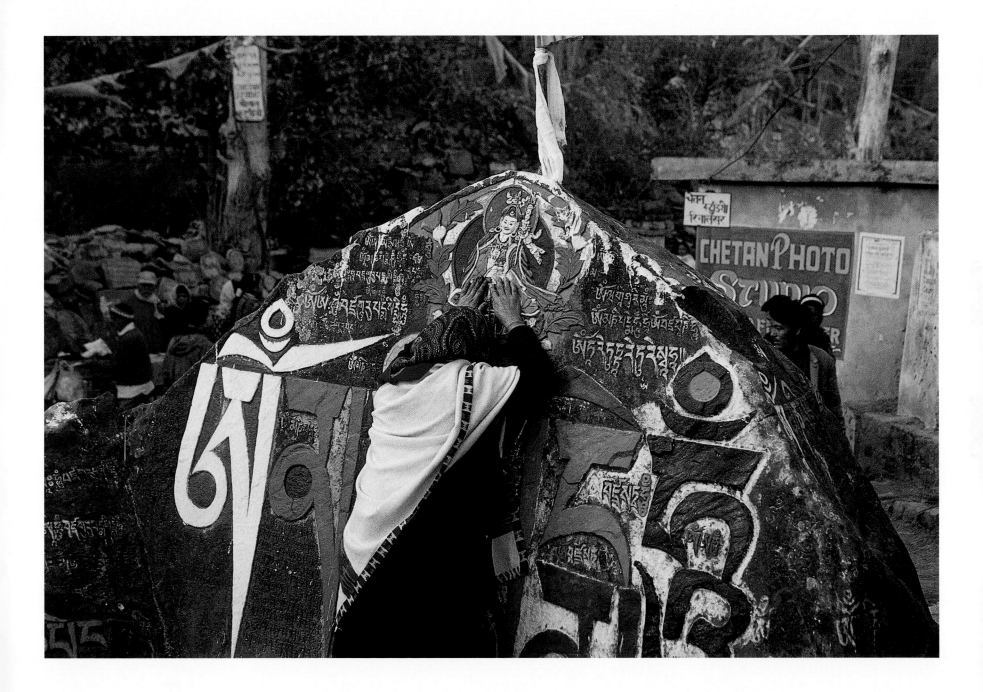

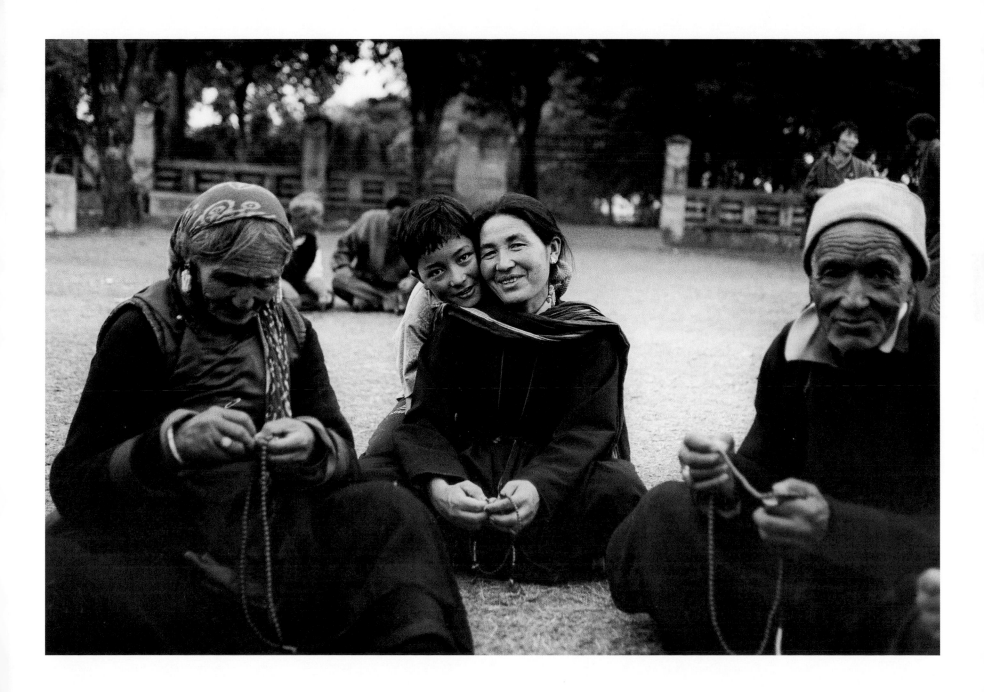

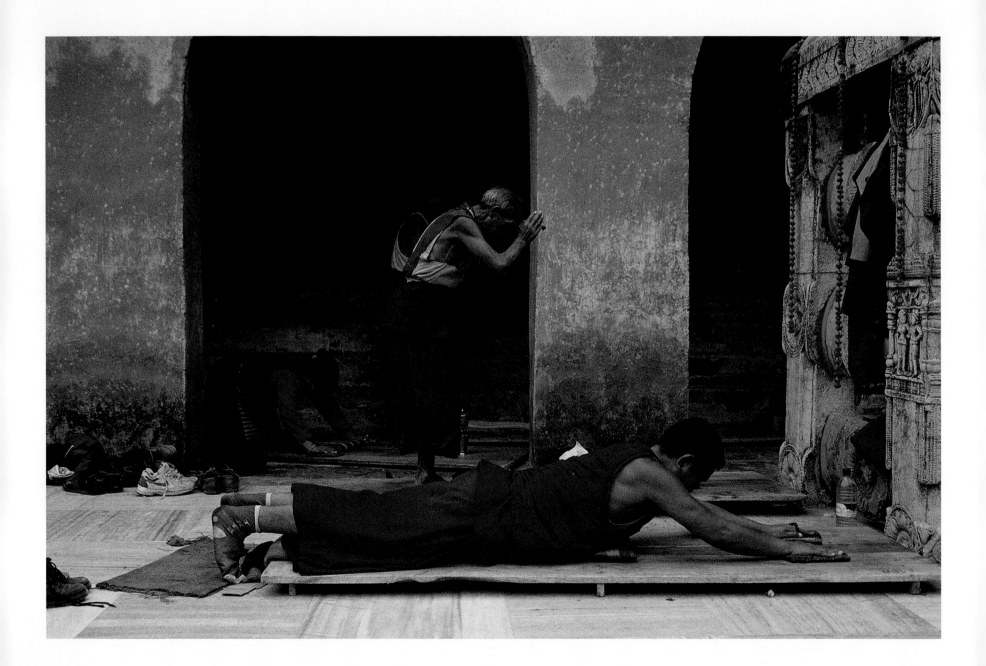

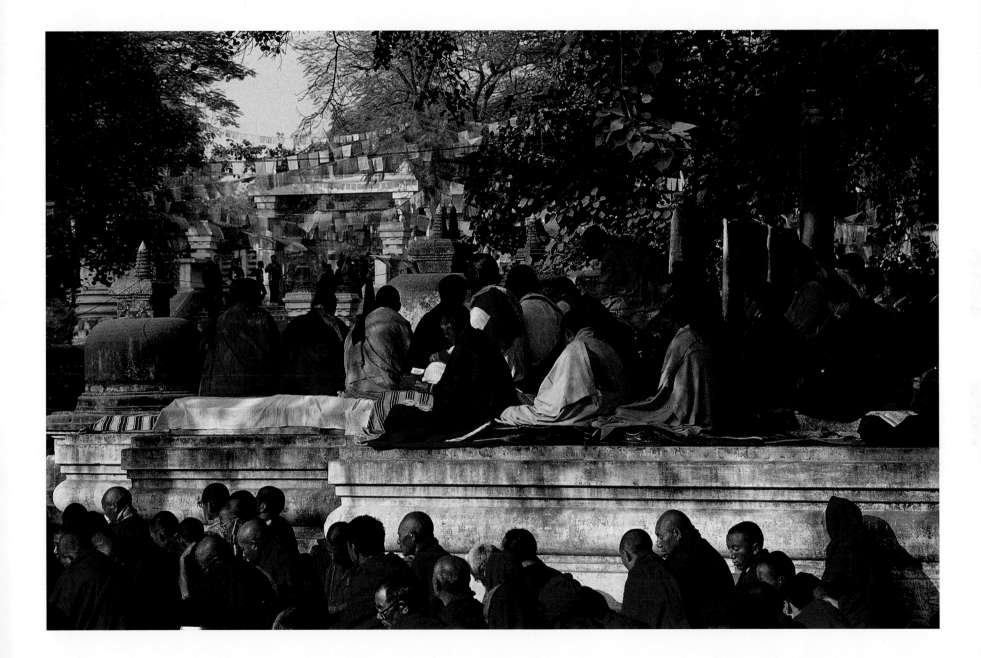

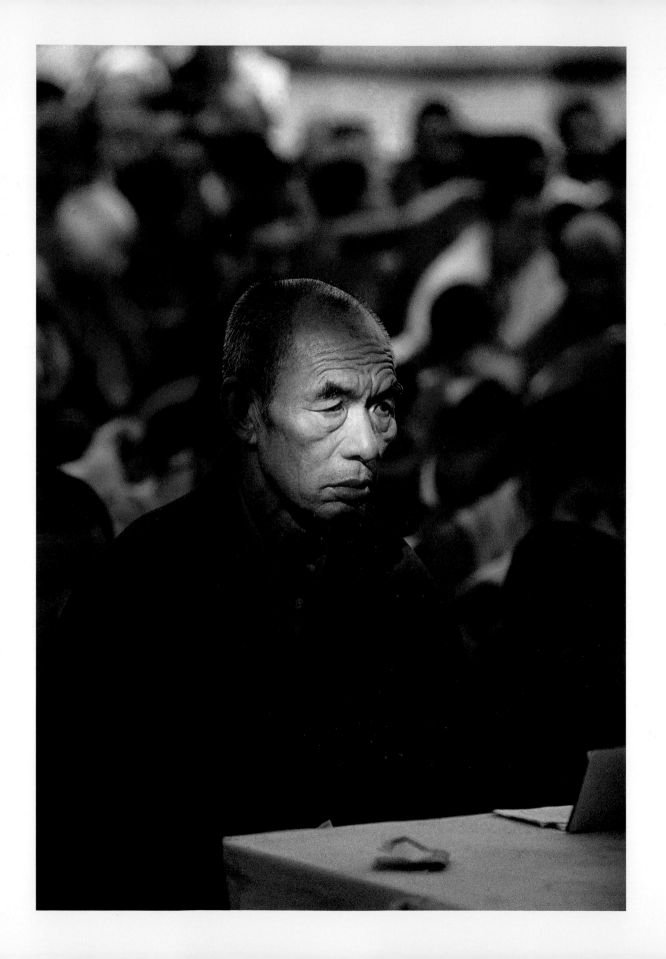

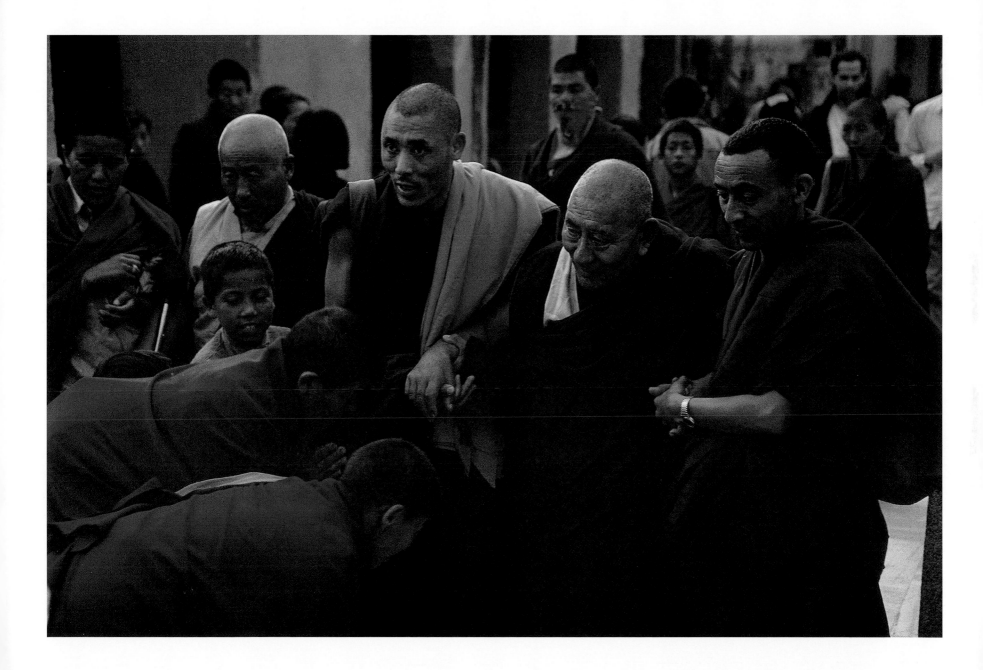

PAGE 179 A Tibetan monk prostrates himself toward the stupa at the Mahabodi Temple in Bodhgaya.

PAGE 180 Vajrakilaya Ceremony, Sakya Center, Rajpur

PAGE 181 This sand mandala was made during the Vajrakilaya Ceremony performed by His Holiness Sakya Trizin at Sakya Center in Rajpur.

PAGES 182–183 Monks perform sacred music and dance during the Tsechu festival, Rumtek Monastery, Sikkim.

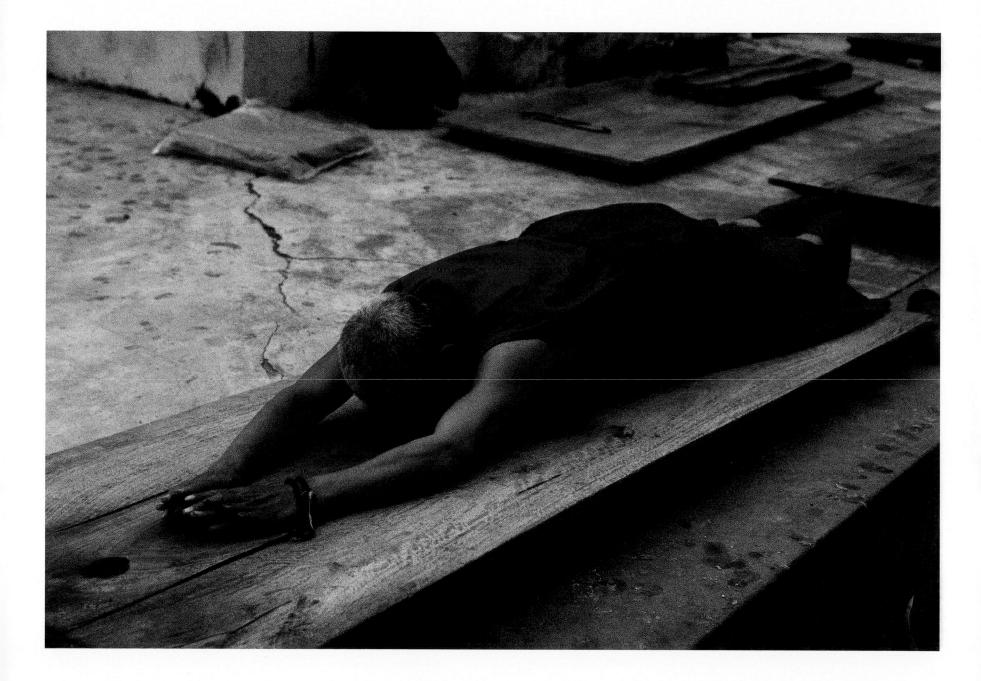

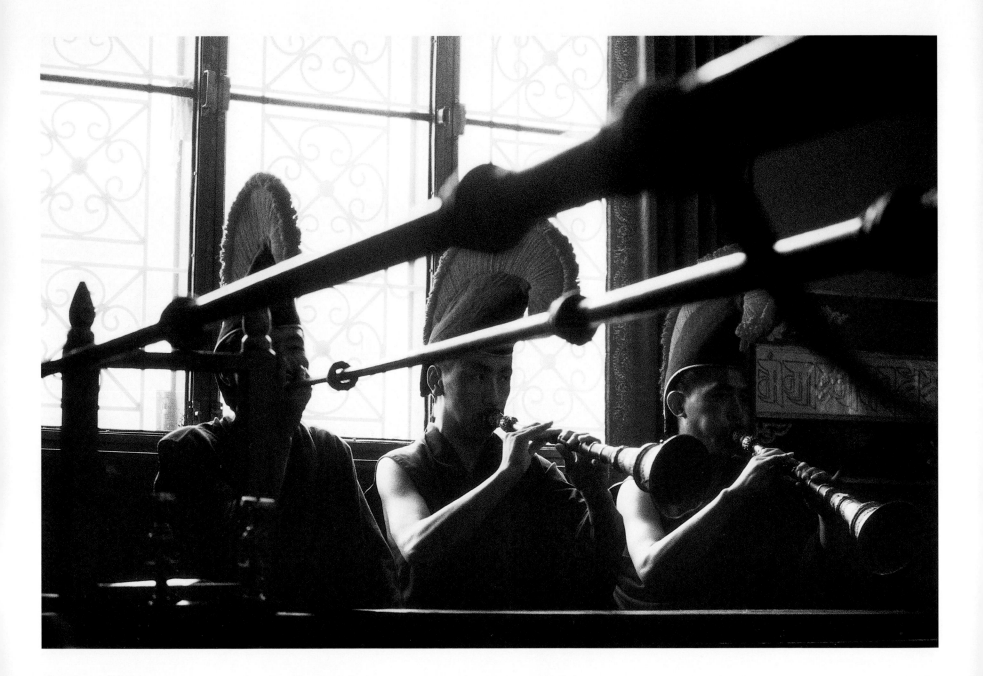

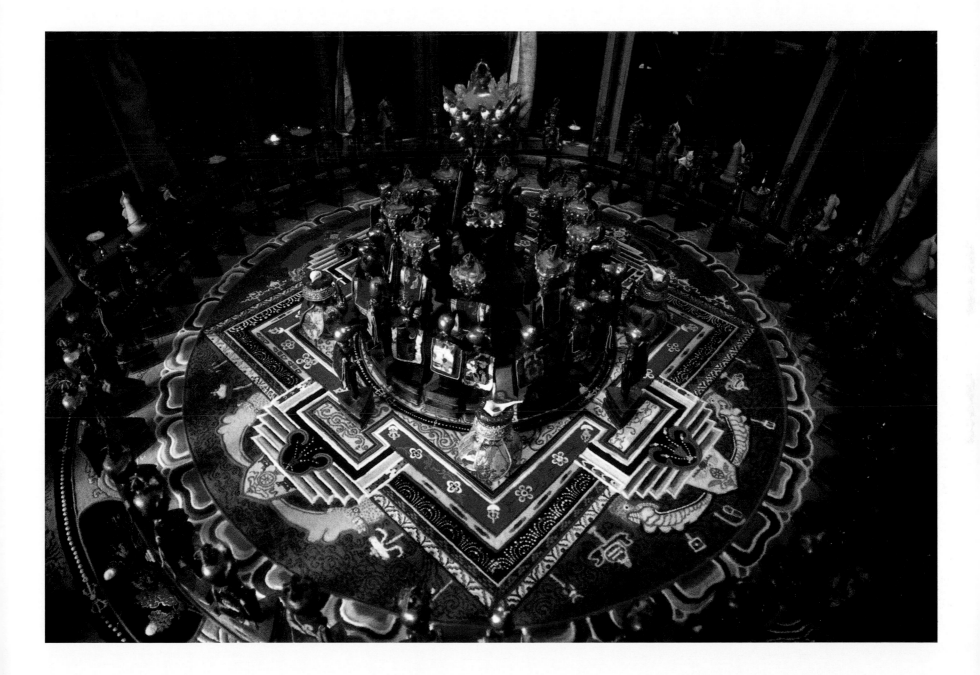

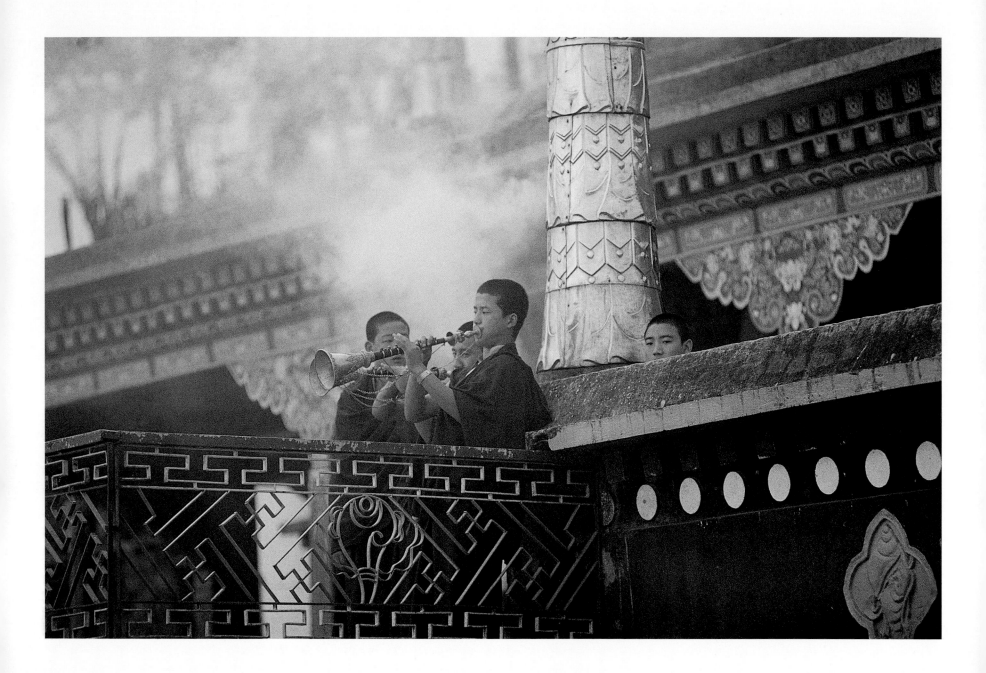

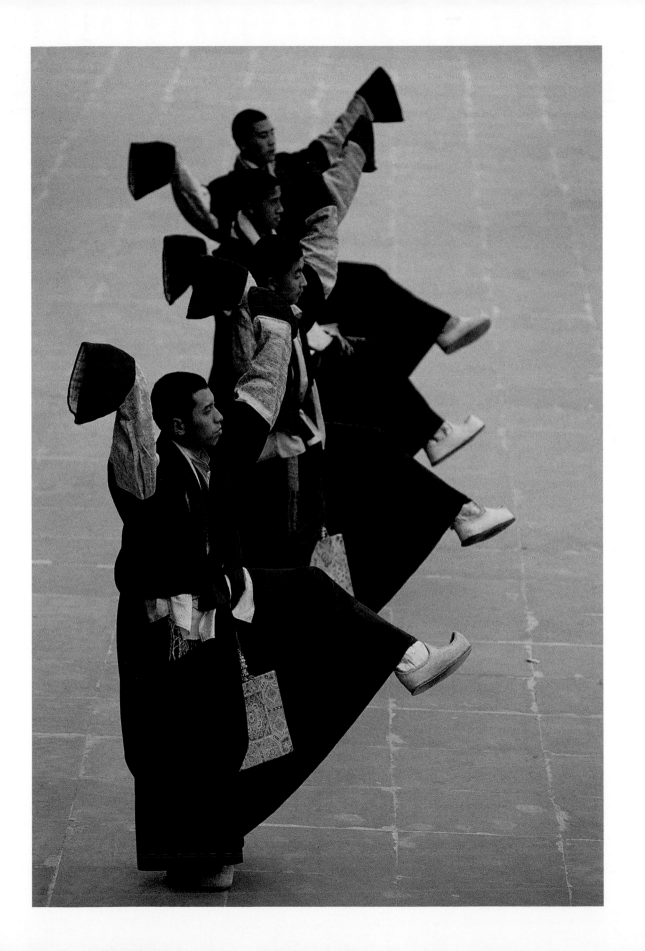

Sacred dance performed by monks at Rumtek Monastery, Sikkim

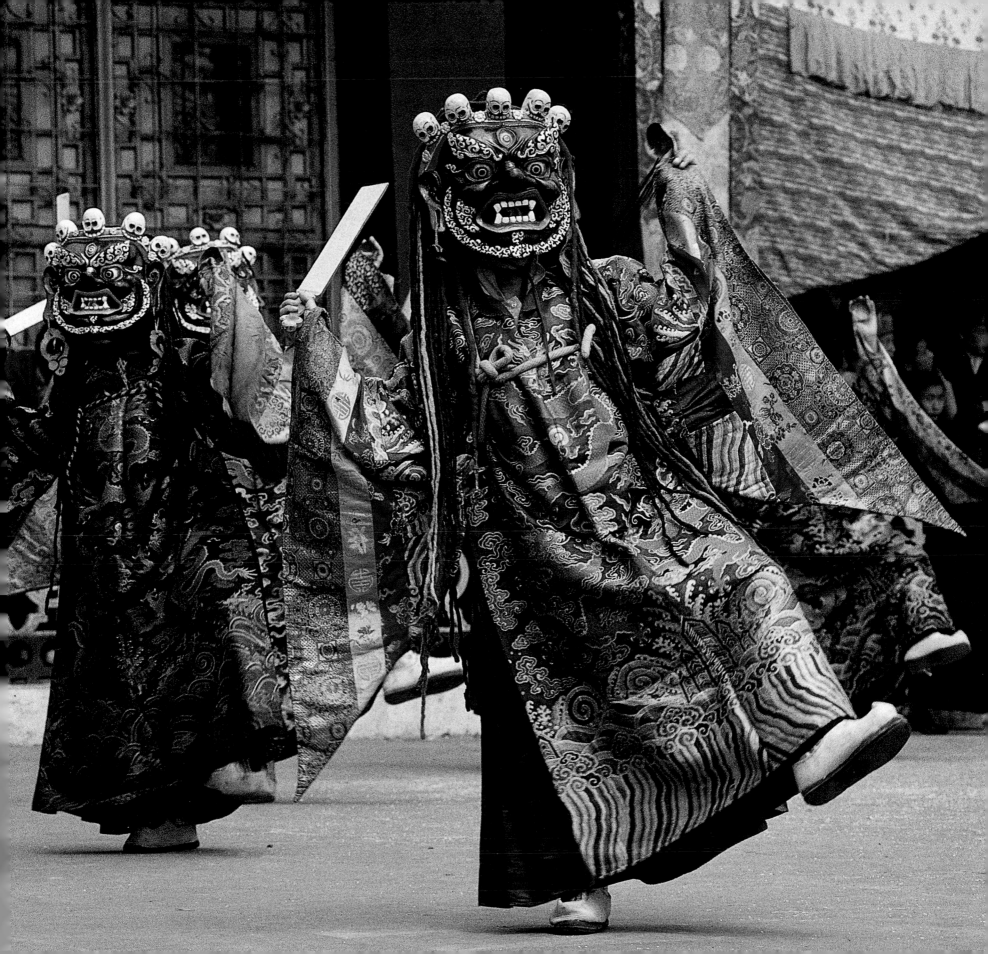

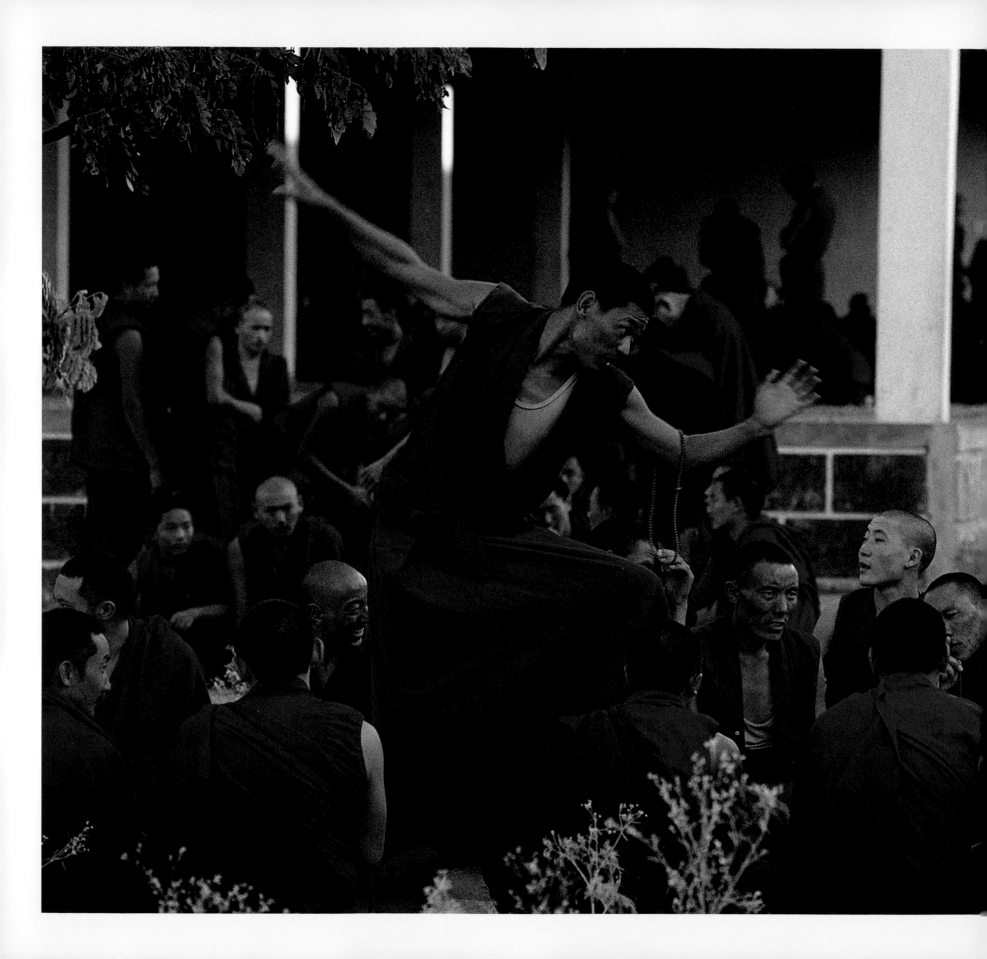

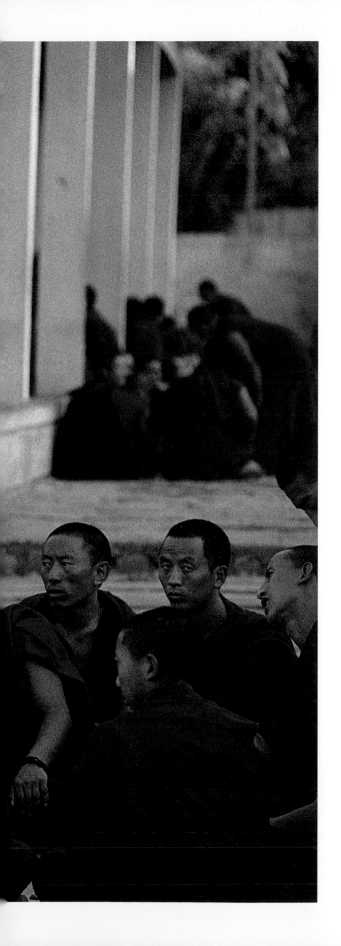

187

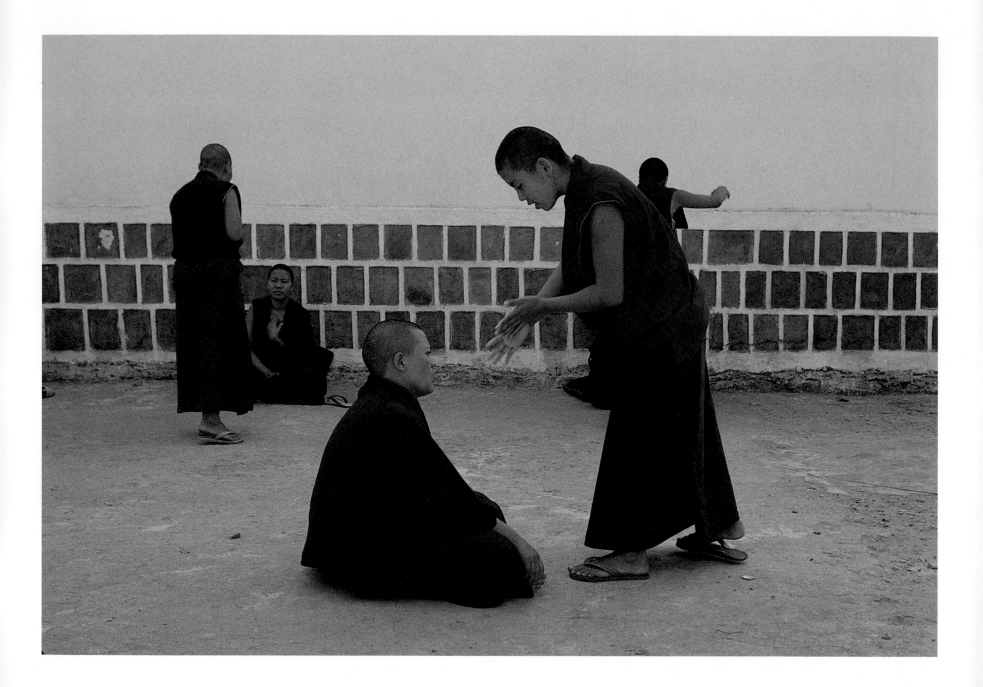

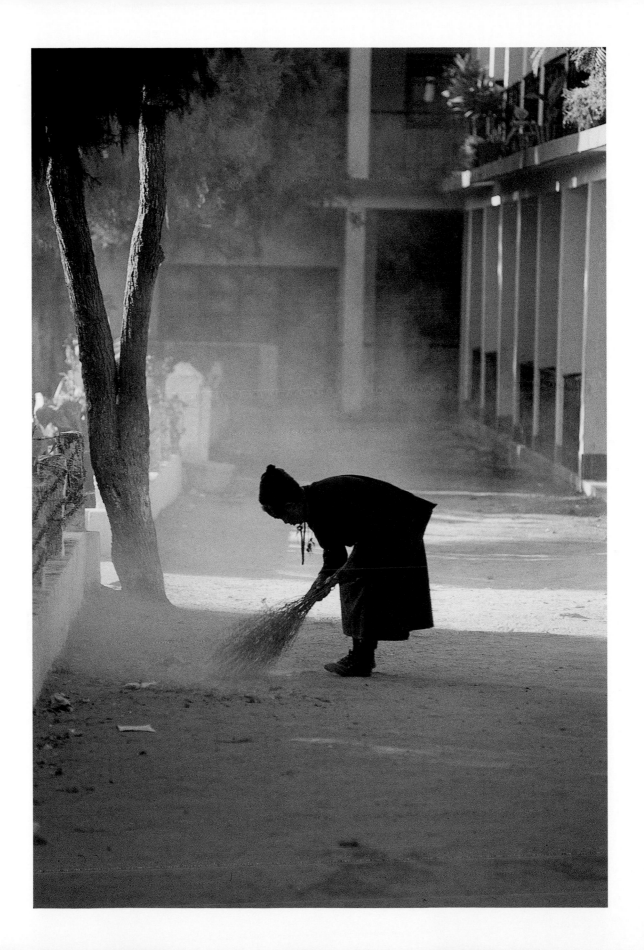

189

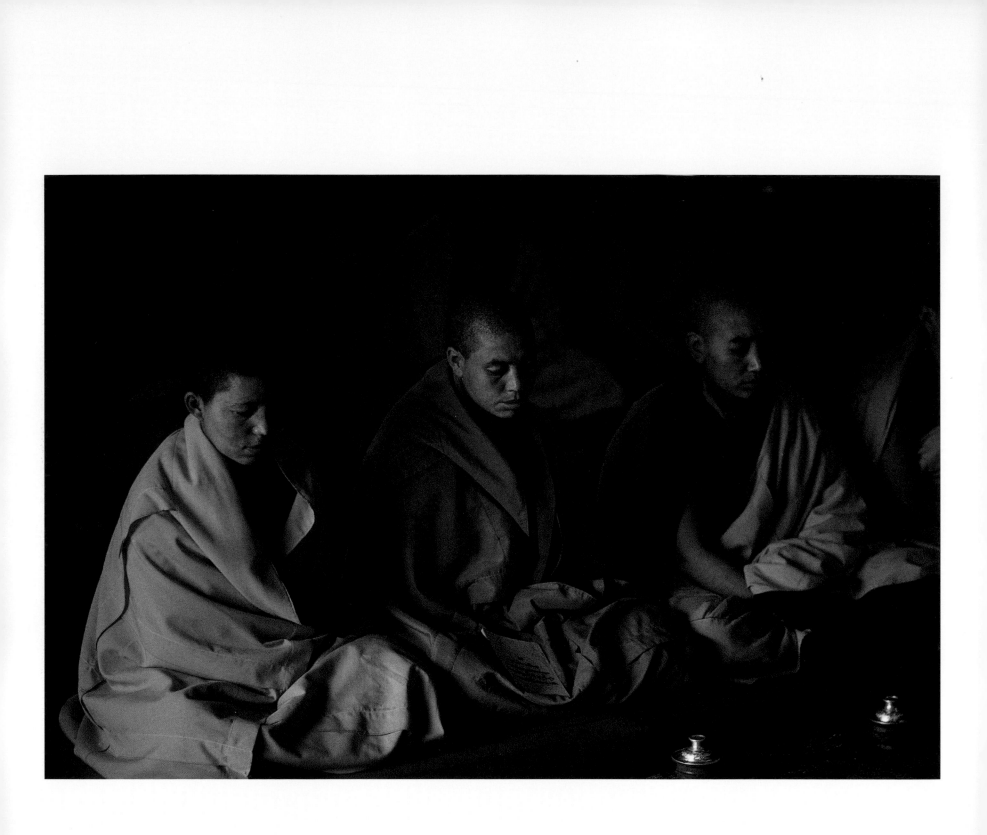

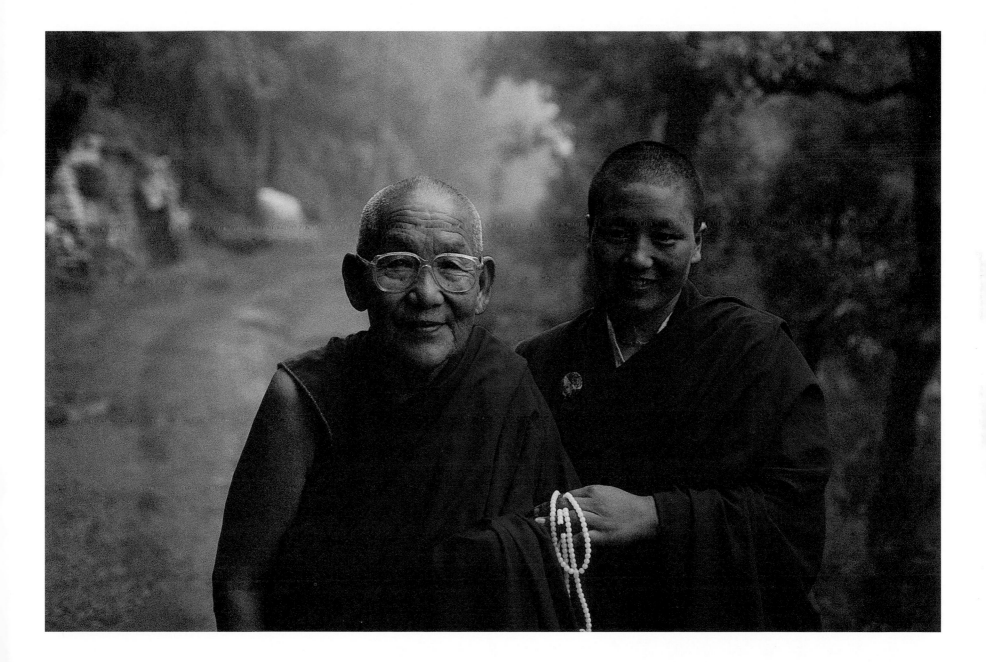

AFTER RETURNING FROM THE KALACHAKRA AND Bodhgaya in January 1997, I met with Tenzin Geyshe, the secretary for His Holiness the Dalai Lama in charge of foreign affairs. I brought a letter from my teacher Geshe Gyeltsen, asking for cooperation for my project. I explained that I hoped to have special access to photograph His Holiness during the nine months that we would be in India. Tenzin Geyshe got back to me with word that His Holiness had agreed and that the summer, five months later, would be the best time to do the photography. In the meantime I could photograph him when he gave public audiences.

One such public audience was in February during Losar, the Tibetan New Year—the most important holiday for the Tibetan people. His Holiness led a ceremony on the roof level of Namgyal Monastery, which is the monastery under his direction. Following the ceremony, His Holiness walked over to the railing and gave a brief talk for the crowd that had gathered before dawn.

After I had taken several trips to various Tibetan settlements in India and Nepal, and spent time in my wife's village, it was summer, the traditional time that monks stay indoors and the time when His Holiness goes into partial retreat in his palace and devotes himself to meditation and study. In addition to photographing His Holiness, I conducted an interview with him. When I asked him about the problems in preserving Tibetan Buddhist culture in exile, he replied: "The promotion of Buddhist knowledge or Buddhist understanding in Tibetan society is crucial. Recently, I have been telling people: parents should be the guru of their own children. The guru in the ordinary sense, that comes much later. So, therefore, once parents become the guru of their own children, teach what is Buddha, what is Buddhism, what is Sambogakaya, what is Dharmakaya, Nirmanakaya, Four Noble Truths, and more, in the children's mind, in the whole society, there can be genuine Buddhists."

He went on to explain: "There are two kinds of Buddhist faith. In the scriptures also this is mentioned—one faith is faith which is completely relying on someone, for example, someone saying Buddhism is good—just relying on that. That, the scriptures say, is not at all reliable, not genuine faith. The other faith—in the beginning, one remains skeptical. Study, investigate, experiment, then, through their own investigation, gain some understanding. Then, faith which comes from that understanding, through your own personal conviction, that faith is genuine faith, and we should have that kind of faith."

Since His Holiness knew that my goal was to photograph Tibetan Buddhist life, he chose activities that he thought would be of interest. I photographed him performing a higher ordination for monks one day. On another day I photographed His Holiness performing a fire ceremony with only his attendants present—as a self-empowerment, enabling him to empower others. The rarest chance came when His Holiness asked me to photograph him meditating and studying scriptures. I spent the night at a guesthouse in McLeod Gange, and it was still dark as I walked along the dirt road to the palace. I met Tsering Tashi, the press secretary, who led me through the palace grounds to the small, simple, but beautifully designed house where His Holiness lives. We waited outside the house and then, when His Holiness was ready, his assistant called us to go inside. His Holiness was sitting in the usual place where he does practice. It was about 7:30 A.M. He said that he would

be doing practice for twenty minutes and I could begin photographing him. The room was too dim to use available light, so I used bounced flash off the ceiling. His Holiness was absorbed in meditation as I photographed and no words were spoken. Then His Holiness got up, walked over to where he reads scripture, and began reading for a while. After this, I asked him if we could take some photographs by the window and he agreed. I set the camera on a tripod and used available light coming through the window.

Without planning it, I got into a conversation with His Holiness as I was photographing him. I told him about my wife's mother, Lhaga, who had been a beautiful young maiden from a respected family in Derge, Kham, eastern Tibet. Fleeing the Chinese Communists, Lhaga and her husband, Wangyal, escaped to India in 1959, but shortly after arriving Lhaga contracted polio (a disease practically unknown in Tibet) and her legs became paralyzed. The couple loved each other very much and, despite Lhaga's paralysis, had two children together. One day, at a hot spring in northern India, they met Rinchen Dolma Taring, the founder of the Tibetan Homes Foundation, a boarding school for Tibetan refugee orphans. She was so touched by seeing Wangyal carrying this beautiful young woman on his back that she invited them to live at the school. Wangyal became the school's handyman, and their children attended the school. As I told this story to His Holiness, he was deeply moved and he said, "All the Tibetan people have suffered so much." Then, all of a sudden, His Holiness said, "Finished." He took me over to his altar and reached for a small white shell and a piece of turquoise. He gave them to me and I expressed my gratitude.

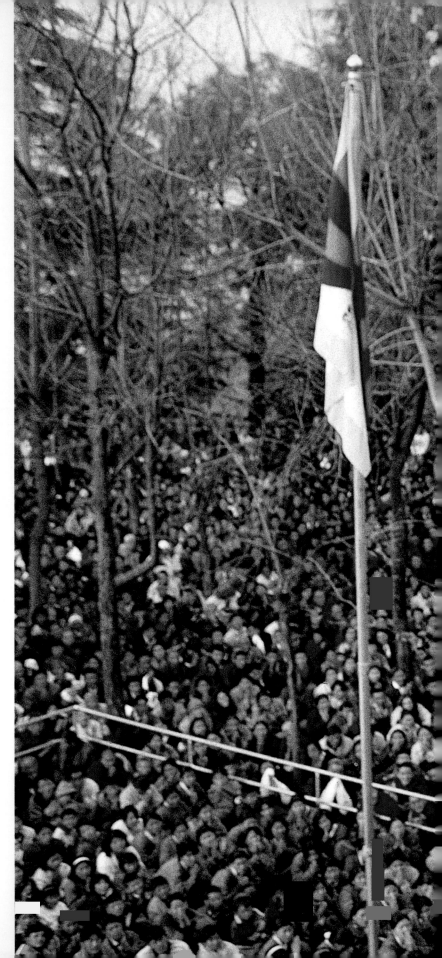

Early in the morning on Losar, the Tibetan New Year, His Holiness the Dalai Lama addressed the crowd gathered outside the palace in Dharamsala.

His Holiness gave the Kalachakra Initiation to an estimated 250,000 people—the largest audience ever to attend a Kalachakra. The event, which took place near Siliguri, close to Darjeeling, attracted Buddhists from India and the entire Himalayan region. Many people wore face masks to avoid breathing in dust.

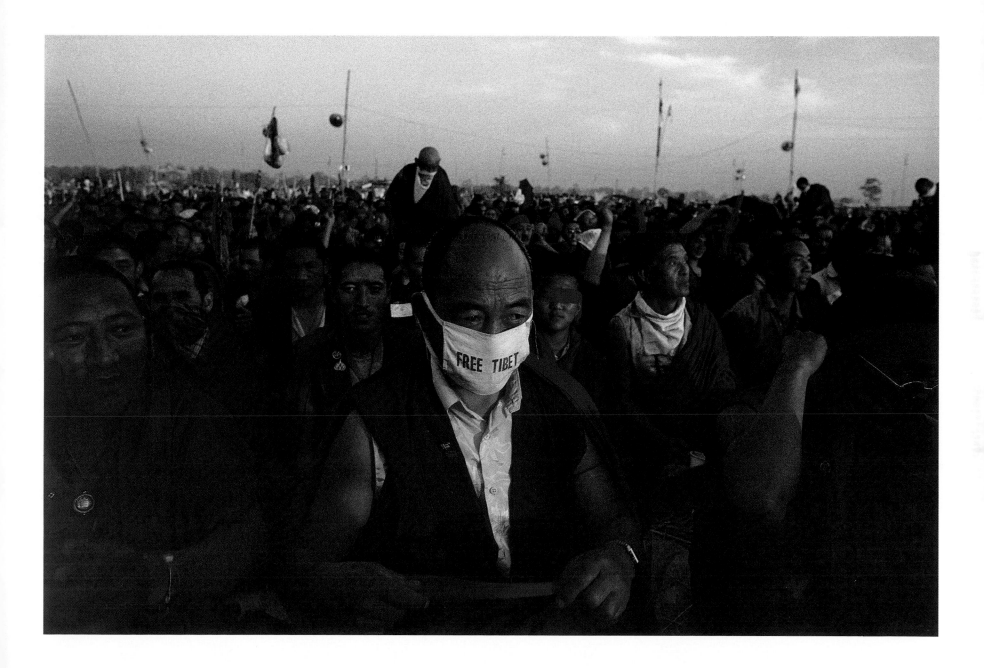

PAGE 199 His Holiness at Bokar Monastery in Mirik, near Darjeeling

PAGES 200–201 His Holiness by a window (left) and in meditation (right) at his residence in Dharamsala

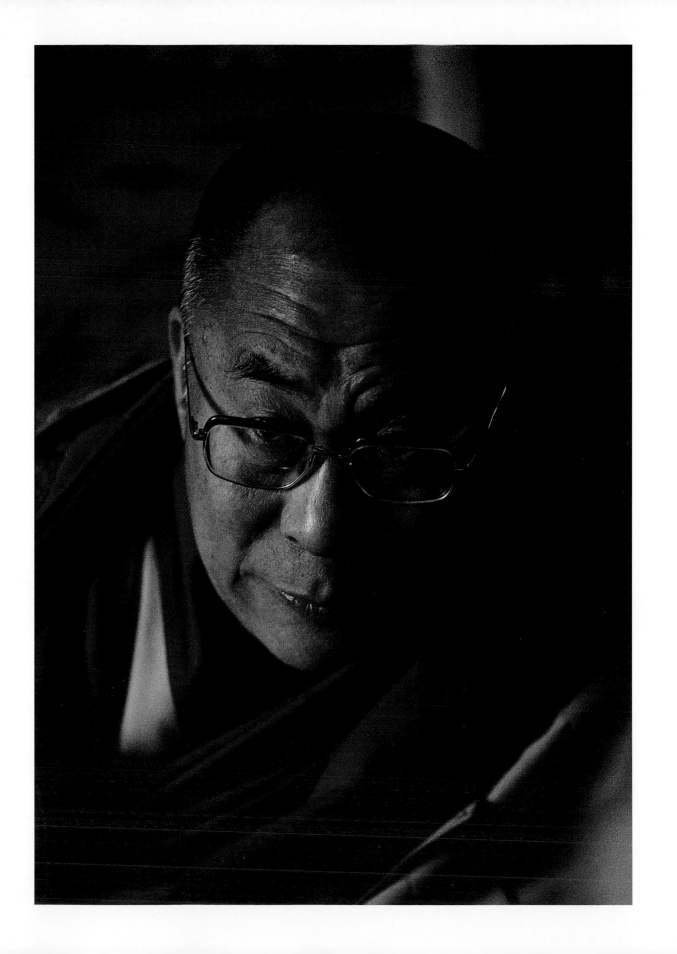

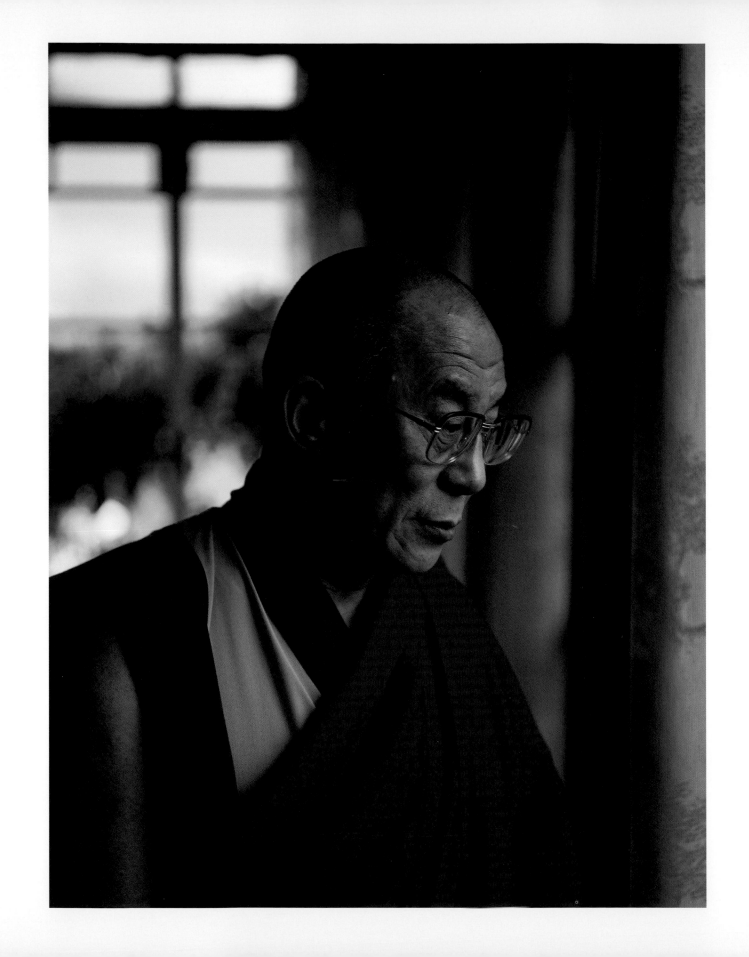

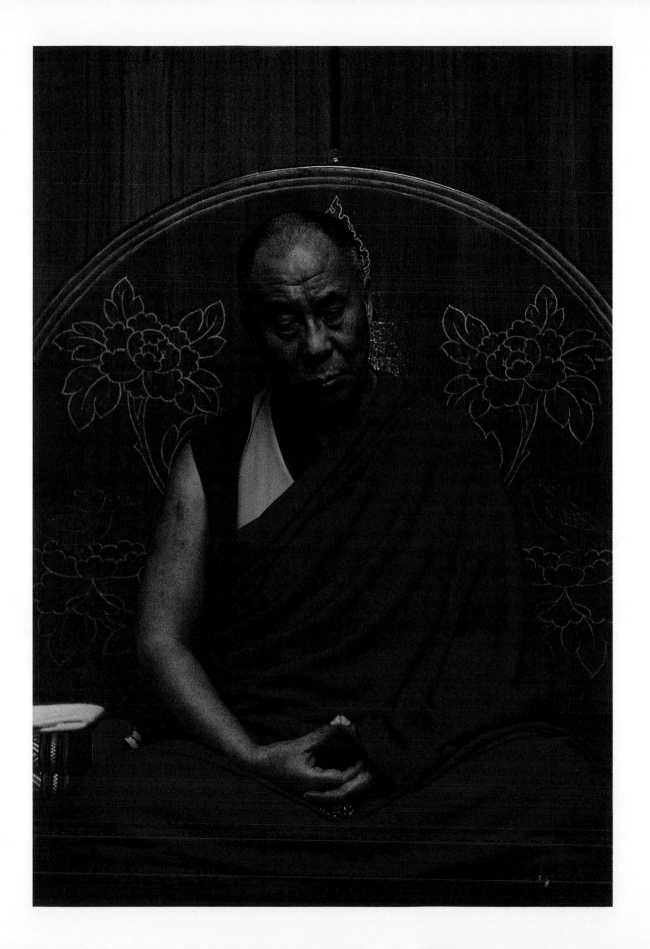

His Holiness reading Buddhist scripture, Dharamsala

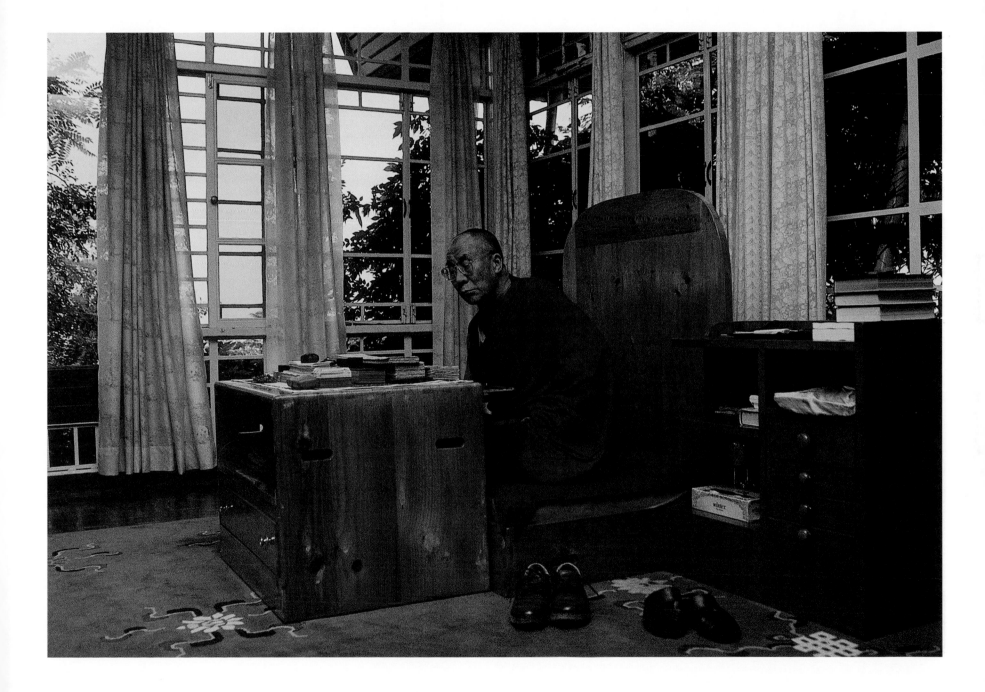

In Mundgod, in southern India, I met His Holiness the Hundredth Ganden Tri Rinpoche, the head of the Gelugpa lineage. I was impressed that someone in his position lived so humbly in a tiny house, no different from most Tibetan refugees in India. He told me, "The Tibetan culture and way of life is passing through one of its most crucial times. The old Tibetan traditions are gradually facing a slow erosion. If people find that this age-old Tibetan tradition is of some use to the world as a whole, then it does not matter whether the people who are striving for its upkeep are Tibetans or not. If there is a person who truly feels that this tradition, if lost, will be a great loss to the whole of mankind, then they should help it or else there is no other reason for clinging onto it like some kind of wealth or land. So, with Tibetans in front and working with others who agree with this idea, together, they should work hard to preserve this culture." (Drepung Loseling Monastery, Mundgod)

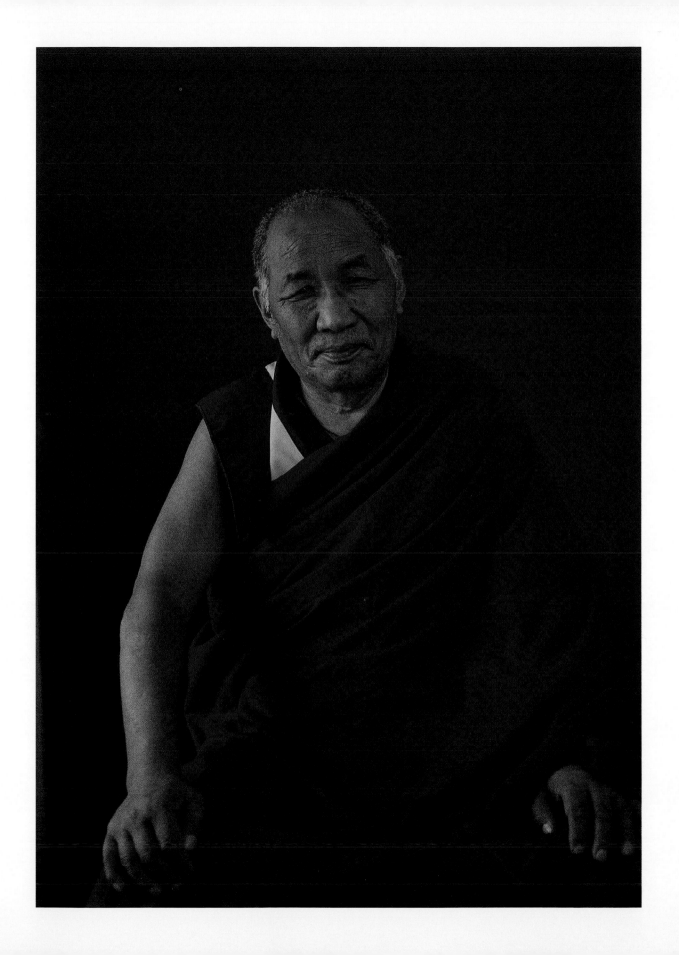

His Holiness Mindrolling Trichen Rinpoche is revered by many Tibetans as one of the greatest living Buddhist masters. He is the head of the Nyingma school of Tibetan Buddhism and of the historically important Mindrolling lineage of the Nyingmapa. I photographed him in the room where he normally does his practice, with light coming from a window. He joked around, exuding tremendous joy and vitality through his eyes. (Mindrolling Monastery, Clementown, Dehra Dun)

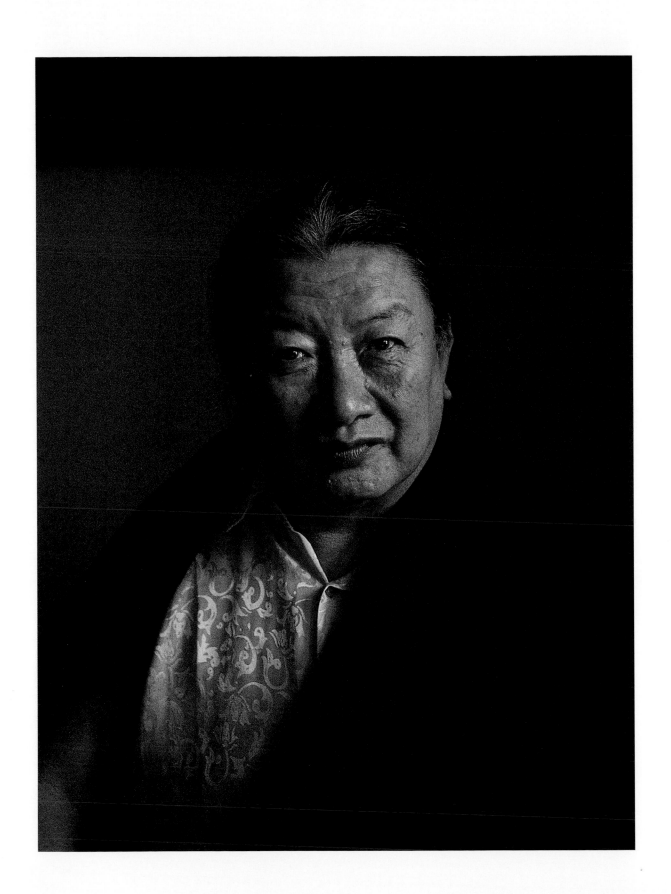

Tibetans in my wife's village spoke of Venerable Khenpo Kunga Wangchuk Rinpoche with the greatest reverence. He is the abbot of Dzongsar Institute and one of the most important teachers in the Sakya lineage. His Holiness the Dalai Lama received teachings and empowerments from him. He was mainly in retreat, but for one day during our stay in India, he came to the institute and I was able to spend about fifteen minutes with him. He told me: "The main merit of the practice of Buddhism is in the improvement or the evolution of the mind and the way of thinking. It stops evil thoughts and instills the power of positive thinking. This will bring, in this life, a harmonious coexistence with all sentient beings. It will end the will to harm, it brings peace, and instills the will to help and to be compassionate and caring. This thought will grow during a man's life, during his death, after his death, even when he is reborn, and through many other rebirths until finally reaching the ultimate aim of Buddhist practice, which is enlightenment which will be devoid of any suffering, be it of the body or of the spirit. These are the merits of Buddhism which are not only for this life but also for all the coming lives until the attainment of Buddhahood."

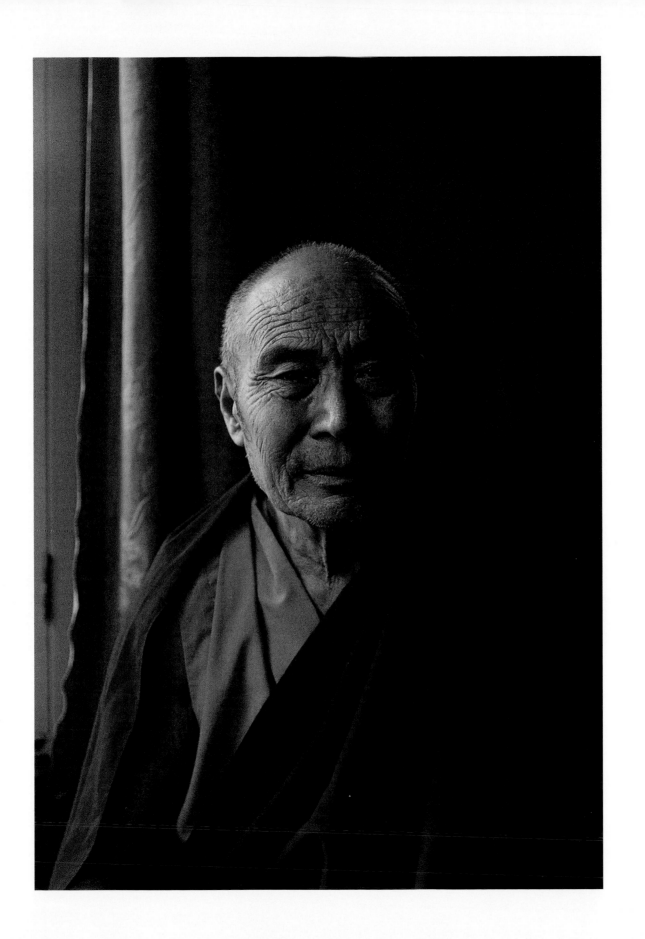

Among the many Tibetans who escaped to India in 1959 were the *togdens* (yogis) who had lived isolated in caves in Tibet. To continue their retreats, they built huts or found caves in the Himalayan foothills of India. Togden Amting, shown here, has lived for many years in a tiny hut under trees, high on a hill in Himachal Pradesh.

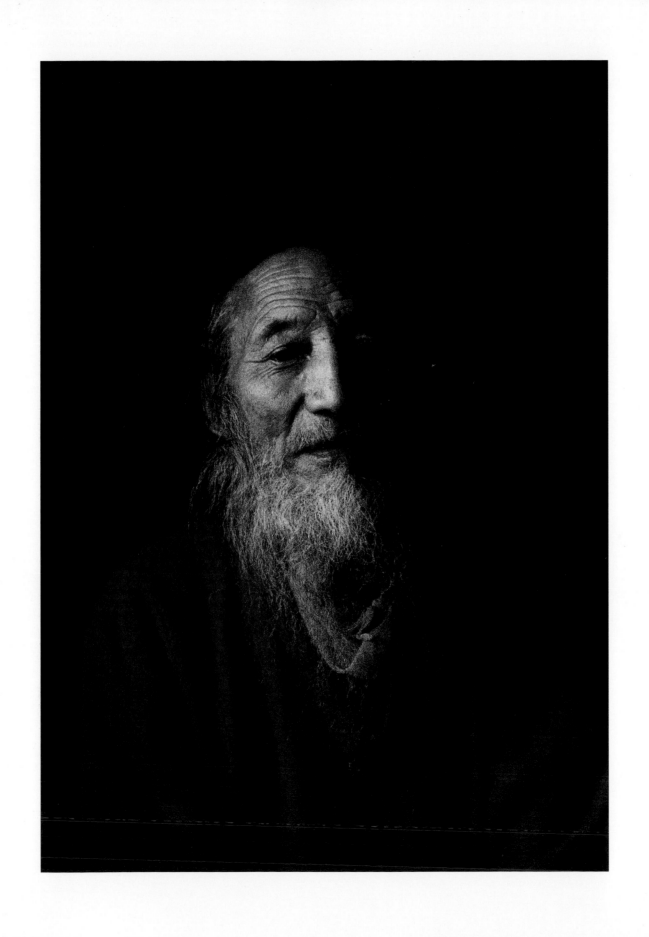

Khandro Tsering Chodron was the spiritual wife of the renowned Sakya master Jamyang Khyentse Chokyi Lodro. She was much younger than her husband, who died in 1959. Sogyal Rinpoche describes her as "the foremost woman master in Tibetan Buddhism." On the invitation of the royal family of Sikkim, she has been living quietly for many years in a small house located on the beautiful grounds of the royal temple atop a hill in Gangtok. She never remarried and lives like a nun, usually doing practice. Just being in her presence, experiencing her warmth and kindness, and seeing how she lived, was a great teaching and blessing.

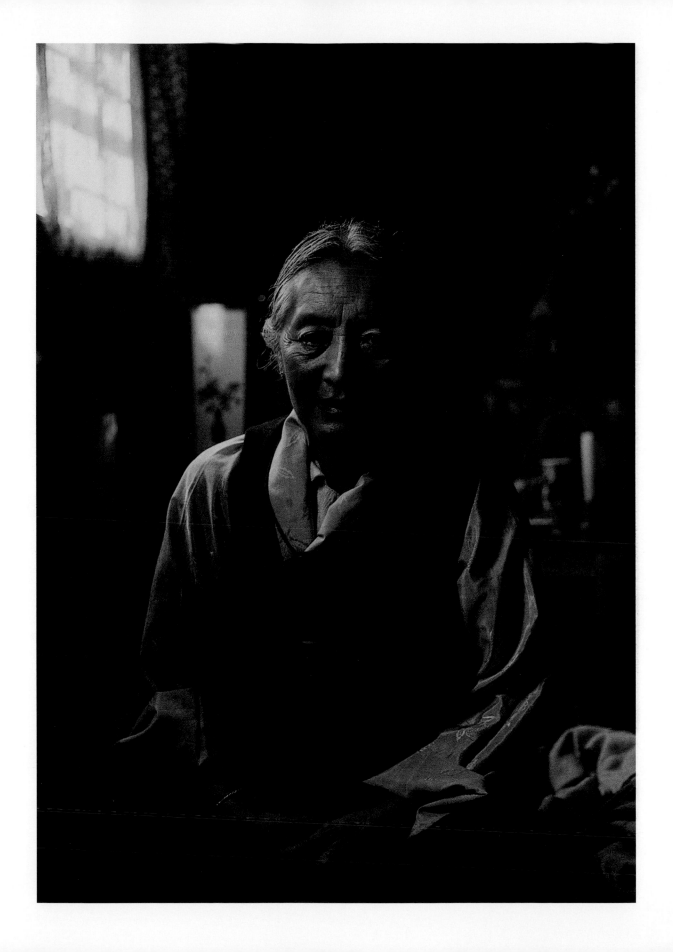

Venerable Gona Tulku Rinpoche, a great master of the Sakya line-age, is the cousin-brother (a Tibetan term that expresses the closeness with which first cousins are regarded in Tibetan society) of my wife's mother. Considered one of the highest incarnate masters from Dzongsar Monastery in Derge, Kham, he is especially renowned for his divinations, what Tibetans call a *mo*. Before each trip we took in India or Nepal, we asked Gona Tulku to do a *mo* to find out if it would be safe to go.

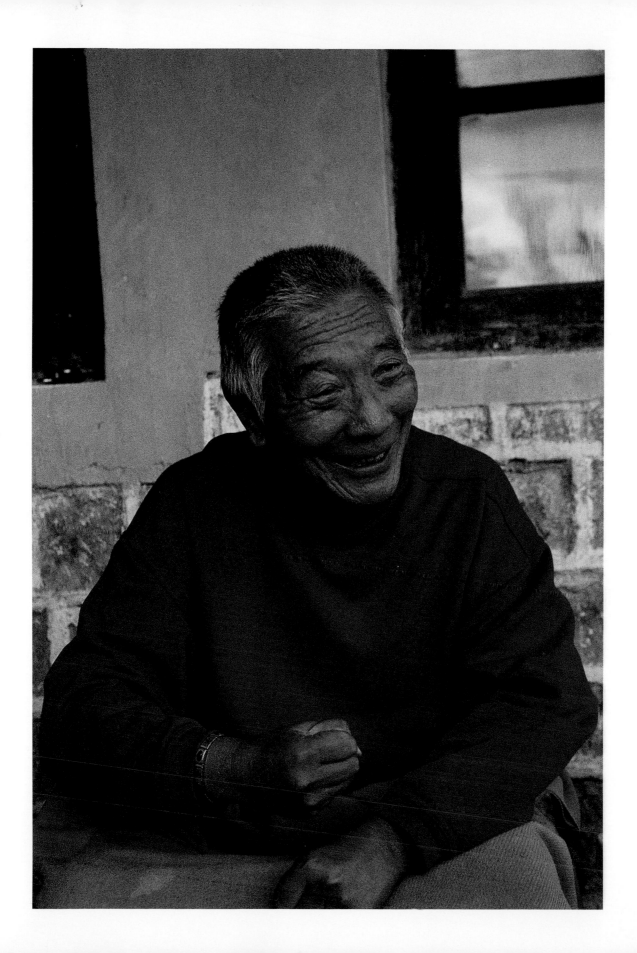

Venerable Ani Patchen was the only child of a powerful chieftain in eastern Tibet. The Communist Chinese army invaded the region in 1950, bringing great suffering to the Tibetans. When her father died in 1958, she was obliged to take over for him and lead her people in resistance to the Chinese. She was caught and spent the next twenty years in prison. With unshakable faith in the Dharma, she secretly maintained her spiritual practice, which gave her the inner strength to endure severe torture and still retain her compassion. At the same time she refused to denounce His Holiness the Dalai Lama or give up her conviction that Tibet must be free. She took the vows to become a nun while in prison. Eventually, she was released and escaped from Tibet, settling in Dharamsala. She was active in the struggle for Tibet's freedom, participating in marches and demonstrations internationally.

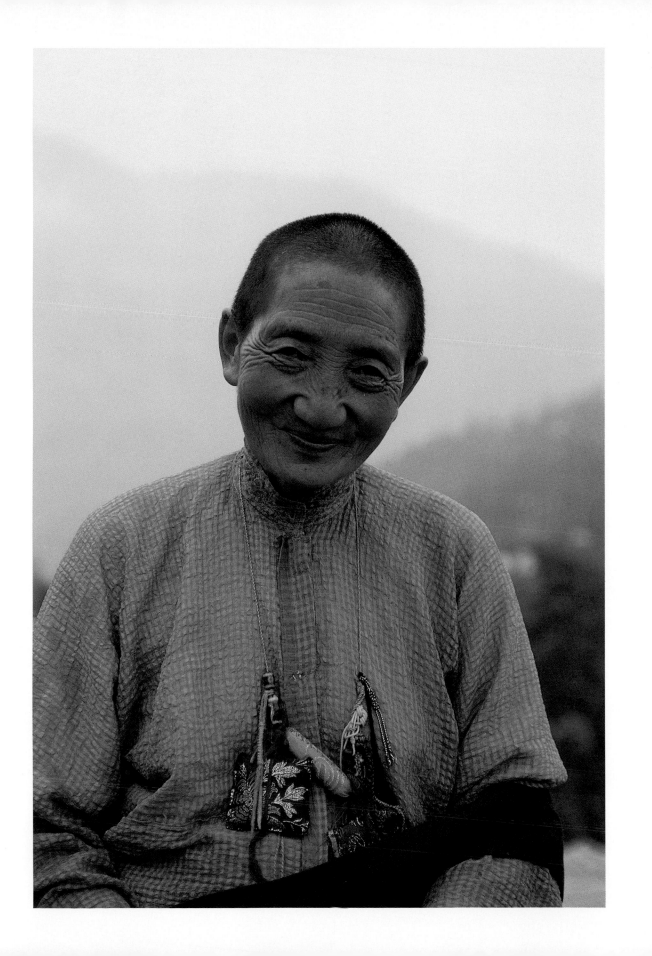

PAGE 219 In Bylakuppe, a village in Mysore, there is a large Tibetan settlement. At Palyul Namdroling Monastery, founded by His Holiness Penor Rinpoche, retreats are regularly held for laypersons who live in the settlement. Within the monastery is an old-age home, and its residents take part in the retreats.

PAGE 220 Yangtso, whose husband, Shaja, was my wife's father's best friend, makes Tibetan-style dry cheese and yogurt for the village. Outside their window is a tray that she dries the cheese on. Above the tray are some pieces of metal tied together and attached to a string, which goes into the house. As Yangtso sits in the house doing her practice, every time a bird comes by to eat the cheese, she yanks the string, which makes the metal clang, and the bird is scared away. (All of the photographs from pages 220 to 229 are from Himachal Pradesh.)

PAGE 221 My wife's mother's close friend, Jangchuk Wangmo

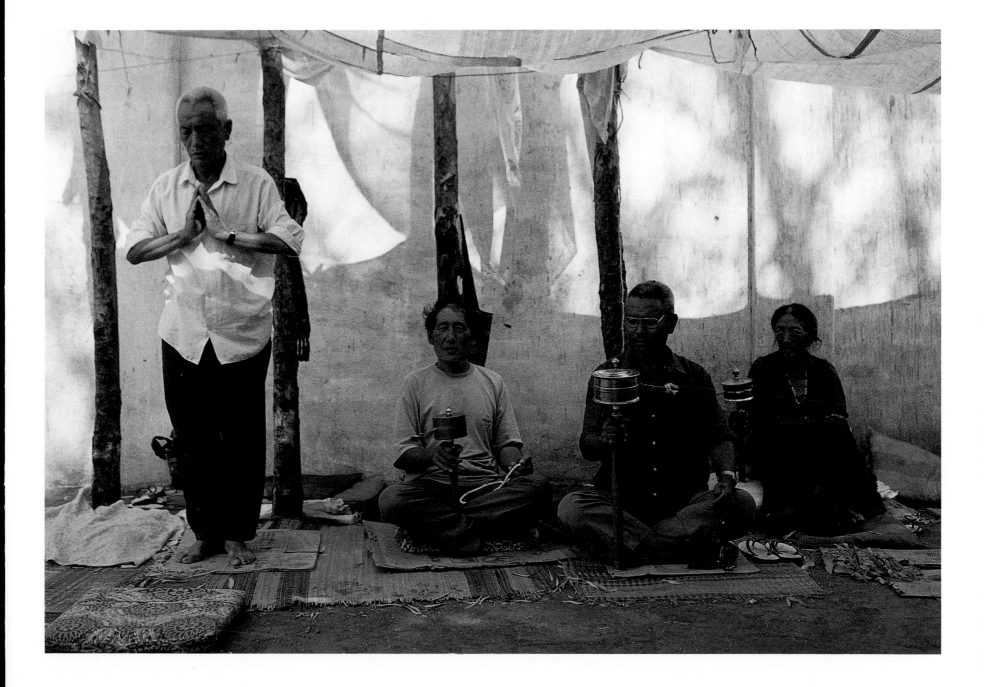

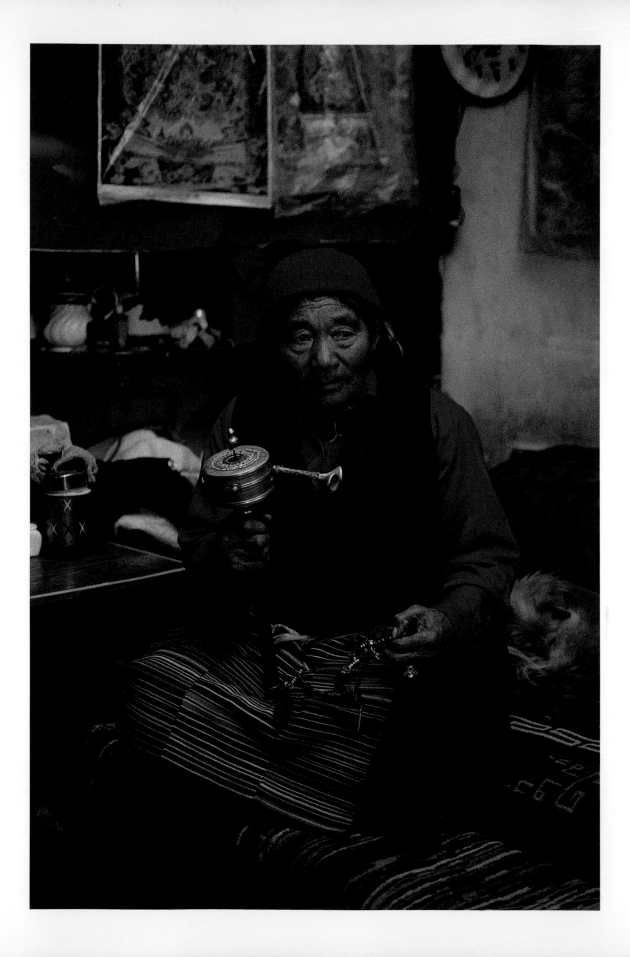

220

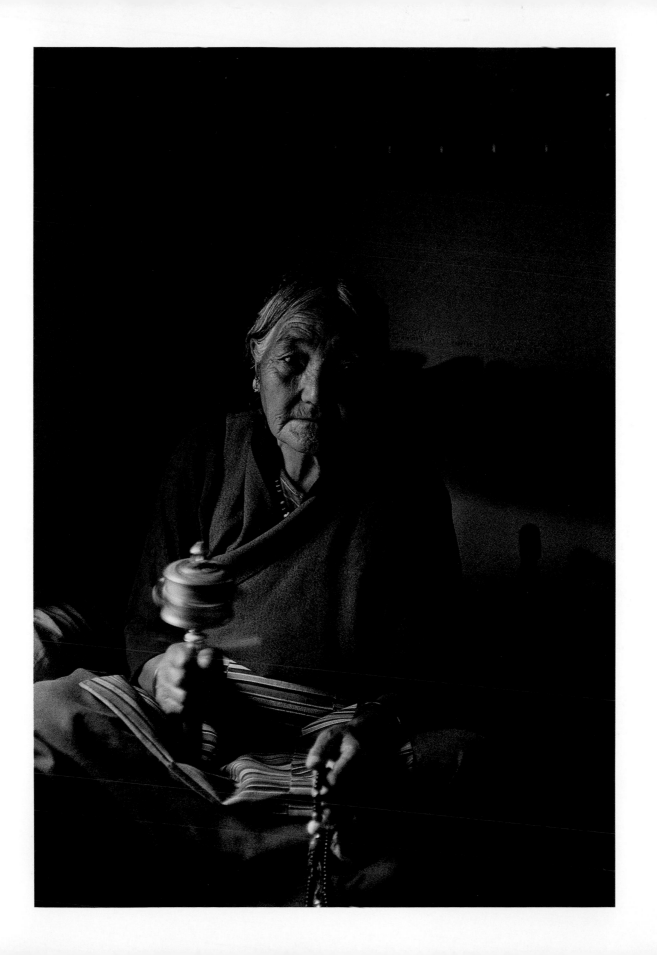

Prayer wheels, large and small, have the mantra *Om Mani Padme Hum* embossed on the outside in Tibetan. Traditionally, long, rolled pieces of paper, with the mantra written on them as many times as possible, are placed inside. Large prayer wheels also contain other mantras and Buddhist texts. As the wheel turns and the practitioner recites the mantra silently or out loud, compassion for all sentient beings is generated.

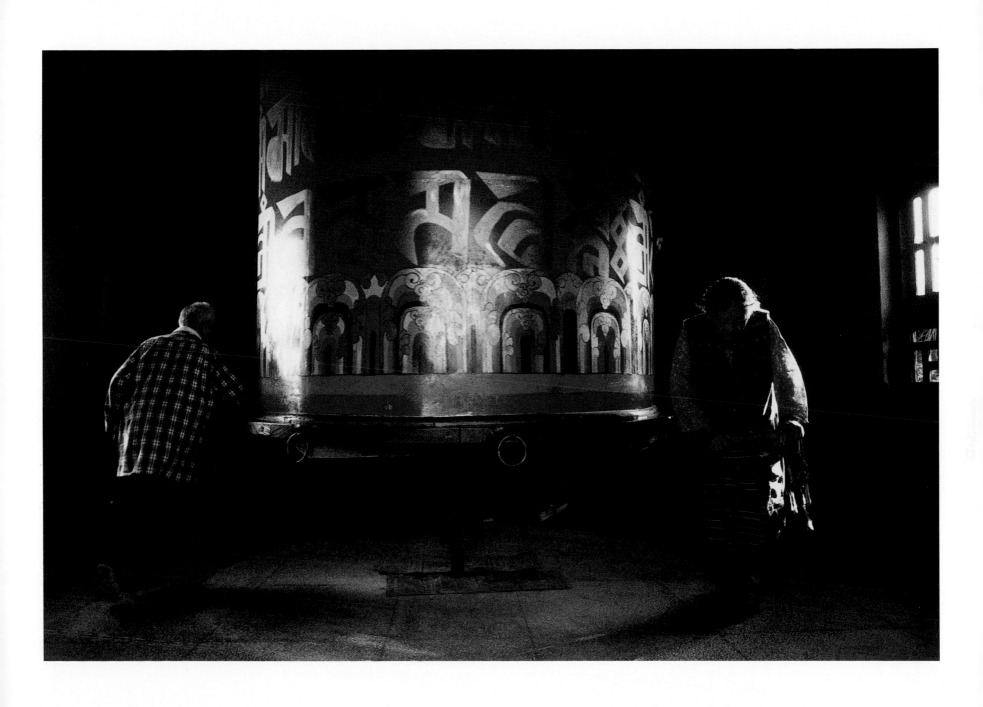

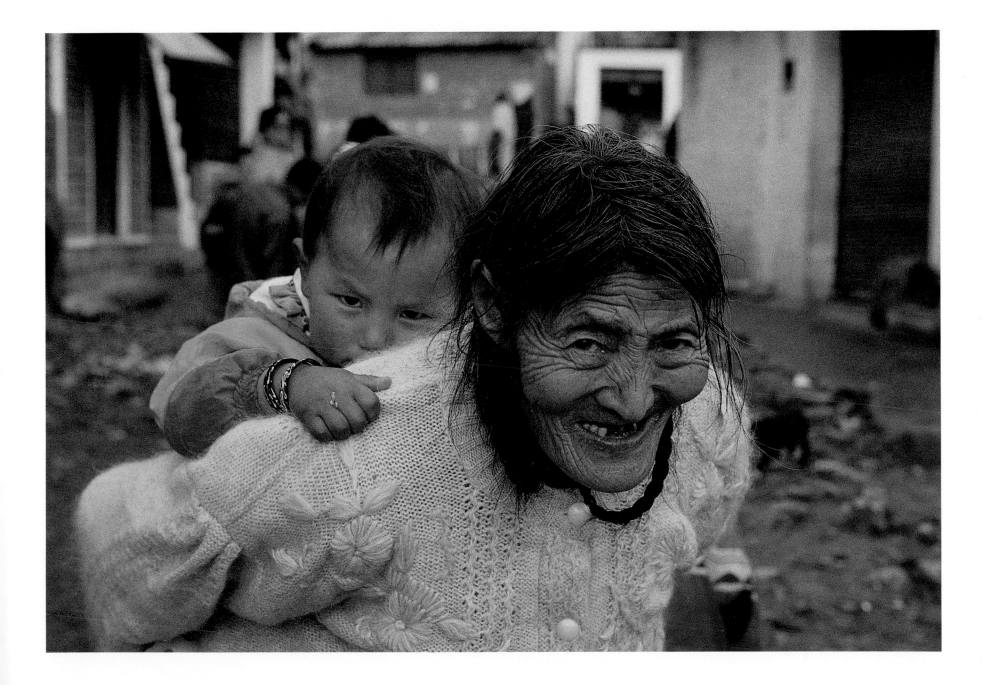

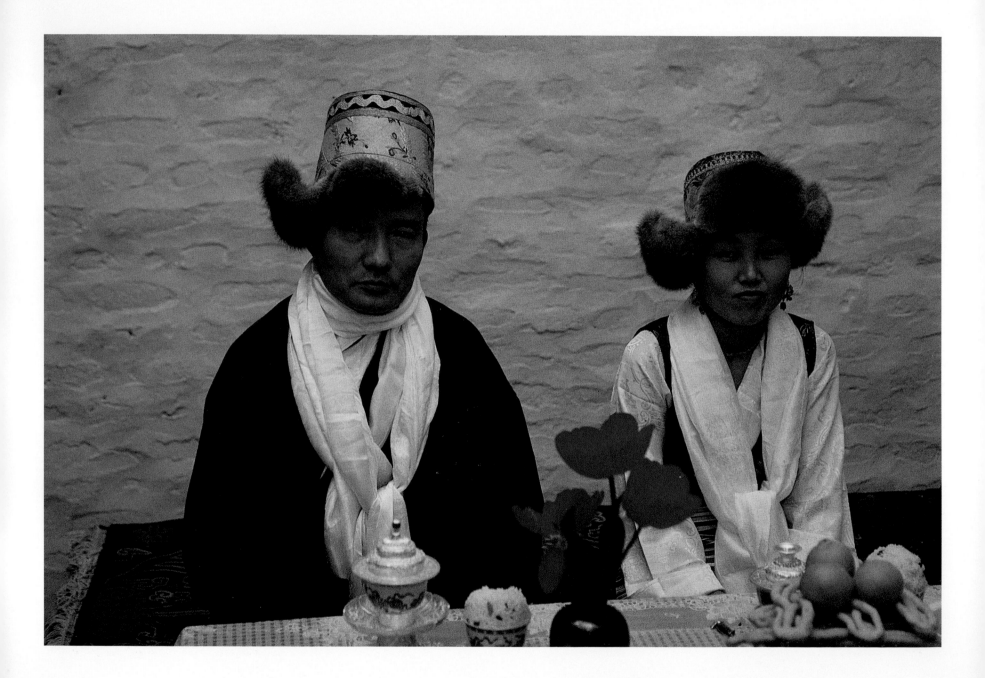

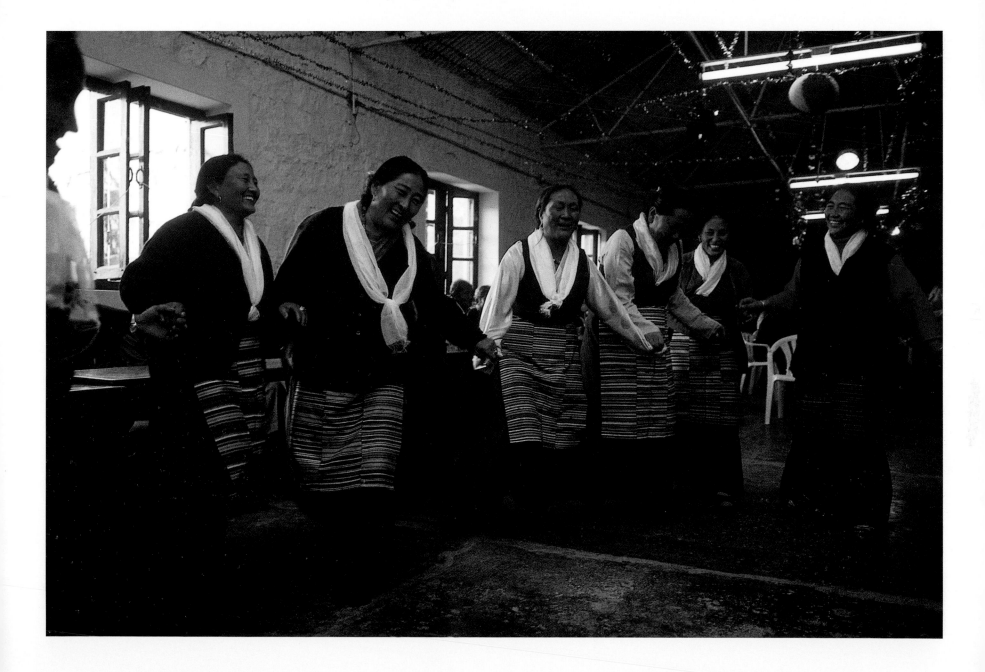

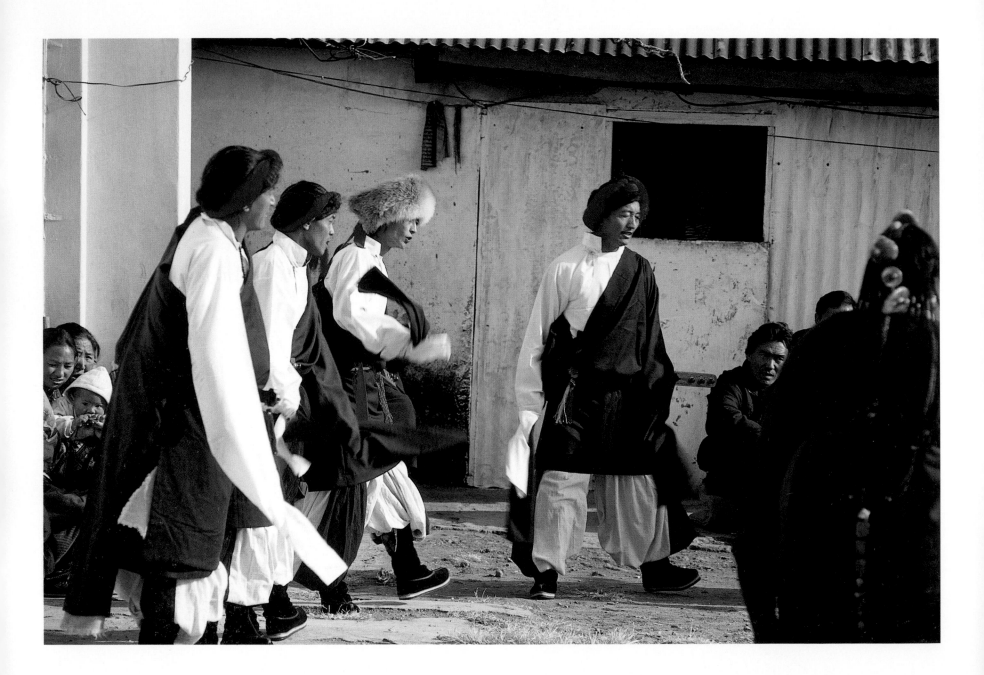

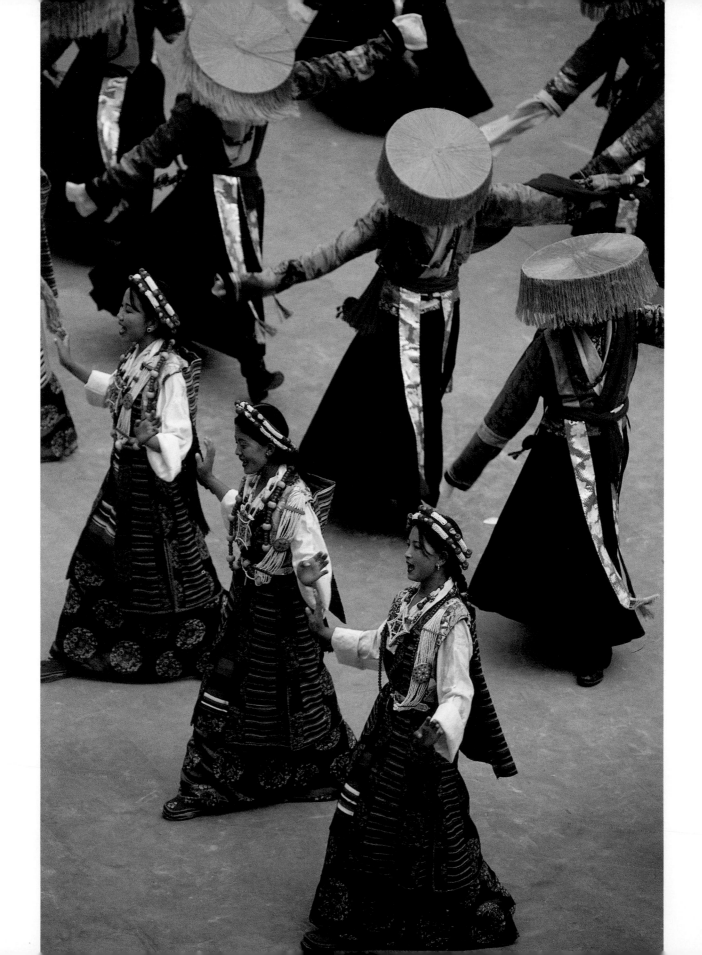

I WAS INVITED BY HIS HOLINESS THE DALAI LAMA TO photograph him when he went to Ladakh in 1997. He was going to give teachings in Leh and then in Zanskar. Located on the Tibetan plateau, Ladakh was a Himalayan kingdom for nine hundred years before it became part of India. The main religion of Ladakh is Tibetan Buddhism.

Lhundup and I went by train to Jammu, intending to fly from there to Leh, but because the flight was cancelled, we headed for Zanskar instead. We flew to Shrinigar and then went by bus to Kargil, where I found the people quite friendly. They are Muslims, and this town, which is in Kashmir, seemed more like Central Asia than India. From Kargil, we took a bus over an 18,000-foot pass into the Zanskar Valley, which is part of Ladakh. The whole trip, from when we left Himachal Pradesh until we arrived in Zanskar, took six days. His Holiness was to fly to Zanskar by helicopter two days later.

In Zanskar, which is 11,000 feet high and accessible only three months of the year, the air is incredibly clear, making mountains that are miles away seem close. On our first day there, we set out to walk to a monastery on what appeared to be a nearby mountain. It took all day to get there. An old monk (page 234), who had trained at a monastery in Lhasa in the 1950s, invited us into his closet-size room, which had a magnificent view of the valley. He made some food for us and showed us around the monastery. After returning to our hotel by truck, I found as I tried to sleep that I could hardly breath. Opening all the windows to get as much air as possible, I tried to relax. I realized that I had pushed myself too hard with all that exercise, without acclimating myself to the altitude first. Fortunately, by the next morning I was okay.

Zanskaris walked into the village of Padam from different parts of the valley for this rare and auspicious occasion, when His Holiness came to give teachings. The women were wearing their finest traditional dresses with magnificent hats covered with turquoise and coral, which are traditionally given by a mother to her daughter when she marries.

An encampment had been set up with tents for the people to stay in during His Holiness's visit, which was hosted by his brother, Ngari Rinpoche, the abbot of several monasteries in Zanskar. His Holiness spoke through a loudspeaker from inside the temple, while the people sat scattered on the ground outside, seeking shelter from the hot sun under bushes that surrounded the temple. Just when His Holiness ended the teachings, everyone looked directly overhead to see a brilliant circle of light around the sun.

That evening Lhundup and I took a bus back to Kargil, where His Holiness was to fly in by helicopter the next day and give a brief talk in a field to a crowd that included both Muslims and Buddhists.

From Kargil, Lhundup and I took a bus to Leh. Along the way it snowed—even though it was July. In Leh we visited some of the important Tibetan Buddhist monasteries, including Hemis and Thiksey. A few weeks later, after our return to Himachal Pradesh, I was saddened to hear there had been a bombing in Kargil. Several months later, war broke out there.

Hemis Monastery, Leh, Ladakh

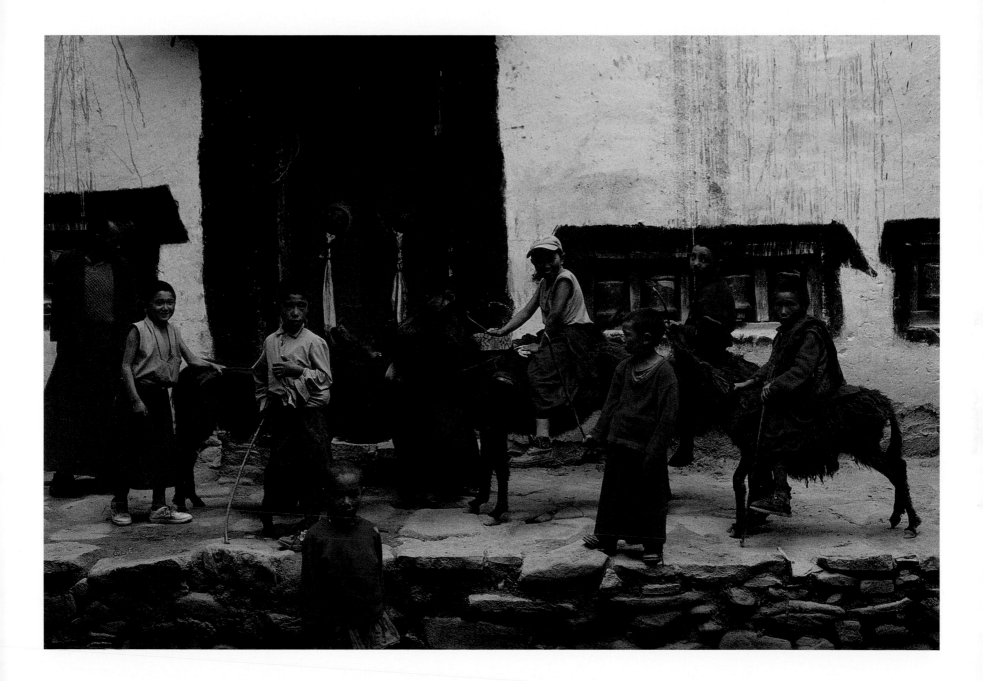

PAGE 233 People of the ethnic group known as Dard Shin listening
to a talk given by the Dalai Lama near the town of Kargil in Kashmir

PAGES 234–235 An old monk and a view from his balcony at
Karsha Monastery, Zanskar

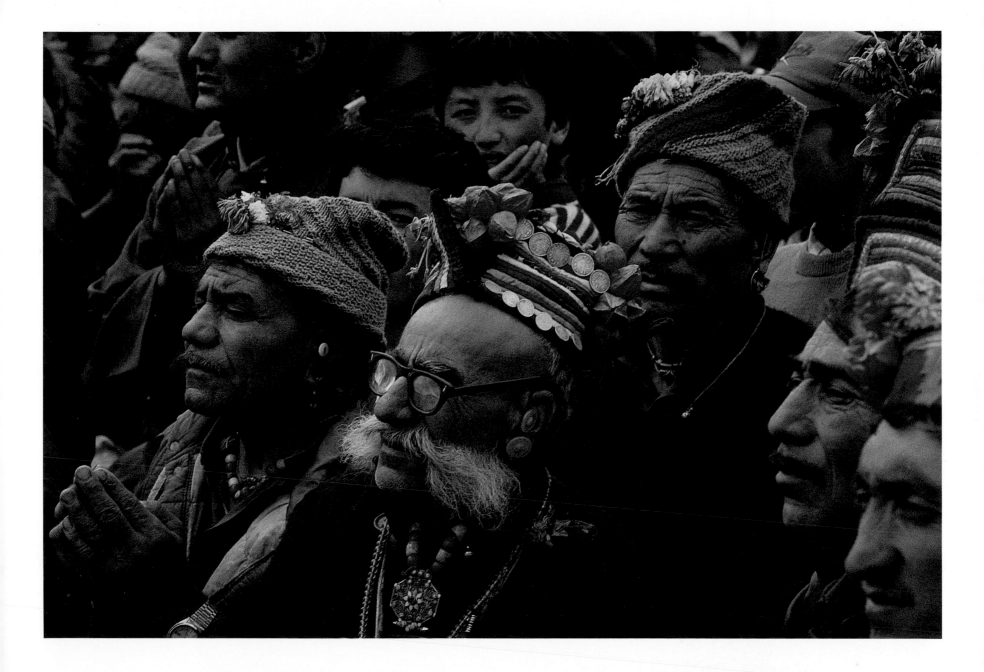

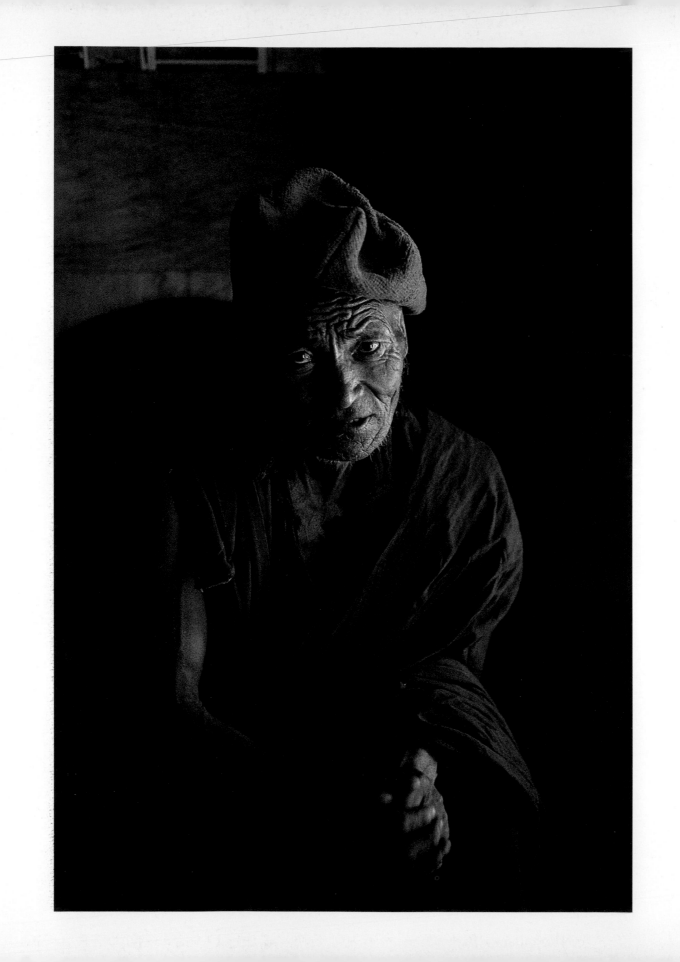

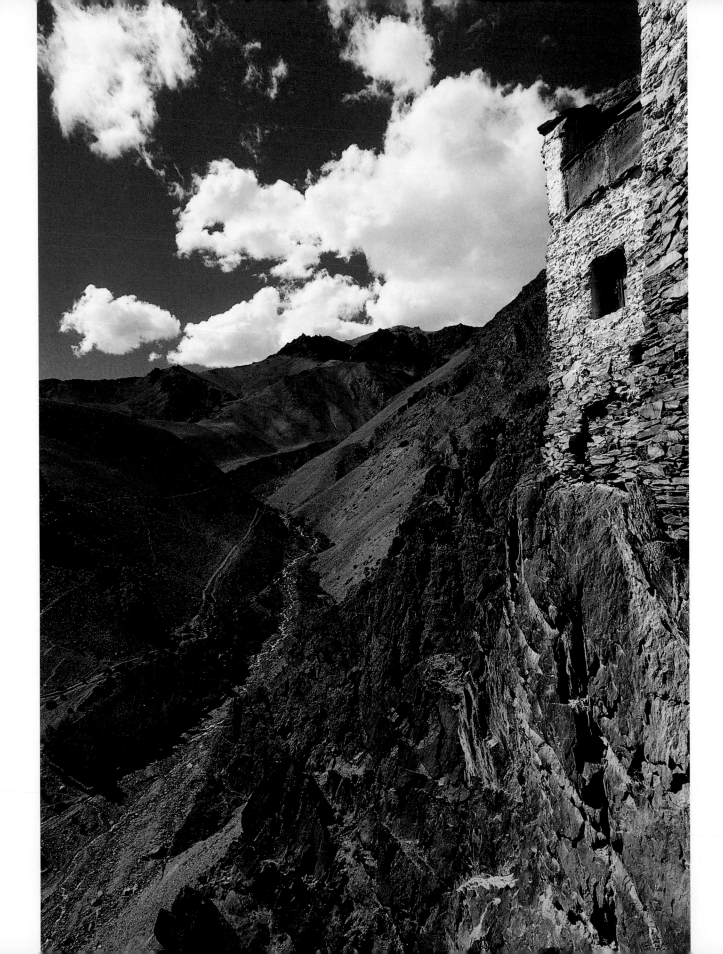

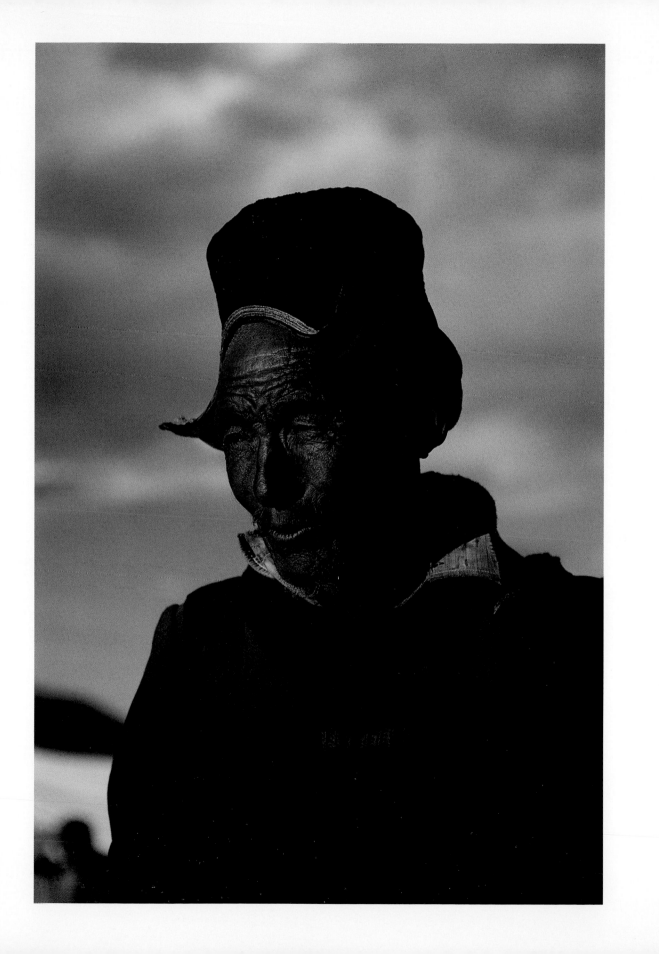

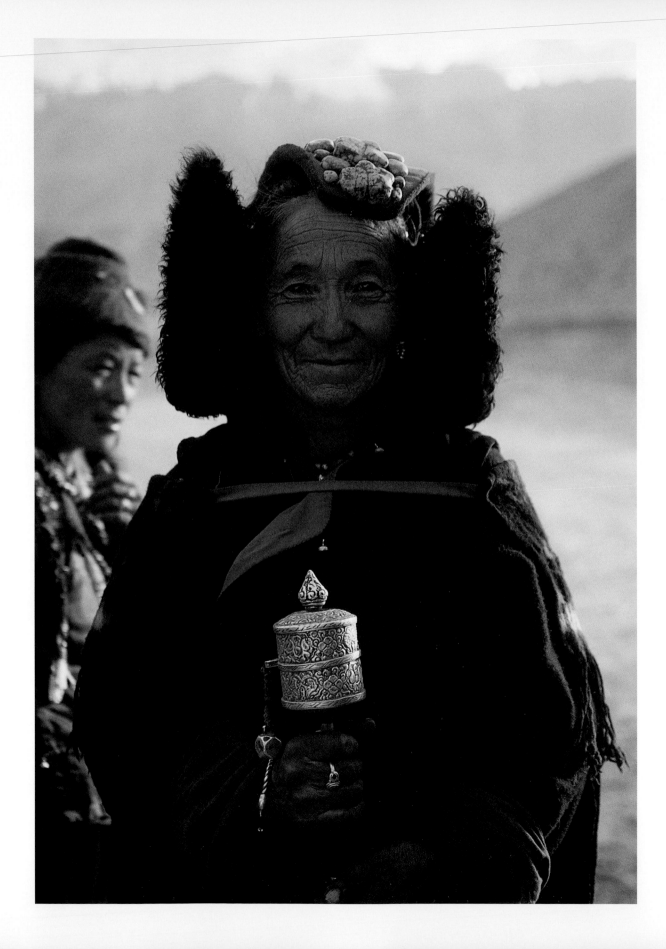

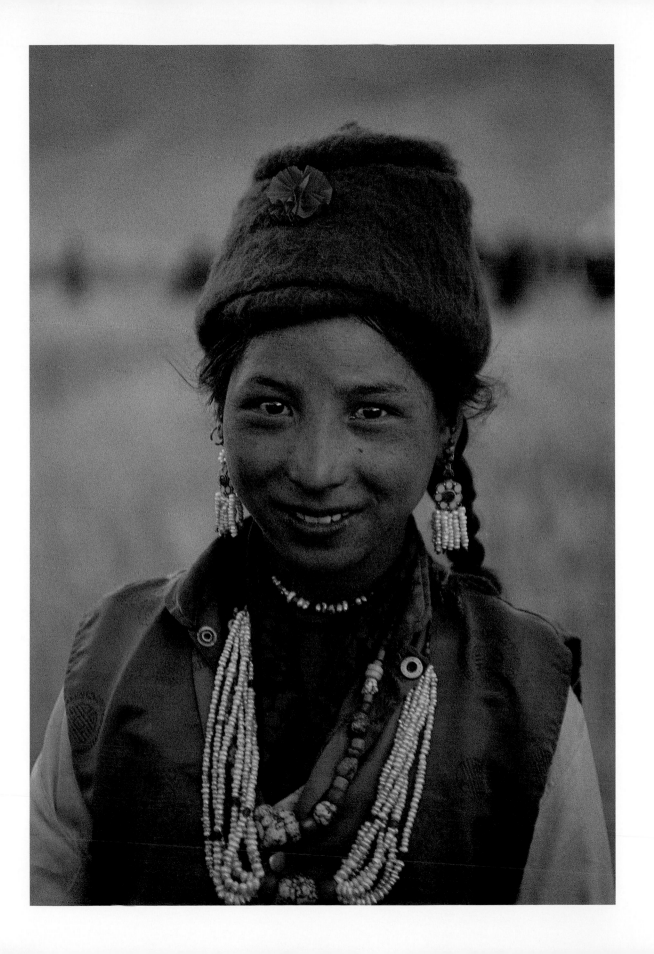

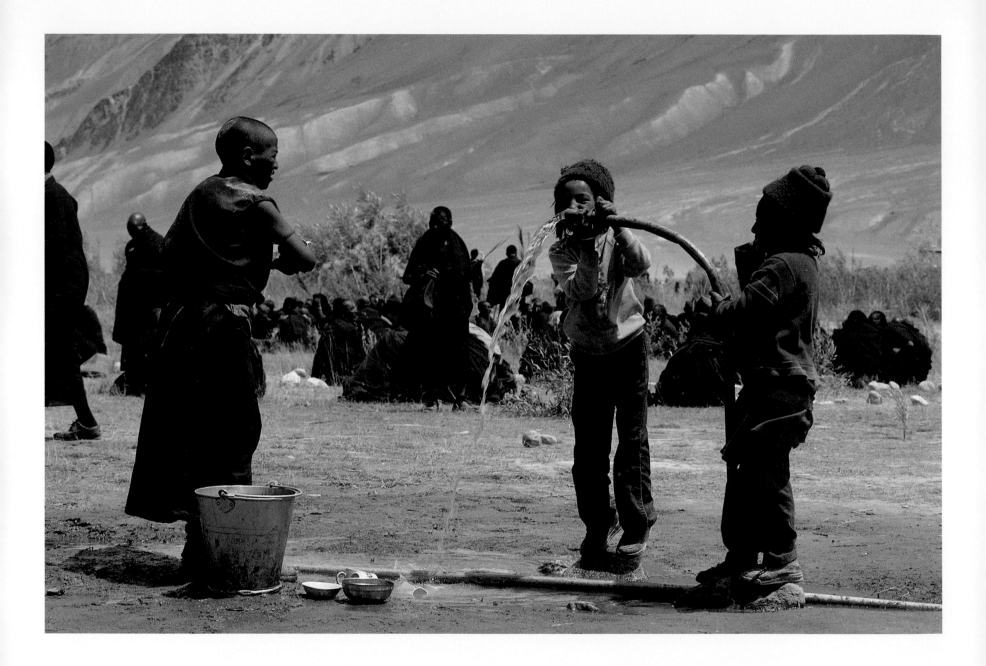

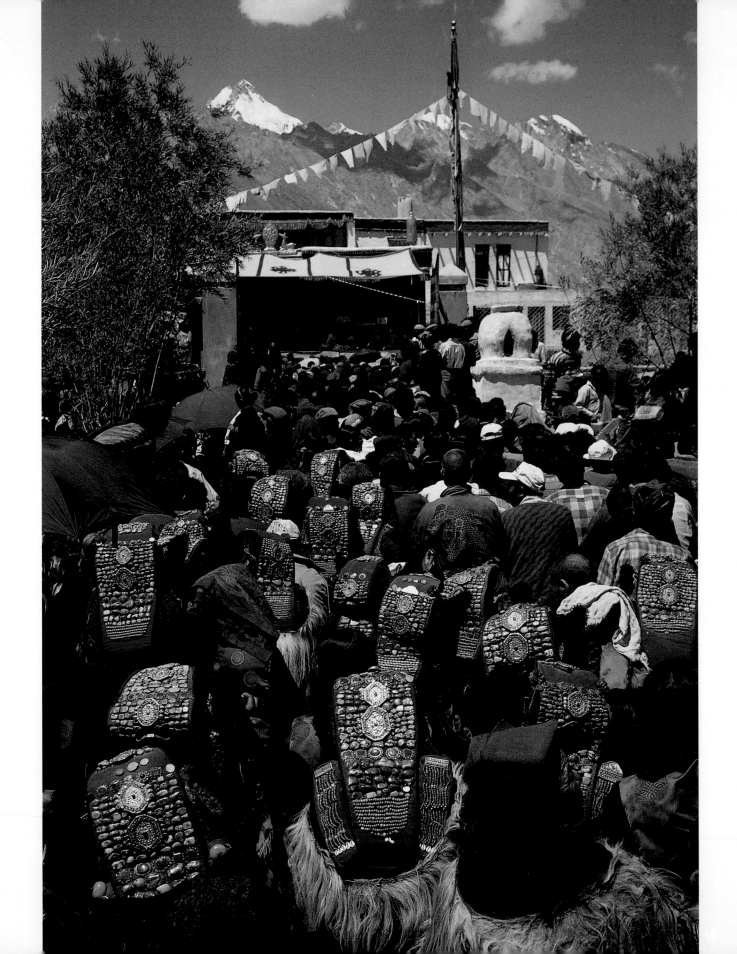

Zanskaris during the visit of the Dalai Lama

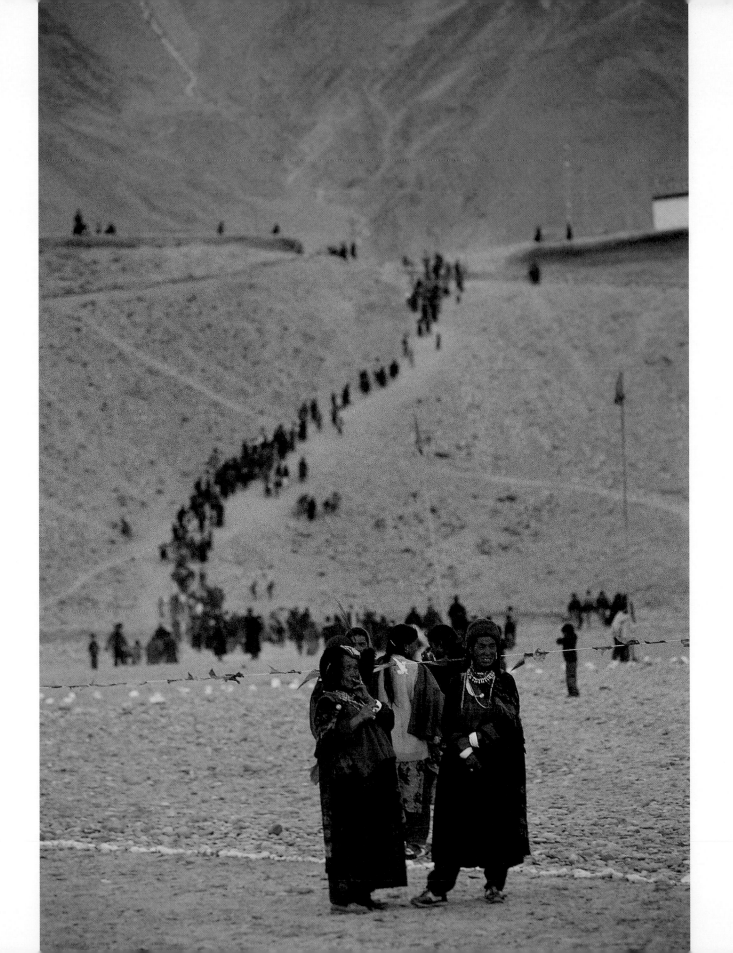

Zanskari mothers and children going to the encampment for lay-people during the Dalai Lama's visit

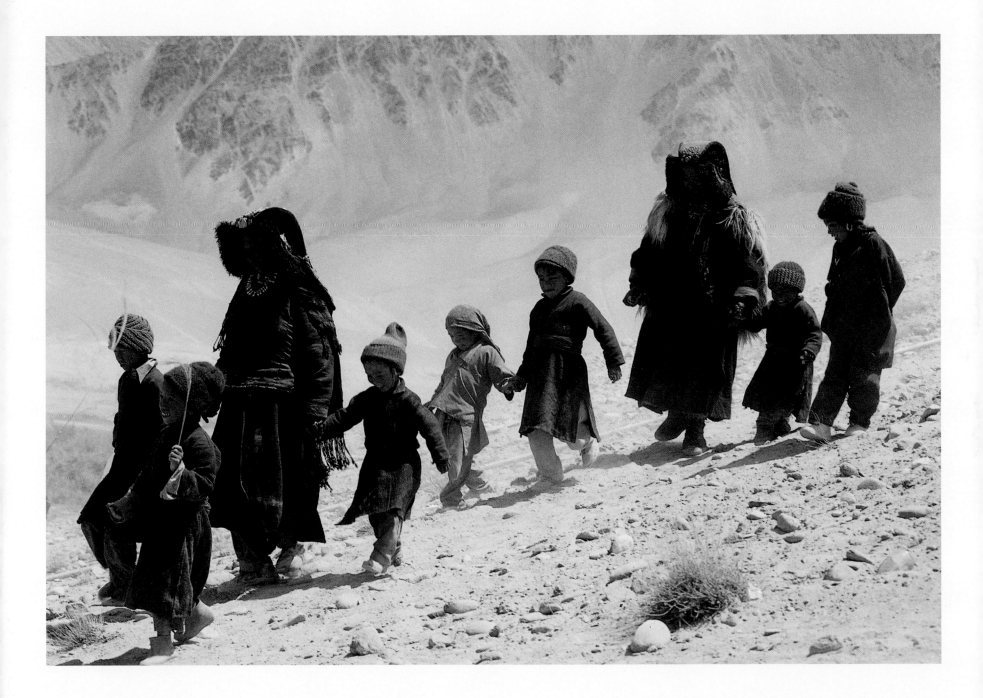

TEXT Adobe Garamond

DISPLAY Akzidenz Grotesk

DESIGNER Nicole Hayward

COMPOSITOR Integrated Composition Systems

PRINTER + BINDER Tien Wah Press